Emmaus High School Library Emmaus, Pennsylvania

WITHDRAWN

PHOTO A TYPE DESIGN SETTING MANUAL

Also by James Craig

Designing with Type: A Basic Course in Typography

Production for the Graphic Designer

Graphic Design Career Guide

PHOTO Amaus High School Library Amaus, Pennsylvania TYPE SETTING DESIGN MANUAL

BY JAMES CRAIG

EDITED BY MARGIT MALMSTROM

686.225 Cra

Copyright © 1978 by James Craig

First published 1978 in the United States and Canada by Watson-Guptill Publications, a division of Billboard Publications, Inc., 1515 Broadway, New York, N.Y. 10036

Library of Congress Cataloging in Publication Data

Craig, James, 1930 – Phototypesetting. Bibliography: p. Includes index. 1. Phototypesetting.

I. Malmstrom, Margit.

II. Title TR1010.C73 686.2'25 78-12276 ISBN 0-8230-4011-9

All rights reserved. No part of this publication may be reproduced or used in any form or by any means—graphic, electronic, or mechanical, including photocopying, recording, taping, or information storage and retrieval systems—without written permission of the publishers.

Manufactured in the U.S.A.

First Printing, 1978

4 5 6 7 8 9/86 85

Dedicated to the designer who uses phototypesetting without really understanding it.

Contents

Acknowledgments, 8 Introduction, 9

Terminology, 11

Type, 12
Typeface, 14
Font, 15
Typestyle, 16
Family of Type, 18
Type Specimen Books, 19
Measuring Type, 20
Points, 21
Points and Linespacing, 22
Picas, 23
Units, 24
Units and Set-Width, 25
Units and Letterspacing, 26
Units and Wordspacing, 28
Units and Phototypesetting, 29

Design, 31

Line Length, 88 Creating Emphasis, 90

Typefaces, 32 Type Specimens, 32 Cross-Reference Chart, 36 Fonts, 38 Pi Fonts, 40 Mixing Typefaces, 42 Choosing Typefaces, 44 Type Sizes, 46 Specifying Type in Inches, 48 How Type Size Affects Quality, 50 How X-Height Affects Size, 52 Mixing Type Sizes, 54 Mixing Type Sizes and Typefaces, 55 Choosing Type Sizes, 56 Letterspacing, 58 Kerning, 62 Choosing Letterspacing, 64 Text Type, 64 Display Type, 65 Wordspacing, 66 Wordspacing and Type Arrangement, 70 Justified, 70 Unjustified, 72 Centered, 74 Asymmetrical, 75 Controlling Wordspacing, 76 Choosing Wordspacing, 78 Linespacing, 80 Specifying Linespacing as White Space, 82 Optical Linespacing, 84 Reverse Linespacing, 85 Choosing Linespacing, 86

Indicating Paragraphs, 92 Run-Arounds, 96 Contour Settings, 97 Display Initials, 98 Small Caps, 100 Ligatures, 101 Rules, 102 Tabular Matter, 104 Specifying Heads, 104 Underscores, 106 Leaders, 108 Boxes, 109 Bullets, 110 Figures, 111 Superior and Inferior Characters, 112 Fractions, 113 Design Considerations for Punctuation, 114 Matching Type, 117 Optical Alignment, 118 Script Typefaces, 120 Custom Lettering, 122 Outline and Shadow Typefaces, 124 Setting Type in Circles, 126 Reproportioning Type, 127 Typographic Ornaments, 128 Borders, 130 Step-and-Repeat, 132 Special Effects, 134 Typographic Guide, 137

Copyfitting, 139

Typewriters, 140 Character Counting, 141 Character Count Table, 142 Counting by Alphabet Length, 143 Copy Mark-up, 144 Formatting Codes, 145 Proofs, 146 Proofreader's Marks, 147 Establishing the Depth, 148 Pica Rule, 150 Copyfitting Tabular Matter, 151 Writing to Fit, 152 Layouts, 153 Comping Text Type, 154 Comping Display Type, 155 Makeup, 156 Copy Preparation, 157 Type Specification Chart, 158

Phototypesetting Systems, 161

Basic Components, 162 Keyboard/Input, 164 Counting Keyboard, 165 Non-Counting Keyboard, 166 Tapes and Discs, 168 Computer, 170 Computer Programs, 172 Photounit/Output, 175 Processors and Proofing Methods, 176 Editing and Correcting, 178 Before Keyboarding, 178 During Keyboarding, 178 After Keyboarding, 178 After Typesetting, 179 Direct-Entry Systems, 180 Photodisplay Systems, 182 CRT Systems, 184 Area Composition Systems, 186 OCR, 187 Paper and Film, 188 Paper, 188 Film, 189 Paper vs. Film, 190 Choosing a System, 192 Choosing a Typographer, 193

Appendix, 195

Point Systems, 197
Metric System, 198
Base Units, 198
Meter, 198
Gram, 198
Liter, 199
Degrees Celsius, 199
Typesetting Symbols, 199
Punctuation, 200
Glossary, 202
Manufacturers of Phototypesetting Equipment, 219
Notes and Credits, 220
Bibliography, 221
Index, 222

Acknowledgments

I would like to thank the following people from the various phototypesetting companies for their cooperation in supplying me with photographs, type specimens, and above all, information: Morton Friedman, of Alphatype Corp.; John Schepper and Dave de Bronkart, of Compugraphic Corp.; Norman G. Hansen, of Dymo Graphic Systems, Inc.; Frank Beauschesne, of Graphic Systems, Inc.; Sheridan Skogen, of Harris Corp.; Robert Elliott, of Itek Corp.; Lorna Shanks and Mike Parker, of Mergenthaler Linotype; and Robert W. Hummerston, of VariTyper.

For giving of their time and expertise, I would also like to thank Ed Ronthaler, of Phototypesetting; Max Baumwell, of M.J. Baumwell Typography; Curtis Dwyer, of Letraset USA, Inc.; Eli Barry, of VGC; Leland J. Katz, of Digital Equipment Corp.; and Carl Palmer, wherever he is.

Special thanks go to Jay Anning, who helped get the manuscript into shape for the editor and the mechanicals into shape for the printer. And to Bob Fillie and Dominick Spodofora for helping me with my other design responsibilities and freeing me to work on *Phototypesetting*.

A special thanks also to Peter G. DeBlass and Ronald Colonna of Gerard Associates Phototypesetting, Inc., and to the excellent staff at Gerard who set this book.

I am especially grateful to Aaron Burns and Ed Gottschall, of International Typeface Corporation; Klaus Schmidt, of Young & Rubicam; and Sandy Levine, of Alphatype Corporation, who took time out of their busy schedules to read over the manuscript and who generously offered suggestions.

There is no way the reader can appreciate the contribution of my editor, Margit Malmstrom, unless they saw the original manuscript. The thoughts are mine, but the words are mostly hers, and for this I thank her.

Introduction

Phototypesetting, although a recent development, is the most widely used method of typesetting today. And like any new technology, it has caused its share of confusion. This book is an attempt to explain how phototypesetting works, clearly and simply, so that designer and nondesigner alike will be able to take full advantage of its enormous potential.

To help the reader find the necessary information quickly, the book is presented in a series of self-contained units that are grouped under four major headings: Terminology, Design, Copyfitting, and Phototypesetting Systems. In some cases information has been repeated so that each unit remains complete in itself.

Although phototypesetting grew out of traditional metal typesetting, I have avoided references to metal type so as not to confuse the reader. I have, however, included all the important metal type terms—many with illustrations—in the glossary.

Some of the information, as well as several of the illustrations, originally appeared in my earlier books *Designing with Type* and *Production for the Graphic Designer*, but this book is in no way intended to be a substitute for either. *Designing with Type* is for the serious student interested in the basics of typography, while *Production for the Graphic Designer* is for the designer concerned about the production aspects of a job. *Phototypesetting* deals with both typography and productions, but strictly in terms of phototypesetting.

James Craig New York City

TERMINOLOGY

This section introduces the basic typographic terms: type, typeface, font, type style, and family of type; letterspacing, wordspacing, and linespacing; x-height, points, picas, and the unit system.

If you are a designer and already familiar with this material, Part One will serve as a quick refresher; if you are a non-designer you will find this section essential to an understanding of the information contained in the rest of the book.

Type

The word *type* is derived from the Greek word *typos*, which loosely translated means "letterform." Today the word is used both individually and collectively to refer to the letters of the alphabet as well as anything else used to create words, sentences, or typographic display.

Individual letters, figures, and punctuation marks are called *characters*. The capital letters are called *uppercase* characters or *caps* and are indicated "u.c." or simply "c." The small letters are called *lowercase* characters and are indicated "l.c." When up-

percase and lowercase characters are combined, such as in the text you are now reading, they are indicated "u/lc" (upper and lowercase) or "c/lc" (caps and lower case).

Other terms with which the designer should be familiar are:

Baseline. The line on which all the capitals and most of the lowercase characters appear to stand.

X-Height. The height of the body, or main element, of the letterform. The x-height is actually the height of the lowercase x.

Ascender. The part of the lowercase letter that rises above the x-height.

Descender. The part of the lowercase letter that falls below the baseline.

Counter. The enclosed or hollow part of the letter.

Serif. The short stroke that projects from the ends of the main strokes. Not all type has serifs; type without serifs is called *sans serif*, which is French for "without serif."

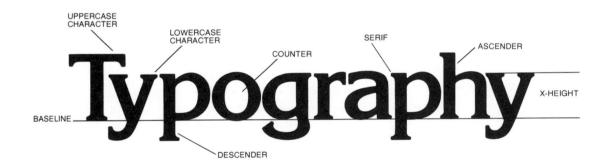

Uppercase and lowercase serifed characters.

Typography

Uppercase and lowercase sans serif characters.

Typeface

A *typeface* refers to a specific design of an alphabet—and there are hundreds!

The difference between one typeface and another is often very subtle; it may be no more than a slight difference in the shape of the serif, the length of the ascenders and descenders, or the size of the x-height. But regardless of how small the difference, the typeface, and therefore the appearance of the printed page, will be affected.

Each typeface has a name for identification: it may be that of the designer (Baskerville, Bodoni, Caslon) or of a country (Egyptian, Caledonia, Helvetica); or it may simply be a name (Futura, News Gothic, Times Roman). The type you are now reading is Helvetica, named after Helvetia, the ancient Latin name for Switzerland.

Note: It may be reassuring to know that in spite of all the different typefaces available, most designers still prefer to work with only a dozen or so favorites.

Baskerville Bodoni Caslon Caledonia Helvetica Futura News Gothic Times Roman

The names of eight popular typefaces, each set in its own typeface.

Font

A font is a complete alphabet of *one* size of *one* typeface. The number of characters in a font varies depending on the number and variety of punctuation marks, special reference marks, accents, etc. A familiar example of a font is the keyboard of a typewriter.

abcdefghijklmnopqrstuvwxyz ABCDEFGHIJKLMNOPQRSTUVWXYZ

1234567890 (&.,:;!?'""-*\$c%/£)

A font of type.

A B C D E F G H I J K L M N
O P Q R S T U V W X Y Z
a b c d e f g h i j k 1 m n
o p q r s t u v w x y z
1 2 3 4 5 6 7 8 9 0
& \$ ¢ @ % # ½ ½
(. , ; : ! ? / - * ")

A typewriter font.

Typestyle

There are times when the designer may wish to emphasize a specific word or sentence. To give the designer this flexibility many type-faces are designed in a variety of different typestyles.

The most common and widely used typestyle is *roman*, in which the letterforms are upright. The type you are now reading is roman. Next is *italic*, in which the letterforms slant to the right. Italic is used mainly for emphasis *and looks like this*. There are also *small caps*, indicated "sc," which are a smaller version of regular caps and are used for emphasis. THEY LOOK LIKE THIS.

Some typestyles are created by varying the weight (thickness of stroke): *light*, semibold, bold, extrabold. Of this group, bold is the most common. It is used for emphasis and **looks like this.** Other typestyles are created by varying the width of the letterform: condensed and extended. Still others are created by varying both weight and width: *light condensed*, semibold condensed, and bold extended, to name a few.

Although some typefaces are available in a wide range of typestyles, most are available in only roman, italic, and bold.

Note: Not all typefaces use the same ter-

minology: some use "oblique" for italic, "expanded" for extended, "demibold" for semibold, and "compact" for condensed; others use "medium" to describe what most designers would consider bold.

Roman *Italic*

The two most common typestyles.

Light Regular Semibold Bold Extrabold

Variations in weight.

Condensed Extended

Variations in width

Light Condensed

Semibold Condensed Bold Extended

Variations in both weight and width.

Family of Type

If we combine all the styles and all the sizes of a given typeface we have a family of type. Using typestyles from within the same family gives the printed piece a unified appearance. This is because all typestyles of a given type size have a family resemblance, as well as the same x-height, cap height, and length of ascenders and descenders.

Souvenir Light Italic
Souvenir Medium
Souvenir Medium Italic
Souvenir Demi
Souvenir Demi Italic
Souvenir Bold
Souvenir Bold Italic

Multiply the above typestyles by all the type sizes available, and you have the Souvenir family of type.

Type Specimen Books

Because there are so many typefaces available from so many typesetters, the designer requires the use of a *type specimen book*. These books show the designer the typefaces offered by a specific typesetter (or manufacturer) and are available upon request.

Type specimen books vary in size and content: some of the smaller books may show only a few letters from each alphabet while others may show complete alphabets or blocks of type.

Trump Mediaeval Semi Bold abcdefghijklmnopqrstuvwxyz ABCDEFGHIJKLMNOPQRSTUVWXYZ 1234567890 (&.,;;]!".'\$¢%/£]

Trump Mediaeval Semi Bold Condensed abcdefghijklmnopqrstuvwxyz ABCDEFGHIJKLMNOPQRSTUVWXYZ 1234567890(&..;;!?""-"Sc%/\$)

Trump Mediaeval Bold abcdefghijklmnopqrstuvwxyz ABCDEFGHJKLMNOPQRSTUVWXYZ 1234567890(&.,;;!?'"-'\$c%/£)

Trump Mediaeval Bold Italic abcdefghijk Imnopqrstuvwxyz ABCDEFGHIJK LMNOPQRSTUVWXYZ 1234567890 (e).,;;!!:"-"\$0%(£)

ABCDEFGHIJKLMNOPORSTUVWXYZ12345A789

Excellence in typography is the result of nothing more than an attitude. Its appeal comes from the understanding sized in its planning, the designer must care in contemporary advertising the perfect integration of design elements often demands unonthodous hypography. It may require the use of compact spacing, minus leading, usual sizes and weights, whatever is needed to improve appearance and impact. Stating specific principles or guides on this subject of hypography of discust the cause the interest and major to one or the control of the principles or guides on this subject of hypography of discust the cause the interest and major to one or the control of the principles or guides on this subject of hypography of discust the cause the interest and major to one or the control of the principles of the principles

abcdefghijkimnopqrstuvwxyz ABCDEFGHIJKLMNOPQRSTUVWXYZ123456789

Excellence in typography is the result of nothing more than an attitude. Its appeal comes from he understanding used in its planning; the designer must care in contemporary advertising it e perfect integration of design elements often demands unorthodox typography. It may require e the use of compact spacing, immus leading, unusual sizes and weights, whatever is needed to migrore appearance and immact. Standing specific principles or guides on the subject of typograph migrore appearance and immact. Standing specific principles or guides on the subject of typograph.

abcdefghijkimnopqrstuvwxyz ABCDEFGHIJKLMNOPQRSTUVWXYZ1234567890

Excellence in typography is the result of nothing more than an attitude. Its appeal con es from the understanding used in its planning, the designer must care. In contempor, ry advertising the perfect integration of design elements often demands unorthodox ypography. It may require the use of compact spacing, minus leading, unisusal sizes at d weights, whatever is needed to improve appearance and impact. Stating specific or d weights, whatever is needed to improve appearance and impact. Stating specific or the stating that is the stating that is the stating that is the stating that is the specific or the stating that is the stating that it is the stating th

abcdefghijklmnopqrstuvwxyz ABCDEFGHIJKLMNOPQRSTUVWXYZ1234567890

Excellence in typography is the result of nothing more than an attitude. Its ap peal comes from the understanding used in its planning, the designer must care are. In contemporary advertising the perfect integration of design elements of the demands unorthodox typography. It may require the use of compact s pengin, minus leading, unusual sizes and weights, whatever is needed to impr

abcdefghijklmnopqrstuvvxyz ABCDEFGHIJKLMNOPQRSTUVWXYZ 1234567890

Excellence in typography is the result of nothing more than an attitud e. Its appeal comes from the understanding used in its planning; the designer must care. In contemporary advertising the perfect integration of design eliments of sten demands unorthoods typography. It may virtualize the use of compact spacing, minus leading, unusualy sizes an

abcdefghijklmnopqrstuvwxyz ABCDEFGHIJKLMNOPQRSTUVWXYZ1234567890

Excellence in typography is the result of nothing more than an attitude. Its appeal comes from the understanding used in its p lanning; the designer must care. In contemporary advertising the perfect integration of design elements often demands unor thodox typography. It may require the use of compact spacin

abcdefghijklmnopqrstuvwxyz ABCDEFGHIJKLMNOPQRSTUVWXYZ1234567890

Excellence in typography is the result of nothing more than an attitude. Its appeal comes from the understanding used in its planning; the designer must care. In contempor any advertising the perfect integration of design elements often demands unorthodox typography. It may require the

abcdefghijklmnopqrstuvwxyz ABCDEFGHIJKLMNOPQRSTUVWXYZ

Excellence in typography is the result of nothing more than an attitude. Its appeal comes from the understan ding used in its planning; the designer must care. In contemporary advertising the perfect integration of desi

abcdefghijklmnopqrstuvwxyz ABCDEFGHIJKLMNOPQRSTUVWXYZ

Excellence in typography is the result of nothing more than an attitude. Its appeal comes from the understanding used in its planning; the design or must care. In contemporary advertising the pe

abcdefghijklmnopqrstuvwxyz ABCDEFGHIJKLMNOPQRSTUVWXYZ

Excellence in typography is the result of no thing more than an attitude. Its appeal com es from the understanding used in its planning; the designer must care. In contempora

abcdefghijklmnopqrstuvwxyz ABCDEFGHIJKLMNOPQRSTUVWXYZ

Excellence in typography is the result of nothing more than an attitude. Its appeal comes from the understanding used in its planning; the designer must car

abcdefghijklmnopqrstuvwxyz ABCDEFGHIJKLMNOPQRSTUVWX

Excellence in typography is the r esult of nothing more than an att itude. Its appeal comes from the understanding used in its planni

Pages from two type specimen books.

Measuring Type

There are three basic type measurements with which the designer should be familiar: points, picas, and units. These measurements are to the designer what feet and inches are to the architect, and it is with these measurements that the designer controls the look of the printed piece.

Points are used to measure the type size, picas to measure the length of the line. There are 12 points in one pica, and six picas (or 72 points) in one inch.

Points are converted into picas just as inches are converted into feet, except when

specifying type size, which is always indicated in points.

Units are used to measure the width of individual characters as well as the space between characters and words.

Note: Throughout this book we have used inches, points, picas, and units. The reader should be aware, however, that in the U.K. and Europe there is a strong move toward adopting the metric system for typographic measurements. This means that type sizes, line lengths, etc., would all be expressed in millimeters and fractions of a millimeter. (See Metric System on page 198.)

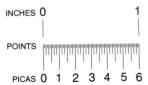

12 points = 1 pica 6 picas = 1 inch

POINTS

The point size, or body size, of a typeface is the measurement from the top of the ascender to the bottom of the descender plus a small amount of space above and below to prevent the lines from touching when set. (Because the space above and below each character varies from typeface to typeface, there is no way to accurately determine the point size of a printed letter. The only sure way is to compare it with a type sample from a type specimen book.)

Type can also be measured from baseline to baseline, providing that no extra space has been added between lines.

Type is traditionally divided into two basic

size categories: *text* type and *display* type. Text type encompasses sizes up to 14 point, display type over 14 point. (Although the distinction between text and display type has virtually disappeared with phototypesetting, it is still used in a rather general way when referring to large or small type sizes.)

To give you an idea of type sizes, the type you are now reading is 9-point Helvetica.

Note: All type measurements are based on metal type. For a more complete explanation see the illustration on page 213 of the glossary.

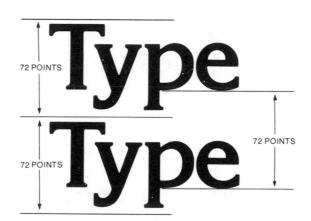

The point size of a typeface is the measurement from the top of the ascender to the bottom of the descender, with a small amount of space above and below. Type can also be measured from baseline to baseline.

Cap H set in one-point increments from 4 through 36 point.

POINTS AND LINESPACING

The term *linespacing*, or *leading*, refers to the space between lines of type. This space is measured in points and sometimes halfpoints.

When type is set without adjusting the space between lines it is said to be set *solid* (10-point type set solid measures ten points from baseline to baseline).

If we add one point of space between the lines, the type would be set "ten on eleven" (10/11). The first figure represents the type size and the second figure the type size plus linespacing. The second figure also represents the baseline to baseline measurement. Adding space is referred to

as linespacing.

If we remove one point of space, the type would be set "ten on nine" (10/9). The second figure in this case represents the type size *minus* the linespacing. Reducing the linespacing is referred to as *minus linespacing* or *negative linespacing*.

The type you are now reading is 9/11 Helvetica; that is, 9-point type and 2 points linespacing.

Note: The terms "linespacing" and "leading" are interchangeable and both are widely used. For this book we will use the term linespacing, which is more widely used in the phototypesetting industry.

	Points, and some-
24 POINTS BASELINE TO BASELINE	times half-points, are
	used to measure the
	space between lines
	of type.

24-point type set solid.

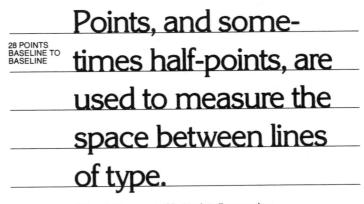

24-point type set with 4 points linespacing.

Points, and someBASELINE TO times half-points, are
used to measure the
space between lines
of type.

24-point type set with 2 points minus linespacing.

PICAS

Picas are used to indicate the length of the line, or *measure*. The type you are now reading was set to a maximum measure of 14 picas. Picas, combined with points, are also used to indicate the depth of a column of type (see page 148).

5 PICAS	Picas are used
6 PICAS	Picas are used to
7 PICAS	Picas are used to i
8 PICAS	Picas are used to in
9 PICAS	Picas are used to indicate
10 PICAS	Picas are used to indicate th
11 PICAS	Picas are used to indicate the l
12 PICAS	Picas are used to indicate the len
13 PICAS	Picas are used to indicate the length
14 PICAS	Picas are used to indicate the length of
15 PICAS	Picas are used to indicate the length of th
16 PICAS	Picas are used to indicate the length of the l
17 PICAS	Picas are used to indicate the length of the line
18 PICAS	Picas are used to indicate the length of the line, o
19 PICAS	Picas are used to indicate the length of the line, or m
20 PICAS	Picas are used to indicate the length of the line, or mea
21 PICAS	Picas are used to indicate the length of the line, or measur
22 PICAS	Picas are used to indicate the length of the line, or measure.
23 PICAS	Picas are used to indicate the length of the line, or measure. Pi
24 PICAS	Picas are used to indicate the length of the line, or measure. Picas
25 PICAS	Picas are used to indicate the length of the line, or measure. Picas ar
26 PICAS	Picas are used to indicate the length of the line, or measure. Picas are a
27 PICAS	Picas are used to indicate the length of the line, or measure. Picas are also
28 PICAS	Picas are used to indicate the length of the line, or measure. Picas are also us
29 PICAS	Picas are used to indicate the length of the line, or measure. Picas are also used
30 PICAS	Picas are used to indicate the length of the line, or measure. Picas are also used to

¹¹⁻point type set in lines ranging from 5 to 30 picas.

(Measuring Type continued)

UNITS

The unit is used to measure the width of the individual characters as well as the space between characters and words.

Units and the Em. To understand the unit and how it relates to the type size, you must first understand the typographic measurement called the *em*. An em is the square of the type size. A 36-point em is a 36-point square and a 72-point em is a 72-point square. By subdividing the em into vertical segments we get "units." Although the number of these units varies with the phototypesetting system, one of the most popular systems is 18-units-to-the-em, which we have used throughout this book.

Other unit systems are 4, 9, 32, 36, 48, 54, and 64. The greater the number of units to the em, the greater the possibilities of typographic refinement. For the average job, however, there is a point beyond which extreme refinement is neither necessary nor noticeable.

One thing to keep in mind when working with units is that they are always relative to the type size. That is, in an 18-unit system, one unit will always be 1/18 of the type size. Therefore, one unit of space added to a line of 10-point type will have exactly the same proportional visual effect as one unit of space added to a line of 72-point type.

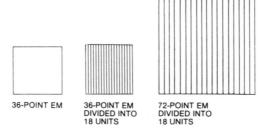

An 18-unit system.

UNITS AND SET-WIDTH

When phototypefaces are designed, each character is allotted a fixed amount of space, measureable in units. This dimension is referred to as the *set-width*, the *set-size*, or simply the *set* of the character, and includes a small amount of space on either side to prevent the characters from touching one another.

The wider the character, the greater the set-width; for example, a cap M may be 18 units wide, while a lowercase a may be 10 units wide and a lowercase t 6 units wide. A period may be 3 units. The set-width, when expressed in units, is referred to as the *unit value* of the character.

Note: The set-width of a particular character may vary from typeface to typeface. For example, a lowercase "a" may have a unit value of 9 in one typeface but only 7 in another.

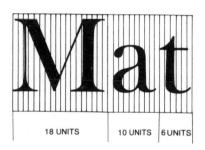

Set-width, or unit value, for three characters.

CHARACTERS	SET-WIDTH
i, j, l	4
f, t, J, ., ,	5
r	6
c, k, s, v, x, y, z, J	9
a, b, d, e, g, h, n, o, p, q, u, L 1, 2, 3, 4, 5, 6, 7, 8, 9, 0	10
F, T, Z	11
A, B, E, K, P, V, X, Y	12
w, C, D, H, N, U, R	13
G, O, Q	14
m, M	15
W	17

Set-width, expressed in units, for 12-point Helvetica Roman.

(Measuring Type continued)

UNITS AND LETTERSPACING

The term *letterspacing* refers to the space between letters. Letterspacing is variable and can be adjusted to suit the designer's needs or taste. It is measured in units, and in some cases, half-units.

Although letterspacing is specified in units, most designers use the general terms normal, loose (or open), tight, and very tight (also referred to as minus letterspacing). Most jobs are set with normal and tight letterspacing. The type you are now reading was set tight (minus one-half unit of letterspacing).

Letterspacing is covered more fully on page 58.

Letterspacing is variable and can be adjusted. -5 UNITS Letterspacing is variable and can be adjusted. -4 UNITS Letterspacing is variable and can be adjusted. -3 UNITS Letterspacing is variable and can be adjusted. -2UNITS Letterspacing is variable and can be adjusted. -1 UNIT Letterspacing is variable and can be adjusted. −½ UNIT Letterspacing is variable and can be adjusted. NORMAL Letterspacing is variable and can be adjusted. +½ UNIT Letterspacing is variable and can be adjusted. +1 UNIT Letterspacing is variable and can be adjusted. +2 UNITS Letterspacing is variable and can be adjusted. +3 UNITS Letterspacing is variable and can be adjusted. + 4 UNITS Letterspacing is variable and can be adjusted. +5 UNITS

Upper and lowercase type with various amounts of letterspacing.

-5 UNITS	LETTERSPACING IS VARIABLE AND CAN BE ADJUSTED.
-4 UNITS	LETTERSPACING IS VARIABLE AND CAN BE ADJUSTED.
-3 UNITS	LETTERSPACING IS VARIABLE AND CAN BE ADJUSTED.
-2 UNITS	LETTERSPACING IS VARIABLE AND CAN BE ADJUSTED.
-1 UNIT	LETTERSPACING IS VARIABLE AND CAN BE ADJUSTED.
−½ UNIT	LETTERSPACING IS VARIABLE AND CAN BE ADJUSTED.
NORMAL	LETTERSPACING IS VARIABLE AND CAN BE ADJUSTED.
+½ UNIT	LETTERSPACING IS VARIABLE AND CAN BE ADJUSTED.
+1 UNIT	LETTERSPACING IS VARIABLE AND CAN BE ADJUSTED.
+2 UNITS	LETTERSPACING IS VARIABLE AND CAN BE ADJUSTED.
+3 UNITS	LETTERSPACING IS VARIABLE AND CAN BE ADJUSTED.
+ 4 UNITS	LETTERSPACING IS VARIABLE AND CAN BE ADJUSTED.
+5 UNITS	LETTERSPACING IS VARIABLE AND CAN BE ADJUSTED.

All caps with various amounts of letterspacing.

(Measuring Type continued)

UNITS AND WORDSPACING

The term *wordspacing* refers to the space between words, and like letterspacing it is variable and measured in units. The number of units between words depends on the typeface and the designer's taste.

The simplest way to specify wordspacing is to forget about units and use the following general terms: normal, loose (or open), tight, and very tight. Most jobs are set with normal or tight wordspacing. The type you are now reading is set with tight wordspacing (minus ½ unit).

Wordspacing is covered more fully on page 66.

LOOSE (7 UNITS) Wordspacing is variable and can be adjusted.

NORMAL (6 UNITS) Wordspacing is variable and can be adjusted.

TIGHT (5 UNITS) Wordspacing is variable and can be adjusted.

VERY TIGHT (4 UNITS) Wordspacing is variable and can be adjusted.

UNITS AND PHOTOTYPESETTING

Perhaps the best way to understand the unit and how it relates to phototypesetting is to think of the standard typewriter, a one-unit system with a very simple counting mechanism. Every letter, punctuation mark, and forward-space occupies exactly one unit. If you set your typewriter for 60 characters, the machine will count sixty keystrokes and a bell will ring. It makes no difference whether you type M's, t's, periods, or merely depress the space bar 60 times.

A phototypesetting machine is basically the same, but more sophisticated. The units are smaller, and each character, instead of being one-unit wide, is made up of a number of smaller units. As the type is being set, a counting mechanism, which is part of the machine, controls the length of each line by adding up the unit values of the characters and the spaces between words.

All typewritten characters occupy the same amount of space—one unit.

Phototype characters occupy varying amounts of space.

DESIGN

This section deals with making day-to-day design decisions such as choosing typefaces and type sizes; mixing typefaces and type sizes; matching type; controlling letterspacing, wordspacing, and linespacing; kerning; methods of creating emphasis; indicating paragraphs; working with display initials, boxes, bullets, rules, borders, ligatures, small caps, underscores, leaders, and fractions.

The purpose of Part Two is to show some of the design options available to help you fully utilize the unique potential of the phototypesetting process.

Typefaces

The design of a specific typeface may vary from one manufacturer to another. Some manufacturers use only original artwork (licensed by the owner), while others prefer to create their own versions of popular typefaces. For this reason, 10-point Helvetica on one system may be quite different from 10-point Helvetica on another, not only in design, but also in x-height and number of characters per pica.

Just as the design of a typeface may differ, so too may the name: Helvetica is also called Claro, Helios, Geneva, or Vega, depending

on the manufacturer. (A cross-reference chart of typeface names is shown on pages 34–35.)

The number of typefaces available also varies with the manufacturer, although all can supply the most popular typefaces. From the designer's point of view, however, the number of typefaces available is less important than their design quality.

Generally speaking, this lack of standardization can be a problem, especially if your typesetting needs bring you in contact with a wide range of different phototypesetting systems.

To minimize the problem, always use a type specimen book for the equipment on

which you intend to set the type. If a book is not available, have a sample set before proceeding with the entire job.

TYPE SPECIMENS

On the following pages we have shown copy set in two typefaces by the major manufacturers of phototypesetting equipment. The purpose of these samples is to make the designer aware of the enormous difference in the design, x-height, and characters per pica from one system to another.

The typefaces are Times Roman and Helvetica, probably the two most widely used typefaces in the world today. They are shown in both 24-point display and 10-point text

Times Roman

Times Roman, originally called the Times' New Roman, is perhaps the most popular serifed typeface in use today. It was designed by Stanley Morison and drawn by Victor Lardent in 1932 for the London Times. It was first cut by the Monotype Corporation and then later produced by Linotype. Times Roman was an immediate success, hailed not only as the perfect newspaper typeface but also as the most important type design of the twentieth century. Since then designers have found that Times Roman makes an excellent typeface for any job. It is compact, attractive and legible. Furthermore, because of its rather large x-height, Times Roman sets exceptionally well in the smaller type sizes.

ALPHATYPE ENGLISH

Times Roman

Times Roman, originally called the Times' New Roman, is perhaps the most popular serifed typeface in use today. It was designed by Stanley Morison and drawn by Victor Lardent in 1932 for the London Times. It was first cut by Monotype Corporation and later produced by Linotype. Times Roman was an immediate success, hailed not only as the perfect newspaper typeface but also as the most important type design of the twentieth century. Since that time designers have found that Times Roman makes an excellent typeface for any job. It is compact, attractive and legible. Furthermore, because of its rather large x-height, Times Roman sets exceptionally well in the smaller type sizes.

COMPUGRAPHIC ENGLISH

Helvetica

Helvetica is, without doubt, the most widely used sans serif typeface today. It was conceived by Edouard Hoffman and drawn by Max Meidinger in 1957 for Haas type foundry in Switzerland and introduced to the United States in the early sixties. Its popularity has increased ever since. Helvetica, with its large x-height and clean design, is a very legible typeface, even in the smaller type sizes. The Helvetica type family is one of the largest, offering the designer a wide choice of type styles ranging from light to extrabold and condensed to extended.

ALPHATYPE CLARO

Helvetica

Helvetica is, without a doubt, the most widely used sans serif typeface today. It was conceived by Edouard Hoffman and drawn by Max Miedinger in 1957 for the Haas type foundry in Switzerland and introduced to the United States in the early sixties. Its popularity has increased ever since. Helvetica, with its large x-height and clean design, is a very legible typeface, even in the smaller type sizes. The Helvetica type family is one of the largest, and offers the designer a wide choice of type styles ranging from light to extrabold and condensed to extended.

COMPUGRAPHIC HELIOS

type, with 1 point linespacing. The text type is set justified on a 16-pica measure with normal wordspacing and letterspacing. Because the names of the typefaces vary from system to system, the manufacturer's name for each typeface is shown under the text block.

The systems represented are: Alphatype Corp. Compugraphic Corp. Dymo Graphic Systems, Inc. Graphic Systems, Inc. Harris Corp. Itek Graphic Products Mergenthaler Linotype Corp. VariTyper *Note:* For more information on the various companies, see Manufacturers on page 219.

Times Roman

Times Roman, originally called the Times' New Roman, is perhaps the most popular serifed typeface in use today. It was designed by Stanley Morison and drawn by Victor Lardent in 1932 for the London Times. It was first cut by the Monotype Corporation and later produced by Linotype. Times Roman was an immediate success, hailed not only as the perfect newspaper typeface but also as the most important type design of the twentieth century. Since then designers have found that Times Roman makes an excellent typeface for any job. It is comapct, attractive, and legible. Furthermore, because of its rather large x-height, Times Roman sets exceptionally well in smaller type sizes.

DYMO TIMES NEW ROMAN

Helvetica

Helvetica is, without doubt, the most widely used sans serif typeface today. It was conceived by Edouard Hoffman and drawn by Max Miedinger in 1957 for the Haas type foundry in Switzerland and introduced to the United States in the early sixties. Its popularity has increased ever since. Helvetica, with its large x-height and clean design, is a very legible typeface, even in the smaller type sizes. The Helvetica type family is one of the largest, offering the designer a wide choice of type styles ranging from light to extrabold and condensed to extended.

DYMO NEWTON

Times Roman

Times Roman, originally called the Times' New Roman, is perhaps the most popular serifed typeface in use today. It was designed by Stanley Morison and drawn by Victor Lardent in 1932 for the London Times. It was first cut by the Monotype Corporation and then produced by Linotype. Times Roman was an immediate success, hailed not only as the perfect newspaper typeface but also as the most important type design of the twentieth century. Since then designers have found that Times Roman makes an excellent typeface for any job. It is compact, attractive, and legible. Furthermore, because of its rather large x-height, Times Roman sets exceptionally well in the smaller type sizes.

GRAPHIC SYSTEMS GENEVA

Helvetica

Helvetica is, without a doubt, the most widely used sans serif typeface today. It was conceived by Edouard Hoffman and drawn by Max Miedinger in 1957 for the Haas type foundry in Switzerland and introduced to the United States in the early sixties. Its popularity has increased ever since. Helvetica, with its large x-height and clean design, is a very legible typeface, even in the smaller type sizes. The Helvetica type family is one of the largest, offering the designer a wide choice of type styles ranging from light to extrabold and condensed to extended.

GRAPHIC SYSTEMS LONDON ROMAN

Times Roman

Times Roman, originally called the Times' New Roman, is perhaps the most popular serifed typeface in use today. It was designed by Stanley Morison and drawn by Victor Lardent in 1932 for the London Times. It was first cut by the Monotype Corporation and then produced by Linotype. Times Roman was an immediate success, hailed not only as the perfect newspaper typeface but also as the most important type design of the twentieth century. Since then designers have found that Times Roman makes an excellent typeface for any job. It is compact, attractive, and legible. Furthermore, because of its rather large x-height, Times Roman sets exceptionally well in the smaller type sizes.

HARRIS TIMES ROMAN

Helvetica

Helvetica is, without doubt, the most widely used sans serif typeface today. It was conceived by Edouard Hoffman and drawn by Max Miedinger in 1957 for the Haas type foundry in Switzerland and introduced to the United States in the early sixties. Its popularity has increased ever since. Helvetica, with its large x-height and clean design, is a very legible typeface, even in the smaller type sizes. The Helvetica type family is one of the largest, offering the designer a wide choice of type styles ranging from light to extrabold and condensed to extended.

HARRIS VEGA

Times Roman

Times Roman, originally called the Times' New Roman, is perhaps the most popular serifed typeface in use today. It was designed by Stanley Morison and drawn by Victor Lardent in 1932 for the London Times. It was first cut by the Monotype Corporation and then produced by Linotype. Times Roman was an immediate success, hailed not only as the perfect newspaper typeface but also as the most important type design of the twentieth century. Since then designers have found that Times Roman makes an excellent typeface for any job. It is compact, attractive, and legible. Furthermore, because of its rather large xheight, Times Roman sets exceptionally well in the smaller type sizes.

ITEK TR 55

Helvetica

Helvetica is, without doubt, the most widely used sans serif typeface today. It was conceived by Edouard Hoffman and drawn by Max Miedinger in 1957 for the Haas type foundry in Switzerland and introduced to the United States in the early sixties. Its popularity has increased ever since. Helvetica, with its large x-height and clean design, is a very legible typeface, even in the smaller type sizes. The Helvetica type family is one of the largest, offering the designer a wide choice of type styles ranging from light to extrabold and condensed to extended.

ITEK HE 55

Times Roman

Times Roman, originally called the Times' New Roman, is perhaps the most popular serifed typeface in use today. It was designed by Stanley Morison and drawn by Victor Lardent in 1932 for the London *Times*. It was first cut by the Monotype Corporation and then produced by Linotype. Times Roman was an immediate success, hailed not only as the perfect newspaper typeface but also as the most important type design of the twentieth century. Since then designers have found that Times Roman makes an excellent typeface for any job. It is compact, attractive, and legible. Furthermore, because of its rather large x-height, Times Roman sets exceptionally well in the smaller type sizes.

MERGENTHALER LINOTYPE TIMES ROMAN

Helvetica

Helvetica is, without a doubt, the most widely used sans serif typeface today. It was conceived by Edouard Hoffman and drawn by Max Miedinger in 1957 for the Haas type foundry in Switzerland and introduced to the United States in the early sixties. Its popularity has increased ever since. Helvetica, with its large x-height and clean design, is a very legible typeface, even in the smaller type sizes. The Helvetica type family is one of the largest, offering the designer a wide choice of type styles ranging from light to extrabold and condensed to extended.

MERGENTHALER LINOTYPE HELVETICA

Times Roman

Times Roman, originally called the Times' New Roman, is perhaps the most popular serifed typeface in use today. It was designed by Stanley Morison and drawn by Victor Lardent in 1932 for the London Times. It was first cut by the Monotype Corporation and then produced by Linotype. Times Roman was an immediate success, hailed not only as the perfect newspaper typeface but also as the most important type design of the twentieth century. Since then designers have found that Times Roman makes an excellent typeface for any job. It is compact, attractive, and legible. Furthermore, because of its rather large xheight, Times Roman sets exceptionally well in the smaller type sizes.

VARITYPER TIMES ROMAN

Helvetica

Helvetica is, without doubt, the most widely used sans serif typeface today. It was conceived by Edouard Hoffman and drawn by Max Miedinger in 1957 for the Haas type foundry in Switzerland and introduced to the United States in the early sixties. Its popularity has increased ever since. Helvetica, with its large x-height and clean design, is a very legible typeface, even in the smaller type sizes. The Helvetica type family is one of the largest, offering the designer a wide choice of type styles ranging from light to extrabold and condensed to extended.

VARITYPER MERGARON MEDIUM

Cross-Reference Chart

This cross reference chart lists popular typefaces whose name varies depending on the manufacturer. Typefaces with a name used in common by all manufacturers are not listed. The chart is divided into two sections: commercial typefaces, such as those used in publishing and advertising, and newspaper typefaces. The original name of the typeface is given in the left-hand column.

TYPEFACES	ALPHATYPE	COMPUGRAPHIC	DYMO	HARRIS	ITEK	MERGENTHALER LINOTYPE	VARITYPER
BASKERVILLE	BASKERLINE	BASKERVILLE	BASKERVILLE	BASKERVILLE	BK 55	BASKERVILLE	BASKERVILLE
BODONI	BODONI	BODONI	BODONI	BODONI	BO 55	BODONI	BODONI
CALEDONIA	CALEDO	CALIFORNIA	HIGHLAND	LAUREL		CALEDONIA	HIGHLAND
CASLON	CASLON	LSC CASLON	CASLON	CASLON		CASLON	CASLON
CENTURY EXPANDED	CENTURY X	CENTURY LIGHT	CENTURY EXPANDED	CENTURY EXPANDED		CENTURY EXPANDED	CENTURY EXPANDED
CENTURY SCHOOLBOOK	CENTURY TEXT	CENTURY TEXTBOOK	CENTURY SCHOOLBOOK	CENTURY SCHOOLBOOK	CS 55	CENTURY SCHOOLBOOK	SCHOOLBOOK
CLARENDON	CLARENDON	CLARENDON	CLARENDON	CLARIQUE		CLARENDON	CLARENDON
COPPERPLATE	COPPERPLATE GOTHIC	COPPERPLATE	-	GOTHIC NO. 31		COPPERPLATE	COPPERPLATE
FUTURA BOOK	FUTURA BOOK	FUTURA BOOK	PHOTURA BOOK	FUTURA BOOK	-	SPARTAN BOOK	
FUTURA LIGHT	FUTURA LIGHT	FUTURA LIGHT	TECHNO LIGHT	FUTURA LIGHT		SPARTAN LIGHT	TECHNO LIGHT
FUTURA MEDIUM	FUTURA MEDIUM	FUTURA MEDIUM	TECHNO MEDIUM	FUTURA MEDIUM		SPARTAN MEDIUM	TECHNO MEDIUM
FUTURA BOLD	FUTURA BOLD	FUTURA BOLD	TECHNO BOLD	FUTURA BOLD		SPARTAN BLACK	TECHNO EXTRA BOLL
GARAMOND	GARAMOND	GARAMOND	GARAMOND	GARAMOND	GD 55	GARAMOND	GARAMOND
HELVETICA	CLARO	HELIOS II	NEWTON	VEGA	HE 55	HELVETICA	MEGARON
MELIOR	URANUS	MALLARD	BALLARDVALE	MEDALLION	ME 55	MELIOR	HANOVER
NEWS GOTHIC	NEWS GOTHIC	NEWS GOTHIC	NEWS GOTHIC	NEWS GOTHIC		TRADE GOTHIC	NEWS GOTHIC
OPTIMA	MUSICA	ORACLE	CHELMSFORD	ZENITH	OP 55	OPTIMA	CHELMSFORD
PALATINO	PATINA	PALADIUM	ANDOVER	ELEGANTE	4 04	PALATINO	ANDOVER
STYMIE	STYMIE	STYMIE	STYMIE	CAIRO	ST 55	MEMPHIS	STYMIE
TIMES ROMAN	ENGLISH	ENGLISH TIMES	TIMES NEW ROMAN	TIMES ROMAN	TR 55	TIMES ROMAN	TIMES ROMAN
UNIVERS 55	VERSATILE	UNIVERS MEDIUM II	UNIVERS MEDIUM	GALAXY MEDIUM	UN 55	UNIVERS	UNIVERS MEDIUM
UNIVERS 65	VERSATILE	UNIVERS BOLD II	UNIVERS BOLD	GALAXY DEMI	UN 65	UNIVERS	UNIVERS BOLD

TYPEFACES	ALPHATYPE	COMPUGRAPHIC	DYMO	HARRIS	ITEK	MERGENTHALER LINOTYPE	VARITYPER
AURORA		NEWS NO. 2	GROTESQUE COND.	REGAL		AURORA	
BODONI BOLD		BODONI BOLD	BODONI BOLD	BODONI BOLD		BODONI BOLD	BODONI BOLD
CORONA	KORONNA	NEWS NO. 3	CROWN	ROYAL	CR 55	CORONA	CROWN
EXCELSIOR	LEAGUE TEXT	NEWS NO. 14	EXCELLA	REGAL BERLIN	EX 55	EXCELSIOR	CAMELOT
MPERIAL		NEWS NO. 4	BEDFORD	IMPERIAL			
ONIC	NEWS TEXT MEDIUM	DORIC	DORIC	IONIC NO. 5		IONIC NO. 5	
REGAL			EMPIRA	REGAL			EMPIRA
REX		NEWS NO. 10	ZAR	REX			
ROYAL		NEWS NO. 13		ROYAL			
SPARTAN BOOK/AGATE			SANS NO. 1	TECHNO BOOK	FUTURA		SPARTAN BOOK

Newspaper typefaces.

Fonts

Type fonts vary from system to system, both in the number and variety of characters available. The number of characters on a font is usually between 86 and 150, depending on the system.

All standard fonts have certain characters in common: a complete alphabet of uppercase and lowercase characters, figures 1 through 0, and the usual punctuation marks. Others have in addition small caps, ligatures, foreign accents, etc.

However, a font does not always carry the particular characters you may need. For

example, the basic punctuation marks may be on the roman font, while other characters, like the percentage mark and mathematical symbols, are on the italic font. But because the roman and italic fonts are generally onmachine at the same time, you should have all the characters you require.

The number of fonts on-machine at one time varies with the system. (See Fonts and Image Carriers on page 174.)

Note: Some manufacturers have more than one font for a given typeface. For example, they may have a book format font, suitable for publishing, and a job format font, suitable for general typesetting.

ABCDEFGHIJKLMNOPQR STUVWXYZ&1234567890\$¢

ABCDEFGHIJKLMNOPQRSTUVWXYZ

abcdefghijklmnopqrstuvwxyz

fi fl ff ffi ffl

1/8 1/4 3/8 1/2 5/8 3/4 7/8

1234567890\$●®©™

BOOK FORMAT

ABCDEFGHIJKLMNOPQR STUVWXYZ&1234567890\$¢

abcdefghijklmnopqrstuvwxyz

1/8 1/4 3/8 1/2 5/8 3/4 7/8

1234567890\$¢

JOB FORMAT

Two standard fonts from the same manufacturer.

ABCDEFGHIJKLMNOPQR STUVWXYZ&1234567890\$

abcdefghijklmnopqrstuvwxyz

1/2 1/3 1/4 2/3 3/4 1/8 3/8 5/8 7/8

?

ABCDEFGHIJKLMNOPQR STUVWXYZ&1234567890\$

ABCDCEFGHIJKLMNOPQRSTUVWXYZ

abcdefghijklmnopqrstuvwxyz

fi fl ff ffi ffl

1/8 1/4 3/8 1/2 5/8 3/4 7/8 1/3 2/3

. ? ! [] ()

,:;''|---†‡§@°/*

Two standard fonts from different manufacturers.

Pi Fonts

The designer may have occasion to use special characters not included on the standard font. These characters, or "sorts," are often available on special fonts called *pi fonts*.

It is not always necessary to buy a complete pi font in order to set a few special characters. Some systems have fonts designed with blank spaces that allow for the hand-insertion of individual pi characters (available from the manufacturer). In some cases, original art (logos, trademarks, etc.), can be adapted for on-machine use.

```
A
                       ≢
α
       \mathbf{B}
β
       д
φ
δ
                       ∢
               \triangleright
       \Delta
       \mathbf{E}
                       \neq
\epsilon
                      \leq
        Φ
               \geq
φ
       Γ
                       ≦
               \geq
γ
                       ≶
       H
               \geq
η
       I
                       ~
ι
ξ
        Ξ
               ≫
                       \ll
                      ¥
        K
               Z
κ
λ
        Λ
               \infty
                       \infty
               ı.c
        M
μ
                      CAP
                       \supset
        N
               \subset
ν
                                                           //
        0
                       \cong
0
                                                           //
                       \triangleq
        П
\pi
               ÷
        Θ
\theta
                                                           λ
                                                    \pi
                       Ŧ
        P
               \pm
ρ
                                                    Δ
        Σ
                       ≎
                                                            Δ
σ
                                                    Ω
        T
               \perp
                                                           Ω
\tau
        Υ
               >
                       <
                                                           Σ
υ
        Ψ
               1
                       1
ψ
                                            &
        \Omega
               X
                       ÷
ω
                                                    \infty
        X
χ
                                                    (
θ
        \mathbf{Z}
                                                           )
```

MATHEMATICAL CHARACTERS

FOREIGN ACCENTS

ABCDEFGHIJKLMNOPQRSTUVWXYZ

Ææ Œœ ßŖ©%%\$Φ \blacksquare \$ \$fifffffff

PI FONT WITH SMALL CAPS

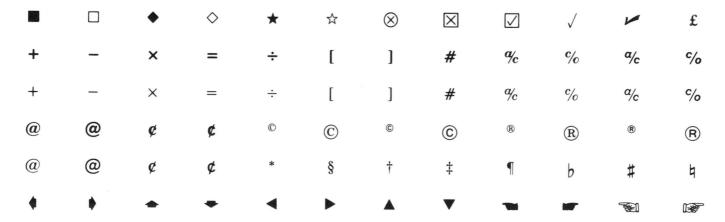

MISCELLANEOUS PI CHARACTERS

Mixing Typefaces

There are few jobs that do not involve a change of typeface or typestyle, even if it is only from roman to italic.

There are two factors to consider when mixing typefaces on a particular piece of equipment: the font-carrying capacity of the system and how font changes are made. The font-carrying capacity dictates the number of typefaces that can be mixed without changing fonts; the font-changing system dictates whether font changes are achieved by keyboard command (automatic) or by hand (manual).

However, just because a machine holds multiple fonts and changes them automatically, do not assume that it is practical or economical to mix a lot of typefaces. Changes require extra keystrokes and slow down the phototypesetting operation. Also, there is a limit to how much typeface mixing one can do and still have legible copy that is inviting to read.

TYPE ALIGNMENT

If you mix typefaces it is obviously important that the characters align along a common baseline. All phototypesetting machines to-day produce base-aligned type no matter what typeface (or size) is being set. If,

however, you wish to align the type along a top or center line, some machines also have this capability—although it may be less expensive to do it by hand.

Note: Just because typefaces have the same point size does not necessarily mean that they have the same x-height or capheight. In other words, different typefaces of the same point size may vary considerably in actual size. So when mixing typefaces, you may also have to mix point sizes if you wish to have all the type appear the same size.

Typestyle change from roman to italic to bold.

Typeface change from Trade Gothic Light to Century Expanded to Souvenir.

TOPALIGNING

CENTER ALIGNING

BOTTOM ALIGNING

Choosing Typefaces

With such a wide selection of typefaces, choosing the "right" one can be difficult. To help make the process a little simpler, consider your selection in terms of the following: esthetics, appropriateness, legibility, and readability.

Esthetics. Choose a typeface that appeals to you. If you are not familiar with the various typefaces available, choose one from the cross-reference chart on page 36. These are all popular, well-designed typefaces. Work with a small number of typefaces until you are thoroughly familiar and comfortable with

them. You may find, like most designers, that you prefer to continue to work with a limited number of typefaces.

Appropriateness. The typeface you choose will depend to a great extent on the product and on the audience. Typefaces have personalities and the one you choose should be appropriate: it should complement the product and be acceptable to the audience.

Another factor to consider is the length of the copy to be set: an ornate typeface, which might be appropriate for one or two words, may be inappropriate for a block of text. **Legibility.** It is not enough that a typeface be esthetically pleasing, it must also be legible.

Sometimes legibility is simply a question of type size and can be improved by setting the job in a larger type size. More often it is a question of typeface design: some typefaces are just easier to read than others.

Legibility is a very personal matter and it is not always possible to please everyone. The typefaces people consider the most legible are the ones they are most familiar with.

For example, there is an ongoing controversy over whether serif typefaces are more legible than sans serif typefaces. Unfortunately, there is no simple answer; so much depends on personal preference and reading habits. Therefore, before you decide on a typeface it may be a good idea to check

American Typewriter

Baskerville

Bauhaus Demi

Bembo

Bodoni

Caledonia

Caslon 540

Century Expanded

Clarendon

Cooper Black

Eurostyle

Garamond No. 3

Garamond Ultra

Gill Sans

Helvetica

Korinna

Melior

Memphis Light

Optima

Palatino

Serif Gothic

Souvenir

Tiffany Medium

Times Roman

Trade Gothic

Univers 55

A sampling of well-designed, popular typefaces.

with the client in case there is a strong preference for any particular one. If there is none, use your own good taste and judgment.

Readability. Readability is different from legibility; it involves not only the typeface, but how it is set—the size, measure, margins, gutters, choice of paper, etc. In other words, everything that makes reading a pleasure. You might say that while legibility depends on typeface and type size, readability is based on the total design.

Legibility can often be improved by setting a job in a larger type size. Sometimes, however, you may find it necessary to choose another typeface.

Legibility can often be improved by setting a job in a larger type size. Sometimes, however, you may find it necessary to choose another typeface.

Legibility can often be improved by setting a job in a larger type size. Sometimes, however, you may find it necessary to choose another typeface.

Readability involves not only the typeface, but how it is set: size, measure, margins, etc.

Readability involves not only the typeface, but how it is set: size, measure, margins, etc.

Type Sizes

Most phototypesetting machines set type from approximately 5 through 36 point, covering all the text sizes and the more popular display sizes. Others can set type up to 72 point with the use of enlarging lenses. Still others set only display type. (See Photodisplay Systems on page 182.)

A small number of machines are also capable of setting text type in half-sizes, $5\frac{1}{2}$, $6\frac{1}{2}$, $7\frac{1}{2}$, $8\frac{1}{2}$, etc., which is useful for tight jobs that have lengthy copy and limited space.

Changing type sizes involves either a font

change or a lens change and can be either manual or automatic, depending on the system. (See page 174.)

5-point type	
6-point type	
7-point type	
8-point type	
9-point type	
10-point type	
11-point type	
12-point type	
14-point type	

The most commonly used text sizes.

Some phototypesetting systems are also capable of setting text type in half-sizes.

Some phototypesetting systems are capable of setting text type in half-sizes.

Some phototype setting systems are capable of setting text type in half-sizes. $% \label{eq:capable}$

Some phototype setting systems are capable of setting text type in half-sizes.

Some phototypesetting systems are capable of setting text type in half-sizes.

Some phototypesetting systems are capable of setting text type in half-sizes.

Some phototypesetting systems are capable of setting text type in half-sizes.

Some phototypesetting systems are capable of setting text type in half-sizes.

Some phototypesetting systems are capable of setting text type in half-sizes.

5-point through 9-point type set in half-point increments.

16-point type
18-point type
20-point type
30-point type
36-point type
42-point type
48-point type
60-point type
72-point type

The most commonly used display sizes.

Specifying Type in Inches

There are times when the designer may find it convenient to specify type in inches rather than points. In this case the cap height, specified in inches, determines the type size. When the word to be set is all lowercase, the lowercase x-height determines the type size. Note however that type specified for one inch is not 72-point type, even though 72 points equals one inch. (See X-Height on page 12.)

Another method of specifying display type is to ignore the type size altogether and

specify, in inches, the length of the word to be set. In this case, the typesetter will set the word as close to the specified size as possible and make any final adjustments by photographically enlarging or reducing the type. There is usually an additional charge for this kind of service.

72-POINT U/I C

Memphis

1 INCH CAP HEIGHT, U/LO

Memphis

1INCH CAP HEIGHT, CAPS THEIGHT, CAPS

INCH X-HEIGHT, LC INCH X-HEIGHT, LC

How Type Size Affects Quality

To understand how type size affects quality you must first understand that large type sizes are not simply small type sizes that have been enlarged.

Traditionally, typeface designers made separate drawings for each type size. Incorporated into each drawing were subtle adjustments: the smaller type sizes were more extended, the counters more open, their strokes finer, and there was comparatively more space between each letter. Larger sizes were similarly adjusted. In this way

the type designer was able to insure that a typeface would retain the same "look" throughout the entire range of type sizes.

Today it is too expensive to make separate drawings for every type size; manufacturers try to attain the highest level of quality with the fewest possible drawings. This means that a master drawing is made at a specific size and then reduced or enlarged photographically to create other sizes. This is satisfactory providing the amount of reduction or enlargement is not so great as to introduce distortions.

The same applies to setting type. If a single font is used for setting too wide a range of sizes there may be distortions—

especially in the very small and very large type sizes. Typical distortions are fuzzy letters, uneven weight, and poor letterspacing.

A particular problem with the larger type sizes is letterspacing that is too loose. To correct this, some machines have a "white space reduction" program that automatically tightens up the space between characters.

If you are planning a job that involves a wide range of type sizes and you are not familiar with the equipment, have samples set to make sure the quality is satisfactory. If you are not satisfied with the larger type sizes, consider having them set separately on a photodisplay machine. (See page 182.)

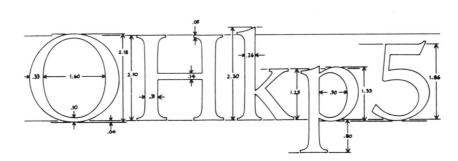

A typeface by Compugraphic called Holland Seminar. Like all typefaces, it was originally drawn oversize (250 point) but is reproduced here at approximately one third size. The above characters were chosen to show all the basic elements: ascenders, descenders, thick and thin strikes, x-height, cap height, etc.

Typography 6-POINT TYPE

Typography

6-POINT TYPE ENLARGED TO 24-POINT

Too great an enlargement leads to fuzzy letters, uneven weight, and poor letterspacing.

Typography

TRUE 24-POINT TYPE

Notice the difference between the 6-point type when enlarged to 24-point and true 24-point type.

How X-Height Affects Size

The x-height is the height of the lowercase letter exclusive of ascenders and descenders. Although the x-height is not a unit of measurement, it is significant because it conveys the visual impact of the type size. In other words, typefaces of the same point size may appear smaller or larger because of the difference in their x-heights.

The three type samples shown on this page are all 10 point, yet notice how much larger the Helvetica appears in relation to the Garamond. One of the advantages of type-

faces with large x-heights is that you can use a smaller size without sacrificing legibility or readability.

Typefaces with large x-heights generally require more linespacing than those with small x-heights.

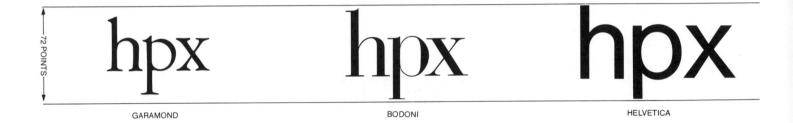

Three typefaces that have the same point size but different x-heights.

The x-height is the height of the lowercase letter exclusive of ascenders and descenders. Although the x-height is not a unit of measurement, it is significant because it conveys the visual impact of the type size. In other words, typefaces of the same point size may appear smaller or larger because of the difference in their x-heights.

The three type samples shown on this page are all 10 point, yet notice how much larger the Helvetica appears in relation to the others. One of the advantages of typefaces with large x-heights is that you can use a smaller size without sacrificing legibility or readability.

Typefaces with large x-heights generally require more linespacing than those with small x-heights.

10/12 GARAMOND

The x-height is the height of the lower-case letter exclusive of ascenders and descenders. Although the x-height is not a unit of measurement, it is significant because it conveys the visual impact of the type size. In other words, type-faces of the same point size may appear smaller or larger because of the difference in their x-heights.

The three type samples shown on this page are all 10 point, yet notice how much larger the Helvetica appears in relation to the others. One of the advantages of typefaces with large x-heights is that you can use a smaller size without sacrificing legibility or readability.

Typefaces with large x-heights generally require more linespacing than those with small x-heights.

10/12 BODONI

The x-height is the height of the lowercase letter exclusive of ascenders and descenders. Although the x-height is not a unit of measurement, it is significant because it conveys the visual impact of the type size. In other words, typefaces of the same point size may appear smaller or larger because of the difference in their x-heights.

The three type samples shown on this page are all 10 point, yet notice how much larger the Helvetica appears in relation to the others. One of the advantages of typefaces with large x-heights is that you can use a smaller size without sacrificing legibility or readability.

Typefaces with large x-heights generally require more linespacing than those with small x-heights.

10/12 HELVETICA

Mixing Type Sizes

Type sizes, like typefaces, can be mixed on-machine and have all the type align on a common baseline.

The method of changing type sizes varies with the system and involves either a font change or a lens change. On some systems font and lens changes are automatic (keyboard controlled), on others the font change is manual. Automatic changes are faster, more efficient, and usually less expensive. If the system with which you are working makes changes manually, try to limit the number of changes.

Note: When mixing type sizes, make sure there is enough linespacing so that the larger type does not overlap adjacent lines.

Type size change from 12 point to 14 point to 18 point to 24 point.

When mixing type sizes, make sure there is enough linespacing so that the **larger type** does not overlap adjacent lines.

Mixing Type Sizes and Typefaces

There are times when you may wish to mix type sizes as well as typefaces. This is possible, but keep in mind that the number of typefaces you can economically mix is dictated by the font-carrying capacity of the phototypesetting machine. Also, if font changes are made manually rather than automatically, they can be expensive.

Mixing type sizes and typefaces.

• How many typefaces can you mix economically?

A It depends on the fontcarrying capacity of the phototypesetting machine.

Choosing Type Sizes

In choosing the type size, a number of factors should be considered in addition to the designer's personal esthetic judgment: typeface, audience, copy, position, to name a few.

Typeface. As you know, it is the x-height and not the point size that determines the visual size of the type. Therefore, you should be more concerned with the visual size and legibility of a typeface than with its point size. **Audience.** It helps to know the audience before you choose the type size. For example, if the audience is very young or very old

you will need a larger type size than if the audience is of a median age.

Copy. If the copy is lengthy and must fit into a small space, choose a typeface that is small (in point size) yet legible (large x-height). It also helps if the typeface is slightly condensed, which will allow for more characters per line.

Position. Position is particularly important when choosing the size of display type, because its purpose is to capture the reader's attention. This does not necessarily mean however that display type must be large. Small type, usually bolder, surrounded by space or printed in a second color, can also be effective.

Typeface. It is the x-height and not the point size of a typeface that determines the visual size of the type. Therefore, when choosing a type size you should be more concerned with its visual size and legibility than its point size.

Typeface. It is the x-height and not the point size of a typeface that determines the visual size of the type. Therefore, when choosing a type size you should be more concerned with its visual size and legibility than its point size.

Typeface. It is the x-height and not the point size of a typeface that determines the visual size of the type. Therefore, when choosing a type size you should be more concerned with its visual size and legibility than its point size.

Three typefaces with the same point size but different x-heights.

Audience. You should consider the audience before you choose the type size. If your readers are of median age, the job can probably be set in 10- or 11-point type; if they are younger or older you may want to consider 12- or 14-point type, or even larger.

Audience. You should consider the audience before you choose the type size. If your readers are of median age, the job can probably be set in 10- or 11-point type; if they are younger or older you may want to consider 12- or 14-point type, or even larger.

Audience. You should consider the audience before you choose the type size. If your readers are of median age, the job can probably be set in 10- or 11point type; if they are younger or older you may want to consider 12- or 14-point type, or even larger.

The same copy set in 10-, 12-, and 14-point type.

Copy. If copy must fit into a small space, choose a typeface that is small in point size and large in x-height. It may also help if the typeface is slightly condensed, which will allow for more characters per

ASTER

Copy. If copy must fit into a small space, choose a typeface that is small in point size and large in x-height. It may also help if the typeface is slightly condensed, which will allow for more characters per line.

TRADE GOTHIC

Copy. If copy must fit into a small space, choose a typeface that is small in point size and large in x-height. It may also help if the typeface is slightly condensed, which will allow for more characters per line.

HELVETICA CONDENSED

Copy. If copy must fit into a small space, choose a typeface that is small in point size and large in x-height. It may also help if the typeface is slightly condensed, which will allow for more characters per

AVANT GARDE GOTHIC BOOK

Copy. If copy must fit into a small space, choose a typeface that is small in point size and large in x-height. It may also help if the typeface is slightly condensed, which will allow for more characters per line.

CENTURY EXPANDED

Five typefaces that remain legible when set in small sizes.

POSITION. This is particularly important when considering the size of display type, because the purpose of display type is to capture the reader's attention.

POSITION

This is particularly important when considering the size of display type, because the purpose of display type is to capture the reader's attention.

POSITION This is particularly important when considering the size of display type, because the purpose of display type is to capture the reader's attention.

A display head set in a variety of positions.

Letterspacing

The term *letterspacing* refers to the space between letters. By adjusting this space it is possible to improve legibility, control the amount of space copy will occupy, and change the "color" of the printed piece.

Letterspacing is measured in units and half-units, depending on the system. (Some phototypesetting systems can also letterspace in points and fractions of points.) However, unless you are very familiar with a particular piece of equipment and very comfortable working with units, you may find it more convenient to specify letterspacing

with the following general terms: normal, loose (or open), tight, and very tight. Display type may also be set touching.

Normal letterspacing, as the name suggests, is the way the type comes off the machine, with no extra space added or deleted. With loose letterspacing, space is added; with tight, very tight, and touching letterspacing, space is deleted.

Letterspacing can be *overall* or *selective*. In overall letterspacing, all the letters are affected: in selective letterspacing, more commonly referred to as *kerning*, only certain letter combinations are affected. (See Kerning on page 62.)

Remember that adjusting the letter-

spacing will affect the number of characters that can be set to a given measure: the looser the setting, the fewer characters per line; the tighter the setting, the more characters per line.

Whatever letterspacing you choose, remember to adjust the wordspacing proportionately.

Note: As the wordspacing also has an effect on the overall color of the setting, the samples on pages 58 and 60 have been set with normal wordspacing, while the samples on pages 59 and 61 have been set with tight wordspacing.

By adjusting the letterspacing it is possible to improve legibility, control the amount of space copy will occupy, and change the color of the printed piece. Letterspacing is measured in units and half-units, depending on the system. However, unless you are very familiar with a particular piece of equipment and very comfortable working with units, you may find it more convenient to specify letterspacing with the following general terms: normal, loose, tight, and very tight.

LOOSE LETTERSPACING (+1/2 UNIT)

By adjusting the letterspacing it is possible to improve legibility, control the amount of space copy will occupy, and change the color of the printed piece. Letterspacing is measured in units and half-units, depending on the system. However, unless you are very familiar with a particular piece of equipment and very comfortable working with units, you may find it more convenient to specify letterspacing with the following general terms: normal, loose, tight, and very tight.

NORMAL LETTERSPACING

By adjusting the letterspacing it is possible to improve legibility, control the amount of space copy will occupy, and change the color of the printed piece. Letterspacing is measured in units and half-units, depending on the system. However, unless you are very familiar with a particular piece of equipment and very comfortable working with units, you may find it more convenient to specify letterspacing with the following general terms: normal, loose, tight, and very tight.

TIGHT LETTERSPACING (-1/2 UNIT)

By adjusting the letterspacing it is possible to improve legibility, control the amount of space copy will occupy, and change the color of the printed piece. Letterspacing is measured in units and half-units, depending on the system. However, unless you are very familiar with a particular piece of equipment and very comfortable working with units, you may find it more convenient to specify letterspacing with the following general terms: normal, loose, tight, and very tight.

VERY TIGHT LETTERSPACING (-1 UNIT)

By adjusting the letterspacing it is possible to improve legibility, control the amount of space copy will occupy, and change the color of the printed piece. Letterspacing is measured in units and half-units, depending on the system. However, unless you are very familiar with a particular piece of equipment and very comfortable working with units, you may find it more convenient to specify letterspacing with the following general terms: normal, loose, tight, and very tight.

LOOSE LETTERSPACING (+1/2 UNIT)

By adjusting the letterspacing it is possible to improve legibility, control the amount of space copy will occupy, and change the color of the printed piece. Letterspacing is measured in units and half-units, depending on the system. However, unless you are very familiar with a particular piece of equipment and very comfortable working with units, you may find it more convenient to specify letterspacing with the following general terms: normal, loose, tight, and very tight.

NORMAL LETTERSPACING

By adjusting the letterspacing it is possible to improve legibility, control the amount of space copy will occupy, and change the color of the printed piece. Letterspacing is measured in units and half-units, depending on the system. However, unless you are very familiar with a particular piece of equipment and very comfortable working with units, you may find it more convenient to specify letterspacing with the following general terms: normal, loose, tight, and very tight.

TIGHT LETTERSPACING (-1/2 UNIT)

By adjusting the letterspacing it is possible to improve legibility, control the amount of space copy will occupy, and change the color of the printed piece. Letterspacing is measured in units and half-units, depending on the system. However, unless you are very familiar with a particular piece of equipment and very comfortable working with units, you may find it more convenient to specify letterspacing with the following general terms: normal, loose, tight, and very tight.

VERYTIGHT LETTERSPACING (-1 UNIT)

By adjusting the letterspacing it is possible to improve legibility, control the amount of space copy will occupy, and change the color of the printed piece. Letterspacing is measured in units and half-units, depending on the system. However, unless you are very familiar with a particular piece of equipment and very comfortable working with units, you may find it more convenient to specify letterspacing with the following general terms: normal, loose, tight, and very tight.

LOOSE LETTERSPACING (+1/2 UNIT)

By adjusting the letterspacing it is possible to improve legibility, control the amount of space copy will occupy, and change the color of the printed piece. Letterspacing is measured in units and half-units, depending on the system. However, unless you are very familiar with a particular piece of equipment and very comfortable working with units, you may find it more convenient to specify letterspacing with the following general terms: normal, loose, tight, and very tight.

NORMAL LETTERSPACING

By adjusting the letterspacing it is possible to improve legibility, control the amount of space copy will occupy, and change the color of the printed piece. Letterspacing is measured in units and half-units, depending on the system. However, unless you are very familiar with a particular piece of equipment and very comfortable working with units, you may find it more convenient to specify letterspacing with the following general terms: normal, loose, tight, and very tight.

TIGHT LETTERSPACING (-1/2 UNIT)

By adjusting the letterspacing it is possible to improve legibility, control the amount of space copy will occupy, and change the color of the printed piece. Letterspacing is measured in units and half-units, depending on the system. However, unless you are very familiar with a particular piece of equipment and very comfortable working with units, you may find it more convenient to specify letterspacing with the following general terms: normal, loose, tight, and very tight.

VERY TIGHT LETTERSPACING (-1 UNIT)

By adjusting the letter spacing it is possible to improve legibility, control the amount of space copy will occupy, and change the color of the printed piece. Letter spacing is measured in units and half-units, depending on the system. However, unless you are very familiar with a particular piece of equipment and very comfortable working with units, you may find it more convenient to specify letter spacing with the following general terms: normal, loose, tight, and very tight.

LOOSE LETTERSPACING (+1/2 UNIT)

By adjusting the letterspacing it is possible to improve legibility, control the amount of space copy will occupy, and change the color of the printed piece. Letterspacing is measured in units and half-units, depending on the system. However, unless you are very familiar with a particular piece of equipment and very comfortable working with units, you may find it more convenient to specify letterspacing with the following general terms: normal, loose, tight, and very tight.

NORMAL LETTERSPACING

By adjusting the letterspacing it is possible to improve legibility, control the amount of space copy will occupy, and change the color of the printed piece. Letterspacing is measured in units and half-units, depending on the system. However, unless you are very familiar with a particular piece of equipment and very comfortable working with units, you may find it more convenient to specify letterspacing with the following general terms: normal, loose, tight, and very tight.

TIGHT LETTERSPACING (-1/2 UNIT)

By adjusting the letterspacing it is possible to improve legibility, control the amount of space copy will occupy, and change the color of the printed piece. Letterspacing is measured in units and half-units, depending on the system. However, unless you are very familiar with a particular piece of equipment and very comfortable working with units, you may find it more convenient to specify letterspacing with the following general terms: normal, loose, tight, and very tight.

VERY TIGHT LETTERSPACING (-1 UNIT)

Kerning

Selectively reducing the space between certain characters, while leaving the rest of the setting the same, is called *kerning*. When used with care and good taste, kerning can greatly improve letterfit and the overall evenness and legibility of a line of type, especially display type.

Certain letter combinations, such as Yo, Te, LY, YA, are generally improved by kerning. When set normally there is too much space between these particular letter combinations compared with the space between adjacent letters. The amount of kerning

needed will depend on a number of factors, such as the specific letter combinations, the typeface, and the overall letterspacing. (Even if the overall letterspacing is tight, kerning individual letter combinations may still be desirable.)

If a particular job warrants it, the designer should specify kerning. Most phototypesetting machines have some kerning ability, ranging anywhere from a keyboard operator deciding which characters should be kerned to a completely automatic kerning program.

Note: Kerning is a typographic nicety and may incur additional charges depending on the typesetter and the equipment.

AV Te Yo Y.

KERNED 19 UNIT AV Te Yo Y.

KERNED 1 UNIT AV Te Yo Y.

KERNED 2 UNITS AV Te Yo Y.

KERNED 3 UNITS AV Te Yo Y.

KERNED 3 UNITS AV Te Yo Y.

Letter combinations with various amounts of kerning.

Typography

NORMAL LETTERSPACING

Typography

TIGHT LETTERSPACING AND KERNING

AT AY AV AW Ay Av Aw A' FA F. F, TO TA Ta Te
To Ti Tr Tu Ty Tw Ts Tc T. T, T: T; T- LT LY LV LW Ly
L' PA P. P, VA Va Ve Vo Vi Vr Vu Vy V. V, V: V; V- RT
RV RW RY Ry f' ff WA Wa We Wo Wi Wr Wu
Wy W. W, W: W; W- II YA Ya Ye Yo Yi Yp Yq Yu
Yv Y. Y; Y; Y: "'s 't "' re ro rr ru ry rw rg rcrq
rh rm rn rx rz rv rt rf rd r. r, r- y. y, v. v, w. w,

Characters that are generally improved with kerning.

Choosing Letterspacing

There are no simple rules that govern letterspacing; much depends on the typeface and the amount of copy, as well as on individual taste. However, there are some general guidelines that may help. Let's look at letterspacing as it relates to text and display type.

TEXT TYPE

The letterspacing you choose for text type will affect the "color" of the printed piece: the tighter the letterspacing, the blacker the lines

of type; conversely, the looser the letterspacing, the grayer the lines of type. Since few people appreciate a gray, washed-out page, most jobs are set with either normal or tight letterspacing.

The amount of letterspacing will depend very much on the typeface: condensed typefaces can be set tighter than regular or extended typefaces; display sizes can be set proportionately tighter than the very small text sizes, which require more space for maximum legibility.

If you are uncertain about the letterspacing, it is a good idea to have a sample set before proceeding with the entire job. This way you can decide for yourself whether the

amount of space added or deleted creates the desired effect.

If you decide to use tight letterspacing, remember that there is a limit to how much space can be removed before the letters start to touch or overlap. Check the round letters first, such as the o's and c's; they will overlap before the straight letters, such as the i's and I's.

Keep in mind also that decisions concerning letterspacing should not be made in terms of design alone. Type is meant to be read—if adjusting the letterspacing does not improve legibility, leave it alone.

The letterspacing you choose will affect the color of the printed piece: The tighter the letterspacing, the blacker the lines of type; conversely, the looser the letterspacing, the grayer the lines.

10-POINT TYPE WITH VERY TIGHT LETTERSPACING

The letterspacing you choose will affect the color of the printed piece: The tighter the letterspacing, the blacker the lines of type; conversely, the looser the letterspacing, the grayer the lines.

10-POINT TYPE WITH VERY LOOSE LETTERSPACING

The amount of letterspacing will depend very much on the typeface: condensed typefaces can be set tighter than regular or extended typefaces.

CONDENSED TYPE WITH TIGHT LETTERSPACING

The amount of letterspacing will depend very much on the typeface: condensed typefaces can be set tighter than regular or extended typefaces.

EXTENDED TYPE WITH NORMAL LETTERSPACING

Also, very small type sizes require more letterspacing for maximum legibility.

7-POINT TYPE WITH NORMAL LETTERSPACING

Schoolbook Hillbilly

Rounded letters will touch before straight letters.

DISPLAY TYPE

Because display type is generally large, any inconsistency in letterspacing will be obvious and therefore distracting. This is seldom a problem with lowercase letters, as they are designed to fit together well; caps, however, are another matter.

To achieve even letterspacing with caps you must open some letter combinations and tighten others. Knowing just how many units of space to add or delete can be a problem unless you are very familiar with both the typeface and the typesetting machine. The best way to get the letterspacing you want is to make an accurate tracing, showing how you want each letter set.

A simpler method, but not quite as accurate, is to use one of the following terms: normal, loose (or TV spacing), tight, very tight, and touching. If any adjustments are necessary they can be made in mechanicals.

Note: Poor letterspacing is more apt to occur when the type is set automatically. When the type is set manually, the operator can see the type as it is being set and is therefore able to control the letterspacing. (See Photodisplay Systems on page 180.)

TOUCHING

Typography
Typography
Typography
Typography
Typography

VERY TIGHT

TIQUE

NORMAL

LOOSE (OR TV SPACING)

Letterspacing guide.

Wordspacing

The term *wordspacing* refers to the space between words, and like letterspacing it is adjustable. The wordspacing you choose will affect the overall appearance of the printed piece, its legibility, and the amount of copy that will fit in a given space.

Wordspacing is measured in units and can be specified by the designer. However, unless you are very familiar with a particular phototypesetting system, do not specify wordspacing in units. There are many different phototypesetting systems, each using a different unit system, and what may be a desirable number of units of wordspacing for one system or typeface may not be for another.

The best way to specify wordspacing is to use the terms *normal*, *loose* (or *open*), *tight*, and *very tight*. Here is a paragraph set in each of the four styles, with both normal and tight letterspacing, as a guide for future jobs.

Note: As the letterspacing also has an effect on the overall color of the setting, the samples on page 66 and 68 have been set with normal letterspacing, while the samples on pages 67 and 69 have been set with tight letterspacing.

The wordspacing you choose will affect the overall appearance of the printed piece, its legibility, and the amount of copy that will fit in a given space. Wordspacing is measured in units and can be specified by the designer. However, unless you are very familiar with a particular phototypesetting system, you may find it more convenient to use the following general terms: normal, loose, tight, and very tight.

LOOSE WORDSPACING

The wordspacing you choose will affect the overall appearance of the printed piece, its legibility, and the amount of copy that will fit in a given space. Wordspacing is measured in units and can be specified by the designer. However, unless you are very familiar with a particular phototypesetting system, you may find it more convenient to use the following general terms: normal, loose, tight, and very tight.

NORMAL WORDSPACING

The wordspacing you choose will affect the overall appearance of the printed piece, its legibility, and the amount of copy that will fit in a given space. Wordspacing is measured in units and can be specified by the designer. However, unless you are very familiar with a particular phototypesetting system, you may find it more convenient to use the following general terms: normal, loose, tight, and very tight.

TIGHT WORDSPACING

The wordspacing you choose will affect the overall appearance of the printed piece, its legibility, and the amount of copy that will fit in a given space. Wordspacing is measured in units and can be specified by the designer. However, unless you are very familiar with a particular phototype setting system, you may find it more convenient to use the following general terms: normal, loose, tight, and very tight.

The wordspacing you choose will affect the overall appearance of the printed piece, its legibility, and the amount of copy that will fit in a given space. Wordspacing is measured in units and can be specified by the designer. However, unless you are very familiar with a particular phototypesetting system, you may find it more convenient to use the following general terms: normal, loose, tight, and very tight.

LOOSE WORDSPACING

The wordspacing you choose will affect the overall appearance of the printed piece, its legibility, and the amount of copy that will fit in a given space. Wordspacing is measured in units and can be specified by the designer. However, unless you are very familiar with a particular phototypesetting system, you may find it more convenient to use the following general terms: normal, loose, tight, and very tight.

NORMAL WORDSPACING

The wordspacing you choose will affect the overall appearance of the printed piece, its legibility, and the amount of copy that will fit in a given space. Wordspacing is measured in units and can be specified by the designer. However, unless you are very familiar with a particular phototypesetting system, you may find it more convenient to use the following general terms: normal, loose, tight, and very tight.

TIGHT WORDSPACING

The wordspacing you choose will affect the overall appearance of the printed piece, its legibility, and the amount of copy that will fit in a given space. Wordspacing is measured in units and can be specified by the designer. However, unless you are very familiar with a particular phototype setting system, you may find it more convenient to use the following general terms: normal, loose, tight, and very tight.

The wordspacing you choose will affect the overall appearance of the printed piece, its legibility, and the amount of copy that will fit in a given space. Wordspacing is measured in units and can be specified by the designer. However, unless you are very familiar with a particular phototypesetting system, you may find it more convenient to use the following general terms: normal, loose, tight, and very tight.

LOOSE WORDSPACING

The wordspacing you choose will affect the overall appearance of the printed piece, its legibility, and the amount of copy that will fit in a given space. Wordspacing is measured in units and can be specified by the designer. However, unless you are very familiar with a particular phototypesetting system, you may find it more convenient to use the following general terms: normal, loose, tight, and very tight.

NORMAL WORDSPACING

The wordspacing you choose will affect the overall appearance of the printed piece, its legibility, and the amount of copy that will fit in a given space. Wordspacing is measured in units and can be specified by the designer. However, unless you are very familiar with a particular phototypesetting system, you may find it more convenient to use the following general terms: normal, loose, tight, and very tight.

TIGHT WORDSPACING

The wordspacing you choose will affect the overall appearance of the printed piece, its legibility, and the amount of copy that will fit in a given space. Wordspacing is measured in units and can be specified by the designer. However, unless you are very familiar with a particular phototype setting system, you may find it more convenient to use the following general terms: normal, loose, tight, and very tight.

The wordspacing you choose will affect the overall appearance of the printed piece, its legibility, and the amount of copy that will fit in a given space. Wordspacing is measured in units and can be specified by the designer. However, unless you are very familiar with a particular phototypesetting system, you may find it more convenient to use the following general terms: normal, loose, tight, and very tight.

LOOSE WORDSPACING

The wordspacing you choose will affect the overall appearance of the printed piece, its legibility, and the amount of copy that will fit in a given space. Wordspacing is measured in units and can be specified by the designer. However, unless you are very familiar with a particular phototypesetting system, you may find it more convenient to use the following general terms: normal, loose, tight, and very tight.

NORMAL WORDSPACING

The wordspacing you choose will affect the overall appearance of the printed piece, its legibility, and the amount of copy that will fit in a given space. Wordspacing is measured in units and can be specified by the designer. However, unless you are very familiar with a particular phototypesetting system, you may find it more convenient to use the following general terms: normal, loose, tight, and very tight.

TIGHT WORDSPACING

The wordspacing you choose will affect the overall appearance of the printed piece, its legibility, and the amount of copy that will fit in a given space. Wordspacing is measured in units and can be specified by the designer. However, unless you are very familiar with a particular phototype setting system, you may find it more convenient to use the following general terms: normal, loose, tight, and very tight.

Wordspacing and Type Arrangement

Any discussion of wordspacing must take into consideration how lines of type are set on the page; that is, type arrangement. There are four basic ways to set type: justified, unjustified, centered, and asymmetrical.

JUSTIFIED

Type set with all lines the same length and aligning on both the left and the right is referred to as *justified type*. It is the most widely used typesetting method, especially

for newspapers, books, and magazines.

To set lines of type equal in length—or justified—the space between words must be adjusted so each line will fill the entire measure. Because the number of words in each line will vary, the wordspacing too will vary from line to line. This uneven wordspacing, necessary to justify lines of type, is not noticeable if the type is properly set.

Because all the lines of justified type are the same length and the margins are even, a page of justified type assumes a quiet look. Justified type is recommended whenever the reading material is lengthy or space is a problem. As a general rule, copy set justified requires less space than unjustified.

When setting justified type, you can control the quality of the wordspacing by giving the typesetter specific guidelines, or parameters, for the minimum and maximum acceptable wordspacing. For instance, if normal wordspacing (in an 18-unit system) is six units, you can specify a minimum wordspacing of four units and maximum of eight units.

The wider the parameters, the simpler the task of justifying lines, and so the quicker and therefore less expensive the process. Newspapers work with exceptionally wide parameters, because the object is to get the news out fast and inexpensively. So it is not unusual to see large spaces between words.

Type set with all lines the same length and aligning on both the left and the right is referred to as justified type. In order to make the lines equal, the wordspacing is adjusted so that each line fills the entire measure. Because the number of words in each lines varies, the wordspacing also varies from line to line. This uneven wordspacing, necessary to justify lines of type, is not noticeable if the type is properly set.

Justified type is the most widely used type arrangement, especially for books, magazines, and newspapers. Because all the lines of type are the same length and the margins are even, a page of justified type assumes a quiet look.

Justified type with normal wordspacing.

Advertisers, on the other hand, work with very narrow parameters, making for slow, exacting, and expensive typesetting, but creating fine typography. (See Controlling Wordspacing on page 76.)

Type set with all lines the same length and aligning on both the left and the right is referred to as justified type. In order to make the lines equal, the wordspacing is adjusted so that each line fills the entire measure. Because the number of words in each line varies, the wordspacing also varies from line to line. This uneven wordspacing, necessary to justify lines of type, is not noticeable if the type is properly set.

Justified type is the most widely used type arrangement, especially for books, magazines, and newspapers. Because all the lines of type are the same length and the margins are even, a page of justified type assumes a quiet look.

Justified type with tight wordspacing.

(Wordspacing and Type Arrangement continued)

UNJUSTIFIED

Type set with lines of varying lengths, and even wordspacing, is referred to as unjustified type. If the lines of type align on the left they will be ragged on the right. This arrangement—which we have used in this book—is referred to as *flush left*, ragged right. Type can also be set *flush right*, ragged left. Unjustified type is the second most widely used typesetting method. A familiar example of an unjustified arrangement is a typewritten letter.

There are three major advantages to unjustified type. First, the even wordspacing creates a uniform overall texture. Second, it is ideal for setting type in narrow columns,

since no matter how narrow the column, the wordspacing will always be even. Third, it reduces hyphenation to a minimum since lines can run short or long and need not be broken in order to justify a line.

With unjustified type, the ragged edge should create a pleasing silhouette. You can control the shape by specifying the shortest acceptable line (excluding "widows," which are very short lines at the end of paragraphs). The type you are now reading is set to a 14-pica measure with a minimum line of 12 picas. This means that all the lines fall between these two measures.

Type set with lines of varying length, and even wordspacing, is referred to as unjustified type. If the lines of type align on the left they will be ragged on the right. This arrangement is referred to as flush left, ragged right. Type can also be set flush right, ragged left. There are three major advantages to unjustified type. First, the even wordspacing creates a uniform overall texture. Second, it is ideal for setting type in narrow columns, and third, it reduces hyphenation to a minimum. Unjustified type is the second most widely used type arrangement.

Unjustified type set flush left, ragged right.

Type set with lines of varying length, and even wordspacing, is referred to as unjustified type. If the lines of type align on the left they will be ragged on the right. This arrangement is referred to as flush left, ragged right. Type can also be set flush right, ragged left. There are three major advantages to unjustified type. First, the even wordspacing creates a uniform overall texture. Second, it is ideal for setting type in narrow columns, and third, it reduces hyphenation to a minimum. Unjustified type is the second most widely used type arrangement.

Unjustified type set flush right, ragged left.

(Wordspacing and Type Arrangement continued)

CENTERED

Another way to arrange lines of type on a page is to center the lines so that both left and right margins are ragged. Centered type, like unjustified type, has even wordspacing. When using centered type, make sure the length of the lines varies enough to create an interesting silhouette. Once again, to control the shape of the setting, give the typesetter a minimum and maximum line length.

Centered type is not recommended for lengthy copy.

Another way to arrange lines of type is to center the lines on the page. Centered type, like unjustified type, has the advantage of even wordspacing. When using centered type, make sure the length of the lines varies enough to create an interesting silhouette.

To control the shape of the setting, give the typesetter a minimum and maximum line length. Reading centered lines can be demanding, therefore centered type is better suited to small amounts of copy.

Type set centered.

ASYMMETRICAL

In this arrangement, each line is laid out asymmetrically; that is, with no predictable pattern in length or placement. The simplest method of achieving this effect is to have the copy set with specified linebreaks and then arrange the lines yourself in mechanicals. There are no rules, and probably no two designers would break the lines in the same way.

Asymmetrical arrangements can be visually interesting, but because they are difficult to read they should be restricted to small amounts of copy.

In this arrangement, the lines have no predictable pattern in length or placement. The simplest method of achieving this effect is to have the copy set with specified linebreaks and then arrange the lines yourself in mechanicals. There are no rules and probably no two designers would break the lines in the same place. Asymmetrical arrangements can be visually interesting, but because they are difficult to read they should be restricted to small amounts of copy.

Type arranged asymmetrically.

Controlling Wordspacing

The designer can do more to control wordspacing than just specify *normal*, *loose*, *tight*, and *very tight*. The designer can also control wordspacing through hyphenation, letterspacing, and line length.

Hyphenation. By permitting hyphenation, the designer gives the typesetter the ultimate tool for controlling the quality of the wordspacing. For example, if a line is setting long, the typesetter can hyphenate the last word and turn the line over to maintain good wordspacing. If hyphenation is not permit-

ted, the entire last word would have to carry over and the line be justified by increasing the wordspacing.

When setting justified type, especially to a narrow measure, hyphenation must be used to achieve better wordspacing. When setting unjustified type, hyphenation can be used to control line length and therefore the shape of the ragged edge.

Avoid having consecutive lines end in hyphens; more than two in a row can be distracting—especially with justified type. (An exception may be justified type set to a short measure, in which case consecutive hyphens may be unavoidable.)

Not only does hyphenation create better

wordspacing, but it can also speed up the typesetting process, which in turn saves money. Therefore, the designer should consider hyphenation on all jobs.

Letterspacing. Unsatisfactory wordspacing can be improved by adjusting the letter-spacing. For example, if the wordspacing in a line is too loose, the letterspacing can be increased throughout the line to create tighter wordspacing. Adjusting wordspacing through letterspacing is a common practice with newspapers. Unfortunately, unless it is skillfully done, the additional letterspacing can be more distracting than the uneven wordspacing it is meant to correct, which often goes unnoticed.

Hyphenation. This is the typesetter's ultimate tool for controlling the quality of the wordspacing. When setting justified type to a short measure, hyphenation is an absolute necessity. When setting unjustified type, hyphenation can be used to control the shape of the ragged edge.

NO HYPHENATION, RESULTING IN POOR WORDSPACING

Hyphenation. This is the typesetter's ultimate tool for controlling the quality of the wordspacing. When setting justified type to a short measure, hyphenation is an absolute necessity. When setting unjustified type, hyphenation can be used to control the shape of the ragged edge.

GOOD WORDSPACING, BUT POOR HYPHENATION

Hyphenation. This is the typesetter's ultimate tool for controlling the quality of the wordspacing. When setting justified type to a short measure, hyphenation is an absolute necessity. When setting unjustified type, hyphenation can be used to control the shape of the ragged edge.

GOOD WORDSPACING AND GOOD HYPHENATION ACHIEVED BY RESETTING TYPE UNJUSTIFIED

Line Length. The length of a line is particularly important when setting justified type. Because a line is justified by distributing extra space between words, the more words per line, the less noticeable the extra space will be. Therefore, type set to a long measure produces more uniform wordspacing than type set to a short measure. Compare any book, with its wide columns, to a newspaper with its narrow columns: books have an even texture while newspapers often have white "rivers" of space running down the columns.

If wordspacing is a problem and you cannot increase the line length, then consider setting the type unjustified, in which case the wordspacing can be controlled.

WORDSPACING TOO LOOSE

Letterspacing. Unsatisfactory wordspacing can be improved by adjusting the letterspacing. For example, if the wordspacing in a line is too loose, the letterspacing can be increased throughout the line to create tighter wordspacing.

Letterspacing. Unsatisfactory wordspacing can be improved by adjusting the letterspacing. For example, if the wordspacing in a line is too loose, the letterspacing can be increased throughout the line to create tighter wordspacing.

WORDSPACING ADJUSTED BY LETTERSPACING

Line Length. The length of a line is particularly important when setting justified type. Type set to a long measure produces more uniform wordspacing than type set to a short measure.

Line Length. The length of a line is particularly important when setting justified type. Type set to a long measure produces more uniform wordspacing than type set to a short measure.

Choosing Wordspacing

Although designers do not agree on the best amount of wordspacing for comfortable reading, they do agree that too much or too little can make reading difficult. Words placed too close together force the reader to work harder to distinguish one word from another. On the other hand, words placed too far apart leave white spaces which run down the page as "rivers" and disrupt the natural left-to-right movement of the eye.

Wordspacing is also affected by the typeface, type size, and type arrangement

you choose. For example, narrow, condensed typefaces require less wordspacing than wide, extended typefaces, and small type sizes tend to be more readable if they have more generous wordspacing.

Whatever the wordspacing, make sure it is consistent with the letterspacing; that is, if you choose tight wordspacing you will probably want tight letterspacing too. The more consistent the wordspacing and letterspacing, the greater the legibility and the more esthetically pleasing the printed piece.

If you are uncertain about the wordspacing, have samples set and choose the one you feel works best with your typeface, type size, and type arrangement.

Toomuch or too little wordspacing can make reading difficult. Words placed too close together force the reader to work harder to distinguish one word from another. On the other hand, words placed too far apart leave white spaces which rundown the pages as "rivers" and disrupt the natural movement of the eye from left to right.

VERY TIGHT WORDSPACING

Too much or too little wordspacing can make reading difficult. Words placed too close together force the reader to work harder to distinguish one word from another. On the other hand, words placed too far apart leave white spaces which run down the pages as "rivers" and disrupt the natural movement of the eye from left to right.

VERY LOOSE WORDSPACING

Too much or too little wordspacing can make reading difficult. Words placed too close together force the reader to work harder to distinguish one word from another. On the other hand, words placed too far apart leave white spaces which run down the pages as "rivers" and disrupt the natural movement of the eye from left to right.

NORMAL WORDSPACING

Wordspacing is also affected by the typeface and type size you choose. For example, narrow, condensed typefaces require less wordspacing than wide, extended typefaces, and small type sizes tend to be more readable if they have more generous wordspacing.

TIGHT WORDSPACING

Wordspacing is also affected by the typeface and type size you choose. For example, narrow, condensed typefaces require less wordspacing than wide, extended typefaces, and small type sizes tend to be more readable if they have more generous wordspacing.

NORMAL WORDSPACING

Small type sizes tend to be more readable if they have more generous wordspacing.

NORMAL WORDSPACING

Whatever wordspacing you choose, make sure it is consistent with the letterspacing. The more consistent the two, the greater the legibility and the more esthetically pleasing the printed piece.

LUUSE WORDSPACING, TIGHT LETTERSPACING

Whatever wordspacing you choose, make sure it is consistent with the letterspacing. The more consistent the two, the greater the legibility and the more esthetically pleasing the printed piece.

TIGHT WORDSPACING, LOOSE LETTERSPACING

Whatever wordspacing you choose, make sure it is consistent with the letterspacing. The more consistent the two, the greater the legibility and the more esthetically pleasing the printed piece.

TIGHT WORDSPACING, TIGHT LETTERSPACING

Linespacing

The term *linespacing*, also called *leading*, refers to the addition of space between lines of type; *minus linespacing* is the deletion of space from between the lines. If space is neither added nor deleted the type is said to be set *solid*. Linespacing is specified in points and sometimes half-points.

On this page we have set a paragraph showing varying amounts of linespacing and minus linespacing. Use it as a guide, keeping in mind that the typeface you choose will have an effect on your decision. (See X-Height, page 12.)

Linespacing, or leading, like wordspacing and letterspacing, can be used to improve legibility. Your choice of typeface, type size, and line length all affect the amount of linespacing you will need. With so many factors involved, you can see why proper linespacing is more a matter of visual judgment than of mathematics.

-1 POINT LINESPACING

Linespacing, or leading, like wordspacing and letterspacing, can be used to improve legibility. Your choice of typeface, type size, and line length all affect the amount of linespacing you will need. With so many factors involved, you can see why proper linespacing is more a matter of visual judgment than of mathematics.

SOLID

Linespacing, or leading, like word-spacing and letterspacing, can be used to improve legibility. Your choice of typeface, type size, and line length all affect the amount of linespacing you will need. With so many factors involved, you can see why proper linespacing is more a matter of visual judgment than of mathematics.

1 POINT LINESPACING

Linespacing, or leading, like wordspacing and letterspacing, can be used to improve legibility. Your choice of typeface, type size, and line length all affect the amount of linespacing you will need. With so many factors involved, you can see why proper linespacing is more a matter of visual judgment than of mathematics.

2 POINTS LINESPACING

Linespacing, or leading, like wordspacing and letterspacing, can be used to improve legibility. Your choice of typeface, type size, and line length all affect the amount of linespacing you will need. With so many factors involved, you can see why proper linespacing is more a matter of visual judgment than of mathematics.

3 POINTS LINESPACING

Linespacing, or leading, like wordspacing and letterspacing, can be used to improve legibility. Your choice of typeface, type size, and line length all affect the amount of linespacing you will need. With so many factors involved, you can see why proper linespacing is more a matter of visual judgment than of mathematics.

4 POINTS LINESPACING

Specifying Linespacing as White Space

When setting lines of display caps there may be times when you will want to bring the lines very close together. Rather than guess at the amount of minus linespacing required, simply specify in points the desired amount of white space between lines. This method is not recommended when setting upper and lowercase type because the ascenders and descenders make it impossible to specify a fixed amount of space. (See Optical Linespacing on page 84.)

Another way to specify linespacing for

display type is to indicate the overall depth and ask that the lines be equally spaced to fill the area.

Note: Although most typographers prefer to work in points, white space can also be specified in fractions of an inch.

WHEN SETTING DISPLAY CAPS, IT IS POSSIBLE TO SPECIFY THE DESIRED AMOUNT OF WHITE SPACE BETWEEN LINES.

Type set with 2 points white space between lines.

YOU CAN ALSO
SPECIFY THE OVERALL
DEPTH AND ASK
THAT THE LINES BE
EQUALLY SPACED
TO FILL THE AREA.

Type equally linespaced to fill area 3 inches deep.

Optical Linespacing

There are times when setting lines of lowercase display type that the space between the lines will appear unequal even though the linespacing is consistent. The reason is that lines with many ascenders and descenders will appear to be closer together than lines that have only a few or none at all. To correct this you may wish to adjust the linespacing in mechanicals to make it optically equal.

Another alternative is to set the lines in all caps, in which case the linespacing will be equal.

Lines having many ascenders and descenders may appear closer together than lines having only a few or none at all.

LINES SET
IN ALL CAPS
HAVE EQUAL
LINESPACING.

Reverse Linespacing

With machines that have reverse linespacing (reverse leading) capabilities, the paper (or film) can move backward as well as forward. This means that a column of type can be set to a specified depth, then the paper can be backed up and a second column set alongside the first.

Reverse linespacing is ideal for jobs involving "area composition" such as page makeup, tabular work, indexes, complex equations, etc. By setting all the elements in position, the need for cutting and pasting (or stripping) is greatly reduced. For example, a

typesetter can set two or more columns of type, put in a head and folio, and deliver camera-ready copy. Not only is reverse linespacing efficient, but it also uses less paper than normal single-column setting.

Although reverse linespacing is completely keyboard-controlled, making corrections can be complicated and expensive. A change in one column may affect subsequent columns. In many cases it may be more expedient and less expensive to set the job in single columns and position the elements yourself in mechanicals.

Note: Not all systems having reverse linespacing are the same; the amount possible, and the accuracy, will vary.

Of the three major printing processes, offset lithography is the most recent. It is a highly refined form of lithography invented in 1799 by a German named Aloys Senefelder. Lithography, which means "stone-writing," is based on the principle that water and grease do not mix. The image to be printed is drawn with a special grease crayon on a slab of highly polished limestone. The stone is then sponged with a solution of water, gum arabic, and acid. This solution is rejected by the greasy image area and absorbed by the non-image area. When the stone is inked, the opposite happens: the ink, which is greasy, is accepted by the image area and rejected by the non-image area. To print the image, a sheet of paper is placed over the stone, pressure is applied, and the image is transferred to the paper. Properly prepared, a lithograph stone can produce hundreds of

All offset presses are of the rotary type and have three cylinders: a plate cylinder, around which the printing plate is wrapped; a blanket cylinder, onto which the image is offset; and an impression cylinder, which presses the paper against the blanket cylinder.

high-quality prints

In operation, the printing plate first comes into contact with dampening rollers. These wet the plate with a solution of water, gum arabic, and acid. This water solution is accepted by the non-image area and rejected by the image area. Next, the plate is inked. The ink, repelled by the water solution in the non-image area, is accepted only by the image area. The inked image is then transferred, or "offset," onto the blanket cylinder, which in turn transfers the image to the

The reason the image is offset onto the rubber blanket rather than printed directly on the paper is because the offset plate is very delicate and the abrasiveness of the paper's surface would cause damage. In addition to extending the life of the plate, the rubber blanket, because it is compressible and conforms to the slightest degree of texture on the paper's surface, makes it possible to print on rough papers.

The commercial form of lithography is offset lithography, more commonly known simply as "offset." (Offset refers to the method of transferring the image from the plate to the paper, which we will discuss later.) In offset lithography the

flat stone is replaced by a thin, flexible metal printing plate designed to wrap around a printing cylinder.

The first step in making an offset plate is to "strip" both the line and halltone film negatives into their proper positions according to the mechanical. This makes up what is called a "flat." Before the actual offset plates are made, a photographic paper proof is made from the flat that shows the client the exact position of the elements. These proofs are called by various names, reflecting their general color. Van Dykes, browns, silvers, blues, or salts. After the proof has been approved, the plate is made and the job printed.

Offset plates are made photographically. The plate, which may be aluminum, stainless steel, or a specially processed paper, is coated with a light-sensitive chemical similar to that used on photographic paper. The flat is brought into contact with the plate and exposed to a high-intensity light. The plate is then either processed by hand or put through an automatic processor where it is developed and made press-ready. (That is, the plate is chemically treated so that the implate is chemically treated so the implantation that the implantation

A format that lends itself to reverse linespacing, or one-piece composition.

Choosing Linespacing

Whether to set type solid or with linespacing is a matter of personal preference. There are no hard rules, but here are some guidelines that may help you decide. Keep in mind, however, that it should be the designer's goal to improve legibility and make reading more comfortable.

Appearance. Linespacing affects the appearance of the printed piece. The more white space between the lines, the grayer the block of type. Conversely, the less white space, the darker, or blacker, the printed piece will appear.

Type Size. Average text sizes are usually set with one or two points of linespacing, although they can also be set solid or with minus linespacing if so desired. Smaller type sizes (5, 6, 7 point), however, generally require linespacing to make them legible. (There are some typefaces specifically designed to set small and remain legible.) X-Height. Some typefaces, such as Helvetica and Century Expanded, have large x-heights and therefore have very little white space between lines when set solid. These typefaces require more linespacing to achieve the same effect than those with small x-heights, such as Futura and Garamond. (See page 48.)

Line Length. When setting long lines (more than two-and-a-half times the alphabet length), extra linespacing is recommended. When long lines are set close there is a tendency on the part of the reader to read the same line twice. Increasing the linespacing helps prevent this.

Copy. The amount of copy is significant. You can fit more copy into a given area if the type is set solid or with minus linespacing. This can be helpful on jobs where space is a problem, such as in classified ads and directories. On the other hand, short copy can be made to fit a larger area by increasing the linespacing.

The nature of the copy is also important;

Appearance. Linespacing affects the appearance of the printed piece. The more white space between the lines, the grayer the block of type. Conversely, the less white space, the blacker the printed piece will appear.

SOLID

Appearance. Linespacing affects the appearance of the printed piece. The more white space between the lines, the grayer the block of type. Conversely, the less white space, the blacker the printed piece will appear.

3 POINTS LINESPACING

Type Size. Average type sizes can be set solid or with one or two points of linespacing. Smaller type sizes generally require some linespacing to make them legible.

10-POINT TYPE, SET SOLID

Type Size. Average type sizes can be set solid or with one or two points of linespacing. Smaller type sizes generally require some linespacing to make them legible.

8-POINT TYPE WITH 2 POINTS LINESPACING

X-Height. Typefaces with large x-heights usually require more linespacing than those with small x-heights.

10-POINT TYPE WITH LARGE X-HEIGHT, SET SOLID

X-Height. Typefaces with large x-heights usually require more linespacing than those with small x-heights.

10-POINT TYPE WITH SMALL X-HEIGHT, SET SOLID

Copy. You can fit more copy into a given area if the type is set solid. On the other hand, a small amount of copy can be made to fit a larger area by increasing the linespacing.

9-POINT TYPE, SET SOLID

Copy. You can fit more copy into a given area if the type is set solid. On the other hand, a small amount of copy can be made to fit a larger area by increasing the linespacing.

9-POINT TYPE WITH 4 POINTS LINESPACING

for example, a directory can be set tighter than a novel, since it is used for reference and does not require sustained reading. gether you may want to consider tight letterspacing and wordspacing too.

Note: If your choice is minus linespacing, be aware that if too much space is removed from between the lines of type, the ascenders and descenders may overlap. Furthermore, if corrections have to be made, the lines may be too close to permit a new line or word to be stripped in. In this case you may have to reset the entire paragraph or page in order to make one minor correction.

Remember that linespacing, letterspacing, and wordspacing should all be compatible; for example, if the lines are close to-

Line Length. Long lines require more linespacing than short or average lines. When long lines are set too close there is a tendency on the part of the reader to read the same line twice.

10-POINT TYPE WITH 1 POINT LINESPACING

Line Length. Long lines require more linespacing than short or average lines. When long lines are set too close there is a tendency on the part of the reader to read the same line twice.

10-POINT TYPE WITH 3 POINTS LINESPACING

Line Length

In general, the length of a line of type should be comfortable to read: too short and it breaks up words or phrases; too long and the reader must search for the beginning of each line, which can be fatiguing, especially if the copy is lengthy.

From a design point of view, line length is dictated by such factors as type size and the amount of copy to be set. The larger the type size, the longer the measure can be. For example, a 30-pica line of 11-point type is easier to read than a 30-pica line of 6-point type. As to the amount of copy, most people

don't mind reading a reasonable amount set on a very short or very long measure, but they would be disturbed if they had to read a lengthy article or novel.

If you are uncertain about line length, a

good rule of thumb is to set the measure approximately one-and-a-half to two-and-a-half alphabets long. Studies have shown that lines having between 40 and 65 characters are the most comfortable to read.

Paper (or Film) Width. From a technical point of view, line length is limited by the phototypesetting machine—you cannot set a line longer than the width of the paper on the machine. Most systems accommodate two different sizes: a narrow roll for jobs set

to a short measure and a wide roll for jobs set to a wide measure. The narrow roll is about 3" wide and sets type up to 15 picas; the wide roll is about 8" wide and sets type up to 45 picas. Most typographers have both sizes. (There are some machines capable of setting type wider than 45 picas, but these are the exceptions.)

The length of a line should be comfortable to read: too short and it breaks up words or phrases; too long and the reader must search for the beginning of each line.

The length of a line should be comfortable to read: too short and it breaks up words or phrases; too long and the reader must search for the beginning of each line. If you are uncertain about the length, a good rule of thumb is to set the measure approximately one-and-a-half to two-and-a-half alphabets long.

The length of a line should be comfortable to read: too short and it breaks up words or phrases; too long and the reader must search for the beginning of each line. If you are uncertain about the line length, a good rule of thumb is to set the measure approximately one-and-a-half to two-and-a-half alphabets long.

The length of a line should be comfortable to read: too short and it breaks up words or phrases; too long and the reader must search for the beginning of each line. If you are uncertain about the line length, a good rule of thumb is to set the measure approximately one-and-a-half to two-and-a-half alphabets long.

The length of a line should be comfortable to read: too short and it breaks up words or phrases; too long and the reader must search for the beginning of each line. If you are uncertain about the line length, a good rule of thumb is to set the measure approximately one-and-a-half to two-and-a-half alphabets long.

The length of a line should be comfortable to read: too short and it breaks up words or phrases, too long and the reader must search for the beginning of each line. If you are uncertain about the line length, a good rule of thumb is to set the measure approximately one-and-a-half to two-and-a-half alphabets long.

A range of type sizes, set 50-60 characters per line.

Creating Emphasis

Very few jobs are set without some word or phrase requiring extra emphasis—this is especially true in advertising.

There are a number of ways to create emphasis; the important thing is to determine which words are to be emphasized and to what degree. Too much emphasis—or too many words emphasized in too many ways—can create an effect opposite from the one intended: the reader, instead of getting the message, will simply ignore it.

In order to emphasize a word, you must make it different from the words surrounding

it. This can be done by changing the type style, size, or weight, or by using a different typeface. (See Underscores on page 106.)

The number of words and their position in the copy may affect how you choose to create emphasis: a single word buried in the middle of the copy will need more emphasis than a lengthy phrase at the beginning of a paragraph.

Here are some ways to create emphasis: **Type Style.** By far the most common way of emphasizing a word is to change from roman to italic. Another possibility, although less common, is to change from roman to small caps. Unfortunately, most phototypesetting systems do not have true small

caps (see page 100), so this method of creating emphasis is not too widely used.

Type Size. A simple way to create emphasis is to choose a larger size of the same typeface; the exact size will depend on the degree of emphasis you wish to create. The most common type size change is simply to switch from lowercase to all caps. One of the advantages of this particular solution is that it permits the typesetter to stay with the same font and lens. If you find all caps too assertive, consider setting the all-cap words one size smaller than the body text size.

One of the problems with words set in all-caps is that they are more difficult to read than words set in lowercase. Therefore it is a

Switching from roman to italic is probably the most common way to bring attention to a particular word or phrase. And because italic is the same size and weight as the roman text, it does not disturb the overall appearance of the printed page. Italic is a quiet way of attracting attention.

Small caps offer another alternative. Like italic, small caps are unassertive; however, because they are small and there are no ascenders or descenders they can get lost unless set as Caps and Small Caps.

Caps are more assertive than italic, in fact at times they border on a command: BUY THIS PRODUCT NOW!

Next to italic, bold type is the most widely used for emphasis. Being a heavier version of the regular type, bold attracts more attention than either italic or caps. It is difficult to ignore words set in bold type!

good idea to use lowercase for lengthy copy and save caps for headlines, heads, leadins, and emphasizing words or short phrases in a body of copy.

Type Weight. The best way to create emphasis by weight is to stay with the same type size and change from regular to bold. It is also possible to change both weight and size by using bold caps or a larger type size.

When used in small quantities, bold type can be very effective. However, when dealing with lengthy copy, consider whether the excessive blackness of the setting will affect legibility.

Mixing Typefaces. When mixing typefaces try to choose a typeface that will afford some contrast with the text. A marked difference will make the effect look deliberate rather than accidental. For example, mixing Bodoni with Baskerville or Baskerville with Garamond will not provide sufficient type contrast and might even create the impression that you have mistakenly used the wrong font.

When mixing typefaces, keep in mind that just because typefaces are the same point size does not necessarily mean that they are the same physical size (see X-Height, page 48). Therefore, to maintain a unity of size. you may have to mix point sizes.

Note: Although there may be times when the

designer is in a position to make decisions regarding emphasis, this is usually an editorial function and is decided by the copywriter or editor.

Creating emphasis is an **important** and **integral** part of designing and typesetting. Handled with taste and good judgment it can help direct and inform the reader. When these qualities are lacking, or someone feels that every word is important and MUST BE EMPHASIZED in some way, then the printed page starts to look like a battlefield and BECOMES DIFFICULT

TO READ!

Indicating Paragraphs

When a paragraph changes, the reader must be made aware of the fact. This is done in a number of ways. The most common, and traditional, method is to start each new paragraph with an indent—usually a one-em indent. Larger indents can also be used, however, especially when type is set to a wide measure.

Indents are not always necessary; paragraphs can also be separated with space—usually a half-line or full line. Using a full-line space has an advantage in that lines of type in adjacent columns will always align.

It is also possible to use both indents and space: variations of this style are quite common with contemporary magazines, books, and advertising.

Another method, quite common in Continental Europe, is to use neither indent nor additional space between paragraphs. In this case the only indication that a new paragraph has been started is that the last line of the previous paragraph is usually shorter than the full measure. Although this may create a pleasing graphic effect, readability may be impaired.

A more unusual method is the hanging indent. Here, the first line of the paragraph is set to the full measure and all the lines are

indented. This is commonly used for dictionaries and other reference sources.

Another possibility is the method used by early printers: all the paragraphs were run together to form a solid block of type and a typographic device indicated the start of each new paragraph. The traditional paragraph mark looks like this \P , but any graphic device can be used.

The most common method of indicating a paragraph is to indent the opening line by a one-em space. Indents larger than one em may also be used.

Paragraphs may also be separated by a half-line or a full-line space. Or a combination of indent and space may be used.

A more unusual method is the hanging indent, where the first line is set to the full measure and all subsequent lines are indented.

Another method is to use neither indent nor space. The only indication that a new paragraph has begun is that the previous line usually falls short of the full measure.

Still another possibility is to run the paragraphs together in a solid block of type, indicating the start of each paragraph with a typographic device.

1 EM INDENT

The most common method of indicating a paragraph is to indent the opening line by a one-em space. Indents larger than one em may also be used.

Paragraphs may also be separated by a half-line or a full-line space. Or a combination of indent and space may be used.

A more unusual method is the hanging indent, where the first line is set to the full measure and all subsequent lines are indented.

Another method is to use neither indent nor space. The only indication that a new paragraph has begun is that the previous line usually falls short of the full measure.

Still another possibility is to run the paragraphs together in a solid block of type, indicating the start of each paragraph with a typographic device.

2-EM INDENT

The most common method of indicating a paragraph is to indent the opening line by a one-em space. Indents larger than one em may also be used.

Paragraphs may also be separated by a halfline or a full-line space. Or a combination of indent and space may be used.

A more unusual method is the hanging indent, where the first line is set to the full measure and all subsequent lines are indented.

Another method is to use neither indent nor space. The only indication that a new paragraph has begun is that the previous line usually falls short of the full measure.

Still another possibility is to run the paragraphs together in a solid block of type, indicating the start of each paragraph with a typographic device.

1/2-LINE SPACE

The most common method of indicating a paragraph is to indent the opening line by a one-em space. Indents larger than one em may also be used.

Paragraphs may also be separated by a halfline or a full-line space. Or a combination of indent and space may be used.

A more unusual method is the hanging indent, where the first line is set to the full measure and all subsequent lines are indented.

Another method is to use neither indent nor space. The only indication that a new paragraph has begun is that the previous line usually falls short of the full measure.

Still another possibility is to run the paragraphs together in a solid block of type, indicating the start of each paragraph with a typographic device.

1-LINE SPACE

The most common method of indicating a paragraph is to indent the opening line by a one-em space. Indents larger than one em may also be used.

Paragraphs may also be separated by a half-line or a full-line space. Or a combination of indent and space may be used.

A more unusual method is the hanging indent, where the first line is set to the full measure and all subsequent lines are indented.

Another method is to use neither indent nor space. The only indication that a new paragraph has begun is that the previous line usually falls short of the full measure.

Still another possibility is to run the paragraphs together in a solid block of type, indicating the start of each paragraph with a typographic device.

1/2-LINE SPACE PLUS 1-EM INDENT

The most common method of indicating a paragraph is to indent the opening line by a one-em space. Indents larger than one em may also be used.

Paragraphs may also be separated by a halfline or a full-line space. Or a combination of indent and space may be used.

A more unusual method is the hanging indent, where the first line is set to the full measure and all subsequent lines are indented.

Another method is to use neither indent nor space. The only indication that a new paragraph has begun is that the previous line usually falls short of the full measure.

Still another possibility is to run the paragraphs together in a solid block of type, indicating the start of each paragraph with a typographic device.

HANGING INDENT

The most common method of indicating a paragraph is to indent the opening line by a one-em space. Indents larger than one em may also be used.

Paragraphs may also be separated by a halfline or a full-line space. Or a combination of indent and space may be used.

A more unusual method is the hanging indent, where the first line is set to the full measure and all subsequent lines are indented.

Another method is to use neither indent nor space. The only indication that a new paragraph has begun is that the previous line usually falls short of the full measure.

Still another possibility is to run the paragraphs together in a solid block of type, indicating the start of each paragraph with a typographic device.

NO INDENT AND NO SPACE

¶ The most common method of indicating a paragraph is to indent the opening line by a one-em space. Indents larger than one em may also be used. ¶Paragraphs may also be separated by a half-line or a full-line space. Or a combination of indent and space may be used. ¶ A more unusual method is the hanging indent, where the first line is set to the full measure and all subsequent lines are indented. I Another method is to use neither indent nor space. The only indication that a new paragraph has begun is that the previous line usually falls short of the full measure. ¶ Still another possibility is to run the paragraphs together in a solid block of type, indicating the start of each paragraph with a typographic device.

SOLID BLOCK WITH PARAGRAPH MARKS

Run-Arounds

A run-around, as the name suggests, is type that runs around a space remaining in the text (to be filled in later by a display initial, illustration, or some other art). Run-arounds can be simple or complex, inexpensive or very expensive.

An example of a simple run-around would be a square or rectangular space left in the text to accommodate the insertion of an initial or art. The typesetter should be told the overall measure, and the number of lines to be indented and by how much. It is also a good idea to send along a layout. If you are planning a more complex runaround, such as a free-form space inside a block of type, first make sure the copy has been properly edited to avoid unnecessary corrections. Then make an accurate layout for the typesetter to follow. All line and space measurements will be taken from your layout; if it is wrong, corrections will be charged to you.

Setting complex run-arounds requires skill, so make sure the typographer is familiar with this kind of work before you send out the job.

Note: When planning a run-around, make a careful character count to be sure there is the proper amount of type to fit your layout.

A run-around, as the name suggests, is type that runs around a space in the text, to be filled later by a display initial or some other art. Runarounds can be simple or

complex, inexpensive or very expensive. The one shown here is perhaps the most common and least expensive: a space left in the upper left-hand corner for a display initial or art. When setting type for a run-around, it is a good idea to send along a layout.

Contour Settings

In contour settings the type is set in the shape of an object; for example, a vase, lightbulb, or bottle. Contour settings, like run-arounds, can be time consuming and expensive.

To hold down cost and assure the success of the job, start by making an accurate layout for the typesetter to follow. Make sure there is enough copy to fill the space exactly. In most cases, if there is too little or too much copy, the entire job must be refigured and reset—usually nothing can be saved. Also, make sure the copy is properly edited;

changes made after the job is set can be disastrous.

Contour settings require skill on the part of the typesetter. Decisions must be made on every line to make sure the contour is being followed accurately. Most jobs require adjustments and resetting before they can be released to the client.

In contour settings the words are set in the shape of an object; for example, a vase, lightbulb, or, in this case, a classic pyramid.

Contour settings, like run-arounds, are time consuming and expensive. To hold down the cost and to ensure the success of the job, start by making an accurate layout for the typesetter to follow. Also, make sure there is enough copy to fill the space exactly.

Display Initials

Display initials offer the designer an effective method of embellishing a printed piece. Simply by adding a display initial, the designer can completely change the look, feeling, and character of a printed piece—and at very little cost.

Display initials fall into three basic categories: raised (or stick-up), drop, and hung. Let's examine each:

Raised Initials. These base-align with the first line of text. It is the simplest and least expensive method of setting display initials, especially if the typeface and type size can

be mixed on-machine. If not, the typesetter will indent the first line so the initial can be stripped in later.

The amount of indent is dictated by the display initial. Although it is usually set flush left, you may want to consider a larger indent so that the initial will fall inside the measure.

When working with display initials, the designer should be aware that certain letters (A, L, F, P, T, V, W, and Y) do not finish with a vertical stroke (as do N, M, H), thus creating too much space between the initial and the following letter. To correct this the designer should specify kerning. (See Kerning on page 58.)

Drop Initials. These are set into the text, requiring a number of lines to be indented. The exact number of lines and the amount of the indent is dictated by the width and depth of the initial. Some phototypesetting machines have the capacity to set drop initials in position; others do not, in which case the text is set with the proper indent and the initials are set separately and stripped in.

When setting a drop initial you may wish to have the type follow the contour of the letter rather than have the letter sitting in a rectangular white space. Or you may want the first line set closer to the initial than the other lines. In this case, it is a good idea to send the typesetter a layout showing the desired

Raised initials represent the simplest and least-expensive method of setting display initials, especially if the typeface and type size can be mixed on-machine.

the simplest and least-expensive method of setting display initials, especially if the typeface and type size can be mixed on-machine.

prop initials are set into the text, requiring that a number of lines be indented. Some phototypesetting machines have the capacity to set drop initials in position; others do not, in which case the text is set with the proper indent and the initials are set separately and stripped in later.

rop initials are set into the text, requiring that a number of lines be indented. Some phototypesetting machines have the capacity to set drop initials in position; others do not, in which case the text is set with the proper indent and the initials are set separately and stripped in later.

indents. Remember, this is custom work and can be expensive.

Drop initials look best when the initial aligns on top with the cap height of the first line of type and on bottom with the baseline of the last line of type. Sometimes this works out naturally, but more often the initial must be enlarged or reduced slightly in order to fit correctly. This is usually done off-machine and the initial is stripped in later.

Hung Initials. Probably the least common of the three: the initial is hung in the left margin outside the measure. It usually aligns on top with the cap height of the first line. The distance between the initial and the text is decided by the designer.

Note: There are other design possibilities, but whatever you do it will probably be a variation of one of the above. Just remember, the more elaborate the treatment, the more keyboarding or stripping, and therefore the more expensive it will be.

ung initials are the least common of the three. In this case the initial is hung in the left margin outside the measure. It usually aligns on top with the cap height of the first line. The distance between the initial and the text is decided by the designer.

ung initials are the least common of the three. In this case the initial is hung in the left margin outside the measure. It usually aligns on top with the cap height of the first line. The distance between the initial and the text is decided by the designer.

Hung initials are the least common of the three. In this case the initial is hung in the left margin outside the measure. It usually aligns on top with the cap height of the first line. The distance between the initial and the text is decided by the designer.

Small Caps

Small caps, indicated "sc," are capital letters which have the same height as the lower-case x-height. Small caps may be used alone or in conjunction with regular caps.

Small caps often substitute for caps in abbreviations where regular caps used throughout the text would be overly assertive and therefore distracting. Because they are about the same height as the lowercase letters, small caps contribute to the uniformity of the page.

Most phototypesetting systems do not have small caps, although they may be

available on pi fonts. In cases where true small caps are not available, the typographer can approximate them by setting caps of a smaller type size. This substitution is usually satisfactory, although there are times when the smaller type size may appear too light next to the regular type. This discrepancy can be particularly obvious when combining CAPS AND SMALL CAPS.

Getting the right size and weight may require a certain amount of experimentation, so when using small caps have a sample set before proceeding with the entire job.

Note: Fonts having true small caps do not have numerals to match. So if you need

matching numerals, either use a smaller type size for both the small caps and the numerals, or if possible, choose a typeface that has old style figures. (Old Style figures vary in size and are more compatible with small caps than Modern figures, which are the same size as regular caps. See page 109.)

Small caps often substitute for caps in abbreviations where regular caps used throughout the text would be overly assertive and therefore distracting (for example in the abbreviations A.M., P.M., B.C., A.D., NASA, AFL/CIO, ILGWU). Because they are about the same height as the lowercase letters, small caps contribute to the uniformity of the page, making it quieter and easier to read.

TYPE SET WITH REGULAR CAPS

Small caps often substitute for caps in abbreviations where regular caps used throughout the text would be overly assertive and therefore distracting (for example in the abbreviations A.M., P.M., B.C., A.D., NASA, AFL/CIO, ILGWU). Because they are about the same height as the lowercase letters, small caps contribute to the uniformity of the page, making it quieter and easier to read.

TYPE SET WITH SMALL CAPS

Times Roman with TRUE SMALL CAPS.

Times Roman with SMALL CAPS set by reduction.

Ligatures

A ligature is two or more characters joined together and set as a single unit. The most common ligatures are ff, fi, fl, ffi, and ffl. Ligatures are a typographic refinement that was common with traditional text typesetting; however, today they are more the exception than the rule.

If you are thinking of setting copy with ligatures check with the typesetter to make sure they are available; not all typesetting systems have them. Others may have only a few of the more common ligatures, such as fi, ffi, and fl.

If ligatures are available, find out if the system is programmed to automatically substitute ligatures for regular characters. If not, the keyboard operator will have to keyboard the ligatures individually, and this can be time consuming and expensive.

Note: When setting type with very tight letterspacing, ligatures may be inappropriate, since the other letters may be closer together than the ligatures, which remain constant no matter what letterspacing is specified.

Some common ligatures.

WITHOUT LIGATURES Set first paragraph flush left.

WITH LIGATURES Set first paragraph flush left.

WITHOUT LIGATURES Set first paragraph flush left.

WITH LIGATURES Set first paragraph flush left.

Rules

Rules can help to visually organize material or they can simply add character to a printed piece.

The weight of a rule, like linespacing, is specified in points and fractions of points. Some are also referred to by name; for example, a ¼-point rule is commonly referred to as a "hairline" rule.

The rules available will depend on the system. Larger phototypesetting systems can set most rules, while the smaller, in-house systems usually offer just a few sizes, such as hairline, ½-point, and 1-point. (Other

sizes may be available from the manufacturer on pi fonts.) In cases where heavier rules are required they can be built up by overlapping lighter rules.

The length of the rule, like line length, is usually specified in picas, but it can also be specified in inches. The maximum rule length that a specific machine can set is the same as its maximum line length. If you are uncertain about the length of the rule you want, have it set long; you can always shorten it.

When specifying rules also specify the amount of space you want above and below to avoid having to make adjustments in mechanicals.

Note: When setting rules, check proofs carefully. Most phototypesetting machines set them by means of a segmented rule, which is a series of short dashes butted together; if the character spacing and alignment are not perfect, you may get jagged or broken rules. Broken Rules. Broken rules, commonly referred to as "coupon rules," are simply short dashes with white space between them. Broken rules, like regular rules, are specified in points.

Vertical Rules. Most phototypesetting systems do not set vertical rules. So if a job (such as a coupon or a table) requires them, simply set horizontal rules and position them vertically in mechanicals.

HAIRLINE RULE (1/4-POINT)	
FINE RULE (1/2-POINT)	
1-POINT RULE	
2-POINT RULE	
3-POINT RULE	
4-POINT RULE	
5-POINT RULE	
6-POINT RULE	
	An assortment of combination rules.

Although some machines are capable of setting vertical rules, not all are capable of doing it efficiently. In many cases setting vertical rules requires extra keyboarding. Also, positioning and butting corners accurately can be a problem.

You may also wish to reconsider whether vertical rules are really necessary. Although they can at times function as a positive design element, tabular material usually looks better without them.

Note: If the setting or positioning of rules presents any problems, you may want to consider making your own rules with transfer type or a ruling pen.

HAIRLINE BROKEN RULE (1/4-POINT)	
FINE BROKEN RULE (1/2-POINT)	
1-POINT BROKEN RULE	
2-POINT BROKEN RULE	
3-POINT BROKEN RULE	
4-POINT BROKEN RULE	
5-POINT BROKEN RULE	
6-POINT BROKEN BUILE	

Name
Address
City
State Zip

Broken rule set horizontally and positioned vertically in mechanicals to make a coupon box.

Tabular Matter

Tabular matter refers to columns of text or figures, such as tables or charts, set at predetermined locations on a given measure. The process of setting tabular matter is known as *tabbing*.

It is not only important to know whether a specific machine is capable of setting tabular matter, but you must also know the number of tab positions available. One tab position is required for each column of type. You will also want to know the machine's capabilities at each tab position: can it set type only flush left, or can it also set type flush right as well

as centered and justified?

Setting tabular matter can be simple or complex. It can involve a single typeface or a number of typefaces; it can also involve rules, leaders, asterisks, superior numbers, and footnotes.

SPECIFYING HEADS

The heads at the top of each column should be short, precise, and consistent in style. When heads are longer than the items in a column they distort the space between the columns. To shorten heads, edit out unnecessary words, use abbreviations, or set them on more than one line.

When setting heads on multiple lines,

specify whether they are to be set flush left, flush right, or centered. If some of the heads are one line and others two or more, also specify whether you want the heads to align across the top, the bottom, or be centered. By making these decisions you are not only controlling the look of the table, but also reducing the risk of items having to be reset.

The type size and weight you choose will be dictated by the length of the heads and the degree of emphasis you wish to give them. It is important that the heads stand out from the rest of the text. This is usually accomplished by setting the heads in boldface or separating them with a rule or extra space. (See Copyfitting Tabular Matter on page 151.)

Typeface	Period	Century
Garamond	Old Style	Early Seventeenth
Baskerville	Transitional	Mid-Eighteenth
Bodoni	Modern	Late Eighteenth
Century	Egyptian	Late Nineteenth
Helvetica	Contemporary	Mid-Twentieth

TYPEFACE	PERIOD	CENTURY
Garamond	Old Style	Early Seventeenth
Baskerville	Transitional	Mid-Eighteenth
Bodoni	Modern	Late Eighteenth
Century	Egyptian	Late Nineteenth
Helvetica	Contemporary	Mid-Twentieth

The same table set with heads in two different styles.

Note: Tabular matter is usually charged at a premium over straight matter. Unlike straight matter, most tabular matter requires a great deal of thinking, as well as extra keyboarding steps. For this reason anything you can do to simplify the job will mean time and money saved. Make sure the copy is properly edited and prepared.

Typeface	Period	Century
Garamond	Old Style	Early Seventeenth
Baskerville	Transitional	Mid-Eighteenth
Bodoni	Modern	Late Eighteenth
Century	Egyptian	Late Nineteenth
Helvetica	Contemporary	Mid-Twentieth

Typeface	Period	Century
Garamond	Old Style	Early Seventeenth
Baskerville	Transitional	Mid-Eighteenth
Bodoni	Modern	Late Eighteenth
Century	Egyptian	Late Nineteenth
Helvetica	Contemporary	Mid-Twentieth

Rules can be used to organize the information in a table.

Underscores

Underscoring is another way to create emphasis. In most cases, the underscore falls just below the baseline and breaks for descenders. If you want the underscore to fall below the descenders, make sure there is enough white space between the lines to accommodate it; this can be a problem when type is set solid.

Underscoring can create problems for some phototypesetting machines. The job may require extra markup or keyboarding; parts of the job may have to be run through twice—once for the type and a second time

for the underscoring. More seriously, the words and the underscores may not align properly, or the underscores may cut through the descenders.

If underscores present a problem for you or the typesetter you may wish to reconsider using them altogether. Underscores make sense when you use a typewriter where the only way to emphasize a word is by underscoring or using all caps. When working with type, however, you have many more desirable alternatives; italics, boldface, caps, to name a few. (See Creating Emphasis on page 90.) On the other hand, if underscoring is essential, try to find a typographer that understands the procedure—otherwise it

can be time consuming and expensive.

If the underscoring cannot be done onmachine, the type should be set separately and the underscores added by hand. This can be done by the typesetter or by the designer. There are three basic methods of underscoring: strip film, transfer type, and ruling pen.

Strip Film. In this case rules are printed by the typesetter on a lightweight (1 mil), transparent acetate sheet with an adhesive backing. The typesetter then cuts out the rules and burnishes them into place on the repro or film. The acetate is so thin that the cut marks disappear in the proofing or platemaking process.

Underscoring creates emphasis.

Underscore falls just below baseline and breaks for descenders.

Underscoring creates emphasis.

Underscore falls below descenders and so does not break.

Transfer Type. These are sheets containing an assortment of rules and can be purchased in most art supply stores. There are two basic types: pressure-sensitive, where the rules are transferred directly from the sheet to the art by burnishing, and cut-out, where the rules are first cut out of a master sheet and then burnished into position. Cut-out transfer type is similar to strip film, except that it is usually handled by the designer rather than by the typesetter. Ruling Pen. A ruling pen is excellent for drawing rules, but not for underscoring words, especially if the type is small. One of the major difficulties is trying to maintain an even line over a short distance. If you use a

ruling pen you may have to retouch the ends of the lines to make sure they are precise.

Note: If underscoring presents a problem, you may wish to consider a more traditional way of creating emphasis, such as italic, boldface, or caps.

Note: If underscoring presents a problem, you may wish to consider a more traditional way of creating emphasis, such as italic, boldface, or caps.

Note: If underscoring presents a problem, you may wish to consider a more traditional lay of creating emphasis, such as italic, boldface, or caps.

NOTE: If underscoring presents a problem, you may wish to consider a more traditional way of creating emphasis, such as italic, boldface, or caps.

Leaders

Leaders are a series of dots designed to guide the eye from one point to another. Properly used, leaders help you read across a page or form such as a table of contents, price list, timetable, etc.

The size of the leader dot will depend on the particular piece of equipment: some machines use a period while others use a special leader dot which is slightly smaller.

The distance between the dots can vary, but a common setting is two dots to the em or one to the en. This means that in 12-point type there would be two dots every 12 points,

or one every six points. For a tighter setting you can specify three or four dots to the em.

When setting leaders it is important that the dots fall into a predictable pattern. There are two basic leader patterns: *aligning* leaders, where the dots align vertically down the page, and *diamond* leaders, where the dots are staggered to form a diamond pattern. Aligning leaders are the most widely used and least distracting.

Getting dots to align vertically down the page can be a problem when the lines of type preceding the dots vary in length. To ensure that the dots align properly, the space between the first few dots is adjusted so that the subsequent dots will align.

DOT EVERY 6 POINTS	***************************************
DOT EVERY PICA	
DOT EVERY 2 PICAS	
DOT EVERY 3 PICAS	
DOT EVERY 4 PICAS	
	Terminology 00
	Design 00
	Copyfitting 00
	Aligning leaders align vertically down the page.
	Terminology 00
	Design 00
	Copyfitting
	Diamond leaders are staggered to form a diamond pattern.

Boxes

Boxes, sometimes referred to as ballot boxes, em-quad boxes, or squares, come in two basic styles: *open*, which is an outlined box, and *solid*, which is a filled-in box. They have a number of typographic uses, the most common being for order forms and checklists.

The traditional box is a square of the type size: a 12-point box is 12 points square. When set, it aligns with the top of the ascender and the bottom of the descender. Unfortunately, when followed by caps or words with very few descenders, the box can

look as though it has dropped. A more generally available box is the square of the cap height. This is slightly smaller than the traditional box and is set base-aligning.

If you are setting a box for a practical purpose, such as checking off items, make sure it is large enough to fulfill its function. You may find that a box set in the text size is too small. In this case, specify a larger box and indicate whether it is to be base-aligning or centered. You can either specify the box size in points or have the typesetter match a layout.

12-point type with full 12-point outline box.
12-POINT CAPS WITH FULL 12-POINT OUTLINE BOX.
12-point type with 12-point base-aligning box.
12-POINT CAPS WITH 12-POINT BASE-ALIGNING OUTLINE BOX.
12-point type with full 12-point solid box.
12-point type with 12-point base-aligning box.
12-point type with 14-point base-aligning box.
12-point type with 18-point base-aligning box.
12-point type with 24-point base-aligning box.

Bullets

Bullets are solid round dots used to emphasize a list of items. They usually come in three sizes—small, medium, and large. Most systems also offer pi fonts which cover a wider range of sizes. The size you choose is dictated in part by esthetics and in part by how strongly you wish to emphasize a given item.

The best position for a bullet is centered on the lowercase characters (x-height), unless the bullet is fairly large or followed by caps, in which case you may wish to center it on the cap height.

- · 8-point Times roman with small bullet.
- 8-point Times Roman with medium bullet.
- 8-point Times Roman with large bullet.
- 10-point Times Roman with small bullet.
- 10-point Times Roman with medium bullet.
- 10-point Times Roman with large bullet.
- 12-point Times Roman with small bullet.
- 12-point Times Roman with medium bullet.
- 12-point Times Roman with large bullet.
- 14-point Times Roman with small bullet.
- 14-point Times Roman with medium bullet.
- 14-point Times Roman with large bullet.
- 16-point Times Roman with small bullet.
- 16-point Times Roman with medium bullet.
- 16-point Times Roman with large bullet.
- medium bullet centered on x-height.
- MEDIUM BULLET CENTERED ON CAP HEIGHT.

Figures

There are two styles of figures: Old Style and Modern. Old Style figures, also referred to as non-lining, are similar to the lowercase alphabet; that is, they are small and have ascenders and descenders. Modern, or lining figures, are similar to caps: they are the same size and align on the baseline.

Old Style figures are generally used in situations where unobtrusive figures are called for; for example, in a body of text or in combination with small caps. On the other hand, in situations where the figures are meant to stand out, as in tables and charts,

Modern figures may be more appropriate.

Unfortunately, most phototypesetting systems offer only Modern figures. Although Old Style figures are sometimes available on pi fonts, you may have to settle for Old Style figures from a different type family.

In cases where Old Style figures are not available, you may consider using Modern figures, but one size smaller.

OLD STYLE FIGURES I 2 3 4 5 6 7 8 9 0

MODERN FIGURES 1 2 3 4 5 6 7 8 9 0

Modern figures, when used in body text, tend to stand out, as in \$12,345.00 or 11:45 AM, for example. Old Style figures, on the other hand, are less obtrusive and are generally more compatible with both lower case characters and small caps, as in \$12,345.00 and 11:45 AM.

Superior and Inferior Characters

Superior and inferior characters are small figures and letters that align either at cap height (superior) or descender (inferior). They are commonly used for footnotes, mathematical equations, scientific formulas, etc. Superior and inferior characters are generally not available on standard fonts, but they can be ordered on pi fonts.

Although it is ideal if the superior and inferior characters match the typeface of the text, this is not always possible. Many manufacturers have only two sets of characters—called "universal" type styles—that are designed to mix with all serif and sans serif typefaces.

Where superior and inferior characters are not available, it is possible to approximate them by using a smaller version of the text type. However, legibility may be a problem. True superior and inferior characters are designed slightly bolder and more extended than standard typefaces, therefore a reduced version of the text type may be too light or tend to fill in when printed. Furthermore, properly positioning substitute figures can be a problem and may involve extra keyboarding, which could be expensive.

Another possibility, for jobs requiring only

a few figures, is to have them set separately and stripped into position, either by the typesetter or the designer. However, if the job involves extensive use of figures, it is better to find a typographer with the equipment and experience to handle this kind of work.

Superior and inferior characters can also be used to make piece fractions (see facing page).

Superior characters ¹²³⁴⁵⁶⁷⁸⁹⁰ and inferior characters ₁₂₃₄₅₆₇₈₉₀.

Superior and inferior characters¹ are commonly used for footnotes, mathematical equations, and scientific formulas. Most typographers use a "universal" type style designed to mix with both serif and sans-serif typefaces.

¹If true superior and inferior characters are not available, they can be approximated by using a smaller version of the text type.

Fractions

Most phototypesetting systems offer case, or solid, fractions only in eighths, quarters, thirds and halves: 1/8, 1/4, 3/8, 1/2, 5/8, 3/4, 7/8, 1/3, and 2/3.

If the fractions you want are not available you may consider using standard full-size figures in combination with a shilling mark (slash or slant). (This is the same system used on standard typewriters for all fractions other than $\frac{1}{4}$ and $\frac{1}{2}$.) If you do decide to use full-size fractions, avoid combining them with the smaller case fractions, as they do not mix well visually.

Another possibility is to use piece fractions; that is, superior and inferior figures in combination with a slash or a dash.

When specifying fractions in this way, check with the typographer to find out whether this can be done automatically or if it will require extra keyboarding and expense. Also, have a sample set before proceeding with the entire job, as you may not like the way the fractions look.

Note: Most systems have fractions only in roman, therefore if you are setting a job in italic be aware that the fractions may have to be set in roman.

1/8	1/4	3/8	1/2	5/8	3/4	7/8	1/3	2/3
				CASE FRACTIONS				
1/8	1/4	3/8	1/2	5/8	3/4	7/8	1/3	2/3
1/8	1/4	3/8	$1/_{2}$	5/8	3/4	7/8	1/3	$2/_{3}$
			PIE	CE FRACTIONS WITH	SLASH			
<u>1</u> 8	$\frac{1}{4}$	$\frac{3}{8}$	$\frac{1}{2}$	$\frac{5}{8}$	$\frac{3}{4}$	$\frac{7}{8}$	$\frac{1}{3}$	$\frac{2}{3}$
			PIE	ECE FRACTIONS WITH	DASH			

Avoid mixing case fractions, such as ½ and ½, with full-size fractions, such as ½ and ½.

Design Considerations for Punctuation

How you handle punctuation affects the legibility and quality of the printed piece. Here are some design considerations you should keep in mind, especially when working with display type where punctuation is highly visible.

Hung Punctuation. When punctuation marks are set outside the type measure, they are referred to as "hung" punctuation. This is a typographic nicety that not only makes a printed piece more attractive, but more legible. It is a common practice to hang

punctuation in the margin of text type as well as in display type.

The reason for hanging punctuation in the margin is to preserve the straight vertical edge created by flush lines of type. Small punctuation (commas, periods, hyphens, apostrophes, asterisks, and quotation marks) have less weight than full-size characters, and when set inside the measure they may create "holes" in the flush alignment. This can be distracting, especially for small amounts of type in highly visible areas, such as ads.

To avoid this, small punctuation marks are set just outside the measure, where they are less conspicuous.

Larger punctuation marks (colons, semicolons, question marks, and exclamation points), which have the same optical weight as full-size characters, are set within the measure. The em-dash, because of its length, is also set within the measure.

Whether or not to hang punctuation is a design decision you must make on a job-to-job basis. Not all jobs are improved with hung punctuation; for example, extra-bold punctuation marks hanging in the margin may be more distracting than the indents.

Before specifying hung punctuation, check the typographer to see if the equipment is programmed to hang punctuation automatically. If not, the job may require

"The reason for hanging punctuation in the margin is to preserve the straight vertical edge created by flush lines of type. Small punctuation, such as commas, periods, hyphens, apostrophes, asterisks, and quotation marks, have less weight than full-size characters, and when set inside the measure they may create 'holes' in the flush alignment. This can be distracting, especially for small amounts of type in highly visible areas, such as ads."

TYPE SET WITH NORMAL PUNCTUATION

"The reason for hanging punctuation in the margin is to preserve the straight vertical edge created by flush lines of type. Small punctuation, such as commas, periods, hyphens, apostrophes, asterisks, and quotation marks, have less weight than full-size characters, and when set inside the measure they may create 'holes' in the flush alignment. This can be distracting, especially for small amounts of type in highly visible areas, such as ads."

TYPE SET WITH HUNG PUNCTUATION

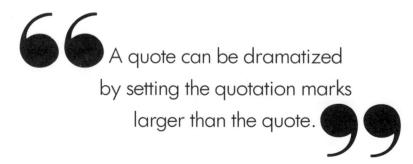

extra programming or keyboarding, which will increase the cost.

Space After Abbreviation Periods. Normally, the typesetter will leave a wordspace after a period. This is fine for the end of a sentence but too generous for abbreviation periods. Always specify less-thannormal wordspacing when setting abbreviations. In some cases, because of the configuration of the letters, abbreviations can be set with no wordspacing, for example N.Y. (See Kerning on page 62.)

Reducing Punctuation Marks. The punctuation marks in display type may sometimes seem overly assertive. This is often the case when there is either an unusual

amount of punctuation or the copy is set in bold type. To create a better visual balance between the punctuation and the copy, consider setting the punctuation marks one or two sizes smaller than the display type. Note, however, that although mixing type sizes can be done automatically, correct position can be a problem. In such cases it may be simpler and less expensive to have the alternate punctuation marks set separately and position them in mechanicals yourself. Enlarging Punctuation Marks. Punctuation marks can be used as a design element to emphasize a point. For example, a quote can be made more dramatic by setting the quotation marks larger than the quote. Once again, setting and positioning oversize punctuation may be a problem for the typesetter and they may have to be set separately.

When working with oversize punctuation marks, allow for enough space in the typeset copy to accommodate them.

Short Dash vs. Long Dash. Most phototypesetting machines have two standard dashes: the en-dash and the em-dash, also referred to as the short dash and the long dash. Unfortunately, neither dash has a standard length; they vary depending both on the typeface and on the manufacturer's interpretation of the typeface.

Although both dashes have specific uses, many designers feel that the long dash—if

"commas, periods, and hyphens..."

PUNCTUATION MARKS SET SAME SIZE AS TYPE

"commas, periods, and hyphens..."

PUNCTUATION MARKS SET ONE SIZE SMALLER THAN TYPE

Mr. H. N. Smith, New York City, N. Y.

NORMAL WORDSPACE AFTER ABBREVIATION PERIOD

Mr. H. N. Smith, New York City, N. Y.

TIGHT WORDSPACE AFTER ABBREVIATION PERIOD

(Design Considerations for Punctuation continued) particularly long—creates a hole in the text, in which case they prefer to use a short dash with a small amount of extra space on either side. Grammarians may take offense to this practice, so you may wish to check with the client before proceeding with any substitutions.

Aligning Hyphens with Caps. Hyphens are designed to set centered on the x-height. This is perfect for lowercase letters but too low for words set in all caps, in which case the hyphen should be centered on the cap height. When setting hyphenated words in all caps, you can specify that the hyphen be centered on the cap height. If this is not possible, you may have to make the adjust-

ment in mechanicals. (The same applies when setting dashes and parentheses.)

Many designers feel that the long dash—if particularly long—creates a hole in the text, in which case they prefer to use a short dash with a small amount of additional space on either side.

SET WITH 1-EM DASH

Many designers feel that the long dash—if particularly long—creates a hole in the text, in which case they prefer to use a short dash with a small amount of additional space on either side.

SET WITH 1-EN DASH AND THIN SPACE ON EITHER SIDE

(set-width) (SET-WIDTH) (SET-WIDTH)

Hyphens, dashes, and parentheses align properly for lowercase but require correcting when set with all caps.

Matching Type

There are occasions when a word or section of a printed piece has to be corrected or updated. To accomplish this, new copy is set and inserted as a *patch* into the existing job. It is absolutely essential that the patch (including letterspacing and wordspacing) match the original; any discrepancy will be obvious to even the most casual reader.

To avoid discrepancies, all patches should be set by the original typographer using the same system (font, lens, exposure, paper, development, and proofing) as the original.

Type is easy to match if patches are set

while the job is still in production. However, it is not so simple if time has elapsed between settings and there is no record of who set the original type. If you recognize the typeface, you can have the patch set by another typographer—but you run the risk of getting a patch slightly different from the original. It might be better to reset the entire job.

Note: When setting patches on the original equipment you need not settle for an unacceptable match. According to the manufacturers of phototypesetting equipment, it is possible to match type precisely. Therefore, it is only a question of insisting upon what you want and not settling for a close match.

There are occasions when a word or section of a printed piece has to be corrected or updated. To accomplish this, new copy is set and inserted as a patch into the existing job. It is absolutely essential that the patch match the original in every way; any discrepancy will be obvious to even the most casual reader.

An unacceptable patch.

Optical Alignment

When lines of display type are set flush left, the vertical alignment may seem irregular. This is especially true when the first letter in each line is a cap. Letters having straight vertical strokes, such as E, F, H, I, M, N, etc., align perfectly, while irregular letters, such as A, J, O, T, V, Y, etc., may appear to be out of alignment, even though the type has been properly set. When this happens, the only solution is to adjust each line so that the letters are optically aligned. Although this can be included in your instructions to the typesetter, it is simpler for the designer to

make the adjustments in mechanicals.

There will be times when no alignment will seem to work. For example, the cap T can be a problem—no matter what you do it will not align. If you align the vertical stroke, the horizontal stroke will overhang; align the horizontal stroke and the line will appear indented. Neither solution is perfect. In such cases, you will just have to settle for the solution you feel is the least distracting. Note: Poor alignment is most apt to occur when type is set automatically. When type is set manually, the operator is able to make the necessary adjustments as the lines of type are being set or assembled. (See Photodisplay Systems, page 179.)

VERTICAL
ALIGNIMENT
MAY SEEM
IRREGULAR
WHEN THE
FIRST LETTER
OF EACH LINE
DOES NOT
START WITH
A STRAIGHT
VERTICAL STROKE. .

LETTERS LIKE
B, D, E, F, H,
I, K, L, ETC.,
DO NOT
PRESENT
PROBLEMS.

Script Typefaces

Script typefaces are based on handwritten letterforms and are not to be confused with italic typefaces. Scripts are available in many styles: formal, informal, sophisticated, playful, etc. They also come in a variety of weights.

Script typefaces are different from standard typefaces in that the individual letters are designed to touch in order to create a flowing, handwritten effect. If the letters are not perfectly connected the result can be distracting; lines that overlap will create a "knob," while lines that fail to touch will

create a "hole." Both are unsatisfactory and require retouching.

To insure the finest quality, many typographers work oversize, precisely butting the individual letters together and retouching where necessary before reducing the type to the specified size.

Setting script typefaces requires a skilled operator, and for this reason some typographers will charge extra.

Bank Script Bernhard Tango Brush Derby Cigno Commercial Script Grayonette

Kaufmann Script

Legend

Lydian Cursive

Park Avenue

Rondo Bold

Stradivarius

Thompson Quillscript

Pespa

Custom Lettering

Every so often there is a job that requires a totally original typographic solution. In this case, the designer may wish to consider custom, or hand, lettering.

Custom lettering may or may not involve a phototypesetting machine, depending on how original you want the typeface or script to be and on the nature of the embellishments. A standard typeface can sometimes be given an entirely new look with a couple of well-placed swashes; on the other hand, there are times when the letterer will have to create an entirely new typeface.

If you are planning to use custom lettering, make a careful layout of how you envision a particular job. Your layout can be based on an actual typeface (or script) and should include a rough idea of how you see the embellishments. The letterer will use this layout as a point of departure, but be aware that achieving a well-balanced design will involve many tracings—all of which takes time and can be very expensive.

House Beautiful Newsweek POST

Hand-lettered logos.

Hand-lettered Spencerian script.

An alternative to hand lettering is to use a standard typeface, in this case Letraset transfer type, with hand-lettered swatches.

Outline and Shadow Typefaces

Most photodisplay typographers have a number of standard outline (contour) typefaces available, both with and without shadows.

Some typographers are also equipped to modify standard typefaces. However, as outlining and adding shadows requires both photography and handwork, the results can be expensive. Furthermore, outlining does not work with all typefaces; for example, typefaces that have thin hairline strokes or fine serifs are almost impossible to outline.

Note: Setting type with shadows can create problems; for example, there is a tendency for the shadow to overlap the adjacent letter. When this happens, the type has to be retouched by hand, which adds to the cost of the job. Generally speaking, typographers charge a premium for jobs involving shadows.

Design Drop Shadow Design Raised Shadow SOLLY COO STAPED

Korimna Outline

Korinna Shadow

VILLAEELis

SANS SERIF SHADED

Swinger Shadow

UMBRA

Setting Type in Circles

Some photodisplay machines are equipped with a special lens that permits the setting of type in circles (or curves).

When ordering type to be set in a circle, specify either the size of the type or the size of the circle, but not both; the size of the type will dictate the size of the circle—and viceversa. The only way to change the size of the circle is by changing the type size or by adjusting the wordspacing and letterspacing, which can be distracting.

If you intend to have the job made up by the typesetter, remember that setting

type in circles is custom work and can be expensive.

Note: Although you may not be able to set the job in a circle, you can have the type set normally and then cut out the individual letters and paste them down in a circle. If you do decide to do the job yourself, have the type set in a larger size and with extra letterspacing to simplify the task of cutting and positioning the letters. After the circle has been made, the type can be reduced to the desired size.

Straight line copy converted to a fan circle photographically. A special lens permits setting type in circles.

Reproportioning Type

There are times when you may wish that a certain display typeface were just a little more condensed, expanded, or oblique (slanted slightly to the right). Some photodisplay machines, equipped with a special lens system, can reproportion type. This involves a certain amount of distortion, which can be distracting—especially if excessive. For example, Helvetica type that has been condensed photographically is not the same as a true "Helvetica Condensed." Therefore, before reproportioning type, check with a type specimen book to see how it looks.

Typography

CONDENSED 24%

Typography

CONDENSED 8%

Typography

EXPANDED 24%

Typography

Typography

EXPANDED 16%

Typography

Typography

EXPANDED 8%

Typography

Typography

Typography

Typography

Typography

A reproportioning guide.

Typographic Ornaments

Typographic ornaments cover a wide range of devices, such as dingbats (called colophons in U.K.), brackets, flourishes, tapered rules and braces. These ornaments, like display initials, offer the designer an opportunity to embellish a printed piece.

Some of these typographic devices can be used singly, or repeated to create a border or overall pattern. (See Borders on page 130 and Step-and-Repeat on page 132.)

Borders

Borders can vary from simple rules to complex floral patterns. Like rules, borders are made by butting a series of segments together. Also like rules, borders can only be set horizontally. If you require a vertical border (to create a boxlike effect, for example), use horizontal borders and position them in mechanicals yourself. Some systems also offer corner units.

Although borders are usually set on photodisplay machines, some text-setting machines can automatically repeat, stagger, and overlap characters to produce borders.

A variety of borders.

Step-and-Repeat

Step-and-repeat is a photographic technique in which a single image is repeated either in straight or staggered lines. Step-and-repeat can be used to create a continuous or overall pattern for borders, book jackets, endpapers, etc.

The line art can be chosen from the typesetter's library of type fonts and pi fonts or it can be supplied by the designer. The stepand-repeat process is not limited to one piece of art; some very dramatic effects can be obtained by mixing two or more pieces of art or typefaces.

Step-and-repeat type.

Step-and-repeat line art.

Step-and-repeat logos.

Special Effects

On the following pages are shown a variety of special effects; some practical, such as type reproportioned to fit a given space, others more novel than practical. Special effects should be used sparingly and with good judgment; not only can they be expensive, but sometimes they are impossible to read!

Balloon effect.

Dip-arch with shadow.

PICAL AFFOCTS PICAL AFFOCTS

Optical effects.

Box perspective.

flexibility flexibility flexibility flexibility

Reproportioning.

Bottom converging perspective.

UMBRELLA WEATHER

Distortion.

Typographic Guide

Some companies, especially those that demand quality type, such as publishers and advertising agencies, supply the typographer with a typographic guide to insure that all copy will be set according to their standards. Below we have reproduced the typographic guide used by the advertising agency Young & Rubicam, Inc.

Photodisplay

- 1. Word-space tightly, depending on the set width of the alphabet. Equalize spacing optically before and after punctuation and reference marks or letters with large amounts of white space.
- 2. An optical alignment should be maintained on both sides of display matter. Hang punctuation marks optically.
- 3. You may set quotation marks 10-15% smaller and hang them left and right. In heavy sans-serif types also set periods, commas and apostrophes smaller.
- 4. Use ligatures, except in sans-serif faces.
- 5. Dashes should not exceed 2/3 the length of the em and should have a small amount of white space on both sides.
- 6. Use italic parentheses with italic display lines.
- 7. Set ellipses tight.
- 8. Use a cap I instead of the numeral 1 in Franklin-Gothic-family display lines
- Use tight letterspacing (normal spacing for TV supers) on all photodisplay. Line spacing should be kept as tight as the ascenders and descenders of the face permit.
- **10.** Do not photomodify display type unless the instructions specifically call for it.
- 11. The spacing between display lines can be varied slightly to achieve better optical spacing.

Phototext

- 12. Maintain relatively tight word spacing. Do not he sitate to break words.
- 13. Hang punctuation marks optically over the width indicated in all settings. This pertains to commas, periods, hyphens, apostrophes, small asterisks and registry marks.
- 14. Use all ligatures
- 15. Use short dashes with thin space on either side.
- **16.** Insert less than normal word space after abbreviation periods. "N.Y." can normally be set without a space.
- 17. Set ellipses tight.
- 18. Use italic parentheses with italic text.
- **19.** Set "a.m." or "p.m." lower-case with periods except for Eastern Airlines, where am and pm are lower-case with no periods. Separate figures in time with colon; i.e., 7:39 a.m.
- **20.** Use cent signs, circle ®, fractions and parentheses with similar style characteristics as the body or display type face. Always use small, superior daggers. Align solid or open squares with the lower-case line of the type.
- 21. Ignore underscores in typescripts if no italic companion face is available, unless you are specifically requested to use bold face or to set underscores.
- 22. Set all-cap words in body text one point size smaller or in true-cut small caps.
- 23. In copyright lines use a © with plenty of white space around the circled "c" so that it does not become an ink trap. Use this ©, or this ©, not this ©.

- 24. For coupon settings, normally use 1 pt. coupon rule boxes and ½ pt. rules for the address lines. Break the address unit into as many lines as the available space permits to provide maximum writing space. The space for "City," "State" and "Zip Code" should be logically distributed, no matter what the layout shows.
- **25.** Kern letter combinations wherever possible for an improved optical fit.
- 26. In "tight" phototext, word spacing must be proportionately reduced.
- 27. It is especially important to get tight settings where the end result is going to be enlarged to a display size.

Make-up

28. Submit galley photoproofs (diazos), then, upon our OK, make up all jobs as per layout with all line elements in position (maximum photomechanical make-up) where marked.

Proofing

- 29. Set our standard guide line in 8 on 9 pt. Times Roman about 4 picas below the type matter. The Copywriter's and Art Director's names are to be separated by 24 pts. from the actual guide line. Use guide lines when you split the job during proofing. Always identify the account name and the name of the buyer in your shop guide line which should be positioned about 4 picas below our standard guide line unit. Delete guide lines on acetate proofs.
- **30.** Unless otherwise specified submit 6 photoproofs and 1 glassine to the respective Print Producer.
- **31.** Square up all made-up photo composition carefully on a line-up table or grid
- **32.** Do not normally send photorepros. We will order negatives (or positives) of the final photomechanical as follows: Letterpress, right-reading negative; Surface offset, wrong-reading negative; Deep-etch offset, wrong-reading positive; Gravure, right-reading negative. Wrong-reading or right-reading refers to the emulsion side of the film.
- **33.** Make sure the "color" (density) of patches or stripped-in corrections are perfectly matched. Stripped-in corrections must be squared up.
- **34.** Send two prints of all photodisplay to the Type Director regardless of the signature on the purchase order. If you supply photorepros of headlines, send four and a glassine to the Print Producer. On all prints include a guide line showing our Job No. Do not submit photodisplay in strip form.
- **35.** Submit a copy or proof of each photodisplay unit with each invoice.

Television Typography

36. For television typography use normal spacing. Longest line of lettering will be 7%." Lettering should be on a 14 "x 11 " sheet. All guideline information should be affixed to the back of the print. We require one negative and one positive print plus a Xerox or other checking proof.

When working with type, it is absolutely essential that you know how to copyfit in order to establish the amount of space typewritten copy will occupy when set. Only then can you specify the typeface, point size, linespacing, etc.

This section describes some of the various methods used to character count. Also covered are copy preparation and markup, proofs and proofreader's marks, copyfitting tabular matter, writing to fit, and comping techniques.

Typewriters

To understand copyfitting we must start with an understanding of the typewriter. There are three basic typewriters: *pica*, *elite*, and *proportional*. We are mainly concerned with the first two, as these are the most commonly used.

The pica typewriter has large characters and types 10 characters per inch. The elite has smaller characters and types 12 characters per inch. Proportional typewriters, such as the IBM Executive and the Remington Rand Statesman, do not type a fixed number of characters per inch. Unlike pica and elite

typewriters, which allow one unit of space for every character (see page 28), the proportional typewriter allows more space for wide characters and less space for narrow characters and punctuation. This improves the letterfit, but makes character counting difficult. For this reason, it is much easier to make an accurate character count when the copy has been typed on a pica or an elite typewriter.

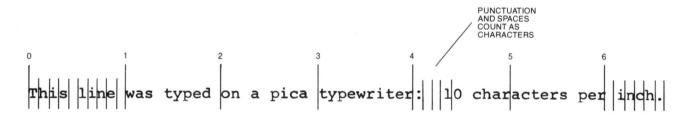

Pica typewriter: 10 characters per inch.

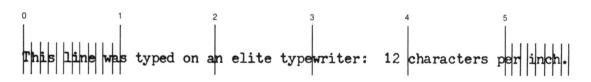

Elite typewriter: 12 characters per inch.

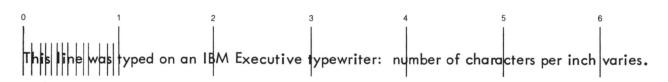

IBM Executive: Spacing varies with each letter.

Character Counting

Since we shall be converting typewritten characters into typeset characters, we must determine the total number of typewritten characters in the copy. This process is called character counting.

Counting each character individually is not only time consuming, but unnecessary. The simplest method is to count the number of characters in an average line and multiply this by the number of lines on the page. Let's do this, using the illustration below.

First, establish the kind of typewriter that has been used by counting the number of

characters per inch. In this case, it was a pica typewriter, which types 10 characters to the inch. Next, take an average line (line 4), and using a ruler, measure it to the nearest inch. Our sample line is five inches long, plus five extra characters. Multiply the line length (5) by the number of characters to the inch (10). This gives you a total of 50 characters. Now add the five characters beyond the five-inch mark, and you get 55 characters. Multiply this by the number of full lines (13), for a total of 715 characters.

For a more accurate count, adjust the total by adding all the characters that extend beyond the average line and subtracting all the characters that fall short of it.

COUNT 2 SPACES

If there is more than one page, multiply the number of characters on an average page by the total number of pages. This method of copy counting is accurate enough for any but the most demanding job. Where extreme accuracy is important you may find it necessary to count each line or page separately.

When working with lengthy manuscripts, check each page for inconsistencies, such as a varying number of lines per page, additions and deletions, change of typewriter, etc., as these will affect your count.

Before you can specify type you Character Counting must calculate the number of typewritten characters in the First, establish the kind of typewriter that was used copy. by counting the number of characters per inch. COUNT 1 SPACE AFTER A COMMA OR SEMICOLON it was a pica typewriter, which types 10 characters AVERAGE LINE IS 55 CHARACTERS Next, take an average line (line 4), and using a ruler, measure it to the nearest inch. Our sample line is five inches long, plus five extra characters. this line length (5) by the number of characters to the PUNCTUATION COUNTS AS 1 CHARACTER This gives you a total of 50 characters. inch (10). add the five characters that went beyond the five-inch mark, Multiply this by the number and you get 55 characters. of lines (13) for a total of 715 characters.

Character Count Table

Having finished the character count, we must now determine how much space the 715 characters will occupy when they are converted into type.

First we must make a number of design decisions, such as the choice of typeface and type size, and the amount of space we would like the copy to occupy. At this stage, these decisions are only exploratory and can be changed or modified if they do not work.

Let's assume that a good choice of typeface would be 11-point Times Roman set to a 20-pica measure. The type will be set solid (without linespacing) and justified (flush left and flush right). Wordspacing and letterspacing will be normal.

Now let's find out how much space the type will occupy. To establish the number of typeset characters that will fit a given measure, we refer to a character count table. These tables are found in type specimen books.

If you refer to the table below, you will see that 11-point Times Roman sets 2.6 characters per pica, or 52 characters to a 20-pica measure (20 x 2.6).

By dividing the total number of typewritten characters (715) by 52, we establish the number of lines required to set our copy.

715 divided by 52 is 13 lines with 29 characters left over. Regardless of how many characters remain they must still be counted as a line. Therefore, to set 715 typewritten characters in 11-point Times Roman by 20 picas will require 14 lines.

The type based on this character count can be seen on page 146. Although it worked out remarkably close to our estimate, keep in mind that copyfitting is not an exact science; the number of lines can vary due to factors such as differences in letterspacing, wordspacing, and hyphenation, etc.

Note: All character count tables are based on normal wordspacing and letterspacing; if

CHARACTERS PER PIC	A															*										
LENGTH IN PICAS	5	6	7	8	9	10	11	12	13	14	15	16	17	18	19	20	21	22	23	24	25	26	27	28	29	30
LOWER CASE	13	15	18	21	23	26	28	31	33	36	39	42	44	47	49	52	54	57	59	62	65	68	70	73	75	78
UPPER CASE (CAPS)	9	11	13	15	17	19	21	23	25	27	28	30	32	34	36	38	40	42	44	46	47	49	51	53	55	57

Character count table shows characters per pica for setting type either lowercase or all caps.

TYPE SIZE	6	7	8	9	10	11	12
TIMES ROMAN	71	84	95	108	120	131	144
TIMES ROMAN BOLD ITALIC	71	84	95	108	121	132	145
TIMES ROMAN BOLD	80	94	106	121	135	147	161

Lowercase alphabet lengths for Times Roman family expressed in points.

you want to set type either tight or loose, call the typographer for an accurate character count.

Also, the number of characters per pica of a specific typeface varies from system to system, so if you do not have a character count table for the equipment you are using, then once again, call the typographer.

COUNTING BY ALPHABET LENGTH

Not all character count tables show the number of characters per pica for each individual typeface. Some show only the lower-case alphabet length—a through z—expressed in points. To find the number of characters per pica, we refer to a master

table, which gives us the characters per pica for the various alphabet lengths.

For example, the alphabet length of 11-point Times Roman is 135 points. If you refer to the table shown below, you will see that any typeface with an alphabet length of 135 points will set 2.5 characters per pica, or 25 characters to a 10-pica measure.

For example, the alphabet length of 11-point Times Roman is 131 points. As there is no 131 shown on the table below, we can use either 129 or 132. Using 129 would give us 52 characters per line, while using 132 would give us 51 characters per line.

1 10 12 14 16 18 20 22 24 26 28 30 32 34 36 38 40 42

LINE LENGTH IN PICAS

			1	10	12	14	10	10	20	22	24	26	20	30	32	34	36	38	40	42	45
		65	4.75	40		07	7.0		05	105		404	400	4.40	450	400	474	101	400	200	045
	STS	67	4.75	48 47	57	67	76 74	86 84	95	105	114	124	133	143	152	162	171	181	190	200	215
	POINT	69	4.65 4.55	46	56 55	65 64	73	82	93 91	102 100	112 109	121 118	130 127	140 137	149 146	158 155	167 164	177 173	186 182	195 191	208 204
		71	4.45	45	53	62	71	80	89	98	107	116	125	134	142	152	160	169	178	187	200
	=	73	4.35	44	52	61	70	78	87	96	104	113	122	131	139	148	157	165	174	183	196
	LENGTHIN	75	4.25	43	51	60	68	77	85	94	102	111	119	128	136	145	153	162	170	179	192
	ž	77	4.15	42	50	58	66	75	83	91	100	108	116	125	133	141	149	158	166	174	186
	Ë	79	4.05	41	49	57	65	73	81	89	97	105	113	122	130	138	146	154	162	170	182
	3ET	81	3.95	40	47	55	63	71	79	87	95	103	111	119	126	134	142	150	158	166	178
	¥	83	3.85	39	46	54	62	69	77	85	92	100	108	116	123	131	139	146	154	162	174
	ALPHAB	86	. 3.75	38	45	53	60	68	75	83	90	98	105	113	120	128	135	143	150	158	170
	Ā	88	3.65	37	44	51	58	66	73	80	88	95	102	110	117	124	131	139	146	153	163
	ASE	91	3.55	36	43	50	57	64	71	78	85	92	99	107	114	121	128	135	142	149	159
	Š.	94	3.45	35	41	48	55	62	69	76	83	90	97	104	110	117	124	131	138	145	155
	OWERCA	98	3.35	34	40	47	54	60	67	74	80	87	94	101	107	114	121	127	134	141	151
	õ	102	3.25	33	39	46	52	59	65	72	78	85	91	98	104	111	117	124	130	137	147
	_	106	3.15	32	38	44	50	57	63	69	76	82	88	95	101	107	113	120	126	132	141
		110	3.05	31	37	43	49	55	61	67	73	79	85	92	98	104	110	116	122	128	137
		114	2.95	30	35	41	47	53	59	65	71	77	83	89	94	100	106	112	118	124	133
		118	2.85	29	34	40	46	51	57	63	68	74	80	86	91	97	103	108	114	120	129
		120	2.80	28	34	39	45	50	56	62	67	73	78	84	90	95	101	106	112	118	127
		122 124	2.75	28 27	33 32	39	44	50	55	61	66	72	77	83	88	94	99	105	110	116	125
AL DUIADET		127	2.70	27	32	38 37	43	49 48	54	59 58	65 64	70 69	76	81	86	92	97	103	108	113	120
ALPHABET LENGTH 131.		129	2.60	26	31	36	42	48	53 52	57	62	68	74 73	80	85	90	95	101 99	106 104	111	118
USE EITHER		132	2.55	26	31	36	41	46	51	56	61	66	71	78 77	83 82	88 87	94 92	97	102	109	116 114
129 OR 132		135	2.50	25	30	35	40	45	50	55	60	65	70	75	80	85	90	95	100	107	112
		138	2.45	25	29	34	39	44	49	54	59	64	69	74	78	83	88	93	98	103	110
		142	2.40	24	29	34	38	43	48	53	58	62	67	72	77	82	86	91	96	101	108
		146	2.35	24	28	33	38	42	47	52	56	61	66	71	75	80	85	89	94	99	106
		150	2.30	23	28	32	37	41	46	51	55	60	64	69	74	78	83	87	92	95	99
		154	2.25	23	27	32	36	41	45	50	54	59	63	68	72	77	81	86	90	92	95
		158	2.20	22	26	31	35	40	44	48	53	57	62	66	70	75	79	84	88	90	93
		162	2.15	22	26	30	34	39	43	47	52	56	60	65	69	73	77	82	86	88	91
		166	2.10	21	25	29	34	38	42	46	50	55	59	63	67	71	76	80	84	86	89
		170	2.05	21	25	29	33	37	41	45	49	53	57	62	66	70	74	78	82	84	87
		175	2.00	20	24	28	32	36	40	44	48	52	56	60	64	68	72	76	80	82	85
		180	1.95	20	23	27	31	35	39	43	47	51	55	59	62	66	70	74	78	80	83
		185	1.90	19	23	27	30	34	38	42	46	49	53	57	61	65	68	72	76	78	81
		190	1.85	19	22	26	30	33	37	41	44	48	52	56	59	63	67	70	74	78	84
		195	1.80	18	22	25	29	32	36	40.	43	47	50	54	58	61	65	68	72	76	82
		200	1.75	18	21	25	28	32	35	39	42	46	49	53	56	60	63	67	70	74	80

Master table showing the characters per pica for various alphabet lengths.

Copy Mark-Up

Typesetting instructions (typeface, type size, linespacing, line length, etc.) should be written legibly with a colored pencil or ballpoint pen so the instructions stand out from the typewritten copy. They should be clear, precise, and grouped in the left-hand margin of the page. Use proofreader's marks where possible (see page 147).

Also, where possible, send the typographer a layout of the job showing how the various design elements should appear. Repeat all the type specifications on the layout. Generally speaking, the more complete

the instructions, the better the chances the job will be set the way you want it. Do not leave design decisions to the typesetter.

Note: If you do not want a job made up (for example, you may wish to have display type set separately so you can position it yourself in mechanicals), be sure to instruct the typographer to set the heads "in galley" or "as patches," otherwise they will be set in position and could cost more.

Set
10/11 Times Roman
x 20 picas
justified
Normal wordspacing
and letterspacing

OKtohyphenate

Character Counting. Before you can specify type you must calculate the number of typewritten characters in the copy. First, establish the kind of typewriter that was used by counting the number of characters per inch. In this case, it was a pica typewriter, which types 10 characters per inch. Next, take an average line (line 4), and using a ruler, measure it to the nearest inch. Our sample line is five inches long, plus five extra characters. Multiply this line length (5) by the number of characters to the inch (10). This gives you a total of 50 characters. Now add the five characters that went beyond the five-inch mark, and you get 55 characters. Multiply this by the number of lines (13) for a total of 715 characters.

Type specifications added by designer.

Formatting Codes

After you specify the type, the typographer will add special formatting codes for the keyboard operator. These codes, which vary from system to system, cover such things as wordspacing, letterspacing, and font changes. They translate your type instructions into a language the phototypesetting machine can understand.

At present, there is little need for the designer to understand these codes, but as more agencies and studios acquire in-house phototypesetting systems, the designer will one day have to be familiar with them.

DAI OPO9 OF 100 OL2000 Orx DEL OTN3 OTACA OFK ON3

Character Counting. Before you can specify type you must calculate the number of typewritten characters in the copy. First, establish the kind of typewriter that was used by counting the number of characters per inch. In this case, it was a pica typewriter, which types 10 characters per inch. Next, take an average line (line 4), and using a ruler, measure it to the nearest inch. Our sample line is five inches long, plus five extra characters. Multiply this line length (5) by the number of characters to the inch (10). This gives you a total of 50 characters. Now add the five characters that went beyond the five-inch mark, and you get 55 characters. Multiply this by the number of lines (13) for a total of 715 characters.

Formatting codes added by typographer.

Proofs

After the type is set, the typographer holds the original typeset copy and returns the manuscript, layout, and as many sets of proofs as you have requested. The first proof is known as a reader's proof or galley proof. The designer should check it carefully against the layout to make sure there are no design or typographical errors.

One proof is usually retained by the designer to make up a dummy; one goes to a proofreader who checks the typeset copy word-for-word against the manuscript; one goes to the author, copywriter, or client; and one, known as the "master proof," goes to the editor (or to the person editorially responsible for the job). The corrections are transferred by the editor from the various proofs to the master, and it is this proof only that is returned to the typographer for corrections.

Every correction should be marked: either with an AA (Author's Alteration), which covers all editorial and design changes, or with a PE (Printer's Error), which covers those mistakes for which the typographer is directly responsible. The client pays for AAs, the typographer for PEs.

After the corrections have been made, the typographer will send you the final proof.

This is called a reproduction proof, or repro, because it is reproduction quality (cameraready) and may be pasted into mechanicals.

If the job is set on film, the typographer will make the corrections and prepare a film mechanical.

Note: If corrections are extensive it is a good practice to request a second reading proof.

Character Counting. Before you can specify type you must calculate the number of typewritten characters in the copy. First, establish the kind of typewriter that was used by counting the number of characters per inch. In this case, it was a pica typewriter, which types 10 characters per inch. Next, take an average line (line 4), and using a ruler, measure it to the nearest inch. Our sample line is five inches long, plus five extra characters. Multiply this line length (A) by the number of characters to the inch (10). This gives you a total of 50 characters. Now add the five characters that went beyond the five-inch mark, and you get 55 characters. Multiply this by the number of lines (13) for a grand total of 715 characters.

Reader's, or galley, proof with corrections properly indicated as either AAs or PEs.

Proofreader's Marks

Proofreader's marks are a standard set of symbols used to convey instructions to the typesetter. They are clear and brief and they communicate rapidly and efficiently. For example, a single line under a word means "set in italic," three lines means "set in caps." These symbols are used and understood by everyone associated with copy or type: copywriters, editors, designers, typesetters, proofreaders, etc. Although you may use only a dozen or so marks, it helps if you are familiar with all of them.

EXPLANATION	MARGINAL MARK	ERRORS MARKED
Take out letter, letters, or words indicated.	ろ	He opened the window.
Insert space.	#	He opened thewindow.
Insert letter.	е	He opned the window.
Set in lowercase.	lc	He pened the window.
Wrong font.	wf	He opered the window.
Broken letter. Must replace.	×	He pened the window.
Reset in italic.	ital	He opened the window.
Reset in roman.	rom	He opened the window.
Reset in bold face.	ef	He opened the window.
Replace with capital letter.	cap	he opened the window.
Use small capitals instead of type now used.	sc	He opened the <u>window</u> .
Insert period.	0	He opened the window
Transpose letters or words as indicated.	tr	He the window opened.)
Let it stand as is. Disregard all marks above dots.	stat	He opened the window.
Insert hyphen.	=/	He made the proofmark.
Equalize spacing.	ej#	He opened the window.
Move over to point indicated.	V	He opened the window.
[if to the left; if to the right]		
Insert comma.	5	Yes he opened the window.
Insert apostrophe.	V	He opened the boys window.
Enclose in quotation marks.	CC D	He opened the window.
Draw the word together.	\sim	He opened the window.
Insert inferior figure.	/2\	Sulphuric Acid is HSO,.
Insert superior figure.	**	$2a + b^2 = c_{\text{N}}$
Used when words left out are to be set from copy.	out, see upy	He _A window.
Spell out words marked with circle.	spell out	He opened the 2d window.
Start a new paragraph.	#	door. He opened the
Should not be a paragraph. Run in.	no #	door.
Over to with a Fraindad	(2)	He opened the window.
Query to author. Encircled.	(was:)	The proof read by.
Out of alignment. Straighten.	=	He opened the window.
1-em dash.	1/1	He opened the window
2-em dash.	121	He opened the window
En dash.	121	He opened the window
Indent 1 em.		He opened the window.
Indent 2 ems.		He opened the window.

Establishing the Depth

Once the number of lines has been determined it is possible to establish the depth by multiplying the number of lines by the point size of the type: 14 times 11 points equals 154 points. Divide the total by 12 (there are 12 points in a pica) and you get the depth in picas (12 picas, 10 points), or divide it by 72 (there are 72 points in one inch) and get the depth in inches (approximately 2% inches).

MAKING ADJUSTMENTS

If you find that the type sets too long or too short and you decide to adjust it by changing the typeface, type size, or measure, you must refigure the characters per pica. On the other hand, you can adjust the linespacing without refiguring. Adding (or deleting) space between the lines does not affect the characters per pica, nor the number of lines; it merely increases the depth. If you add one point linespacing—that is, 11/12—the depth will be 15 times 12 (type size plus linespacing), or 15 picas.

Note: For a simpler, more convenient, method of establishing the depth of a column of type, see Pica Rule on page 150.

DEPTH IS 154 POINTS OR 12 PICAS, 10 POINTS Character Counting. Before you can specify type you must calculate the number of typewritten characters in the copy. First, establish the kind of typewriter that was used by counting the number of characters per inch. In this case, it was a pica typewriter, which types 10 characters per inch. Next, take an average line (line 4), and using a ruler, measure it to the nearest inch. Our sample line is five inches long, plus five extra characters. Multiply this line length (5) by the number of characters to the inch (10). This gives you a total of 50 characters. Now add the five characters that went beyond the five-inch mark, and you get 55 characters. Multiply this by the number of lines (13) for a total of 715 characters.

11-point Times Roman set solid.

DEPTH IS 168 POINTS OR 14 PICAS Character Counting. Before you can specify type you must calculate the number of typewritten characters in the copy. First, establish the kind of typewriter that was used by counting the number of characters per inch. In this case, it was a pica typewriter, which types 10 characters per inch. Next, take an average line (line 4), and using a ruler, measure it to the nearest inch. Our sample line is five inches long, plus five extra characters. Multiply this line length (5) by the number of characters to the inch (10). This gives you a total of 50 characters. Now add the five characters that went beyond the five-inch mark, and you get 55 characters. Multiply this by the number of lines (13) for a total of 715 characters.

11-point Times Roman set with 1-point linespacing.

Pica Rule

Figuring the depth of a column of type mathematically is not only time consuming, but can lead to errors. It is much simpler and more accurate to use a pica rule, which is calibrated in points and covers all the more popular sizes, such as 6, 7, 8, 9, 10, 11, 12, 13, and 15. (To get 14 points you simply use the 7-point scale and count every second increment.) When measuring type, these increments represent the baseline-to-baseline measurement and not necessarily the type size; that is, the 11-point increment could represent 11-point type set solid, but it could

also represent 8/11, 9/11, or 10/11.

Pica rules are also used to measure line length. Some, for added convenience, are calibrated in inches as well as in points.

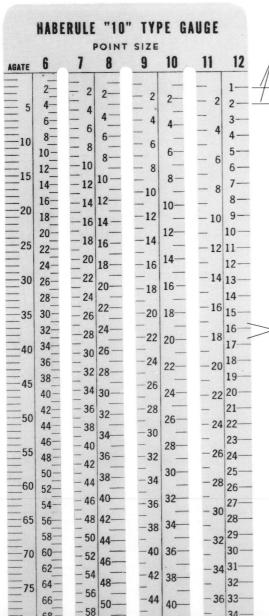

MEASURE

Character Counting. Before you can specify type you must calculate the number of typewritten characters in the copy. First, establish the kind of typewriter that was used by counting the number of characters per inch. In this case, it was a pica typewriter, which types 10 characters per inch. Next, take an average line (line 4), and using a ruler, measure it to the nearest inch. Our sample line is five inches long, plus five extra characters. Multiply this line length (5) by the number of characters to the inch (10). This gives you a total of 50 characters. Now add the five characters that went beyond the five-inch mark, and you get 55 characters. Multiply this by the number of lines (13) for a total of 715 characters.

EACH UNIT REPRESENTS 12 POINTS OR 1 PICA

34

46

Pica rule permits fast and accurate calculations.

68 80

Copyfitting Tabular Matter

Tables and charts are not difficult to copyfit if you approach them properly. First, decide on the overall pica measure. Next, starting at column one, take the longest line and count the number of characters. Do the same for the longest item in each of the columns and then add up the total number of characters. You now have the maximum amount of copy that can fit on one line. Next, decide on the typeface and type size and then refer to a character count table to determine how many picas will be required to set the copy.

Subtract this from the overall pica measure (the width of the entire table). The difference represents the total amount of white space available for margins between the columns. (If the type sets wider than the overall pica measure, consider using a smaller or more condensed typeface, or breaking lines. If the type sets short, and there is too much white space, consider using a larger or more expanded typeface.)

It is important that a table be designed so you can read across it without getting lost. To guide the eye, the designer can use rules, leaders, space, or a combination of these. (See pages 104 and 111, and Tabular Matter on page 106.)

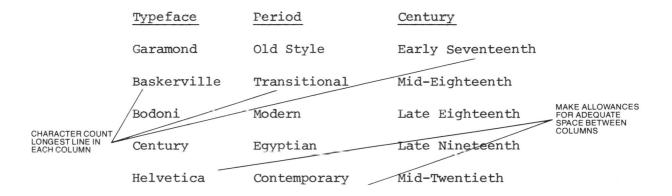

Typewritten copy to be set in table form.

Typeface	Period	Century
Garamond	Old Style	Early Seventeenth
Baskerville	Transitional	Mid-Eighteenth
Bodoni	Modern	Late Eighteenth
Century	Egyptian	Late Nineteenth
Helvetica	Contemporary	Mid-Twentieth

Table typeset in 11/20 Times Roman by 20 picas.

Writing to Fit

In most cases the designer first gets the typewritten copy and then designs the piece. There are times however when the procedure is reversed: the designer designs the piece first and then the copy is written to fit the layout. In this case, the designer will have to specify the number of characters or words to be written.

Specifying the number of characters is the most accurate guide you can give the copywriter. To do this, the designer must first determine the typeface, type size, and measure. By referring to a character count table, as previously outlined, it is possible to establish the number of characters per line. Multiply this by the number of lines and you have the total number of characters to be written.

If you wish to specify the number of words, just divide the total number of characters by five, which is the number of characters in an average English word. Although estimating the number of words is not as accurate as specifying the number of characters, it does give a copywriter a good working estimate.

Let's assume we wish to fill the above area with 11/12 Times Roman. First, we would refer to the character count table on page 142. 11-point Times Roman sets 52 characters to a 20-pica measure. The 20-pica column will contain 20 lines of 11/12 type. Therefore the total number of characters will be 1,040 (20 x 52). Divide by five to get the approximate number of words (208).

Layouts

A layout, or visual, is the designer's approximation of the printed piece. It can vary from a rough sketch, called a "rough," to a tightly rendered comprehensive layout, called a "comp."

One reason for making a layout is so that both the designer and the client can get a general idea of what the job will look like before any typesetting expenses are incurred.

Another reason for making a layout is to give the typographer a visual idea of what is required.

For the layout to be effective, the designer must be able to approximate the look of both text and display type. This is called "comping" type.

Rough layout.

Tight layout, or "comp."

Comping Text Type

When comping text type, it is only necessary to suggest the lines of type, not the individual letters. This is done by drawing two pencil lines for every line of type. The distance between the lines represents the x-height of the specific typeface. All you need is an ordinary pencil, pica rule, T-square, and triangle. Let's make a comp of the copy on page 147, which is to be set in 11/12 Times Roman by 20 picas (see illustration below).

First draw a box 20 picas wide by 14 picas deep. (These lines represent the text area and should be drawn lightly, as they do not

appear on the printed page and can be distracting on the comp.) Next, draw a small dot every 12 points down the left side of the margin. Each dot indicates a line of type plus linespacing; in this case 11 points of type and one point of linespacing. Using the T-square, draw in the lines as shown below. The distance between the pairs of lines represents the x-height of the typeface.

Try to keep all the lines the same weight to create the appearance of type printed on a page. When comping boldface type, just press more heavily on the pencil.

Note: Text type may also be comped using a standard pencil with the lead cut in a chisel shape to match the x-height.

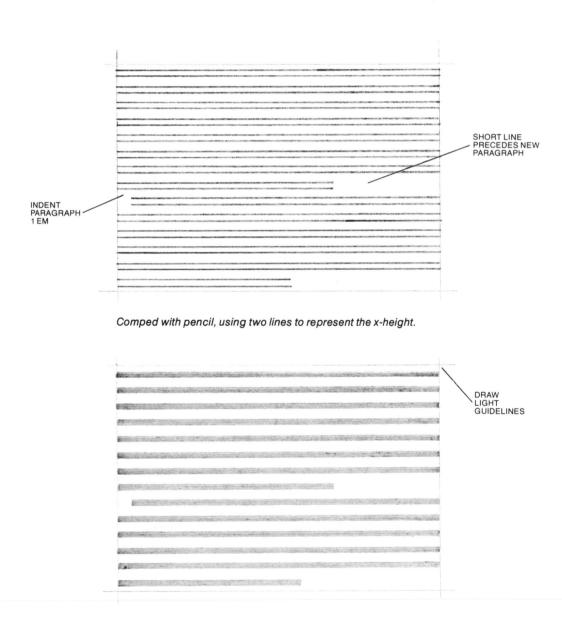

Comped with chisel-point pencil, using a single line to represent the x-height.

Comping Display Type

When comping text type, we only *suggested* the lines of type; with display type, however, the copy must be readable and the typeface recognizable. Each display letter has to be carefully traced.

You will need a tracing pad and a sharp pencil. You will also need a specimen of the typeface you are using, preferably one that shows a complete alphabet of both uppercase and lowercase letters. If some of the letters are missing—and this is often the case—then it becomes necessary to make up these letters from existing ones; for ex-

ample, the letters R from B, and F from E.

First, lightly draw the baseline on the tracing paper. Next, lay the tracing paper over the alphabet to be traced, making sure that the two baselines align. Trace the first letter carefully, then move the tracing paper and start the second letter. As you do this, consider the letterspacing carefully; remember to keep it visually even between the letters. The same applies to wordspacing. (See Letterspacing on page 61 and Wordspacing on page 62.)

When the comp is finished you can either leave it in outline form or fill it in with your pencil. The degree of the finish is usually dictated by the purpose of the comp. If it is

just a spacing guide for the typesetter, the pencil outline is adequate; if it is to be shown to a client for approval you may wish to fill in the letters to create a better appearance.

Note: Printed type is blacker and more assertive than comped type; therefore if you are in doubt about which type size will match your comp, it is often safer to choose the smaller.

Letterforms can be filled in or left as outline, depending on the purpose of comp.

Makeup

When a job is made up, all the elements are set in their correct position according to the designer's layout.

Having a job made up is usually more expensive than having it set in galleys (not made up), and once it is made up design changes can mean additional.cost.

If you are uncertain about the final design you may find it more convenient, and economical, to have the job set in galleys and position the elements yourself in mechanicals.

PHOTOTYPESETTING

Prototypeaeting, athough a recent development, is the most widely used method of typeaeting today. And tike any new technoogy, it has caused its share of confusion. This book is an attempt to explain how photo typeaeting works, clearly and simply, so that designer and nondesigner able will be able to take hill advantage of its enormous potential. To help the reader find the necessary information quickly, the book is presented

Seminology Delgin, Copylifting, and Philodopheeling Sylamin, in norm case and unit remains complete in teach and with the copyling of the copyling of the Although philodopheeling green out of Although philodopheeling green out or references to metal type so as not to conclus the reader. Taken, thouse, included all the important metal type some and to conclus the reader. Taken, thouse, included all some of the information, as well as serviced of the Mazintations, originally appeared in years after books. Surging with Type as for the book is no very vierteded to be a substitute of the copyling with type and the copyling with the production aspects of the Copyling with green and Copyling with Copyling

Job set in galleys.

PHOTO TYPE SETTING

Phototypesetting, atthough a recent development, is the most widely used method of typesetting loday. And like any new technology, it has caused its share of confusion. This book is an attempt to explain how phototypesetting works, clearly and simply, so that designer and nondesigner alke will be able to take full advantage of its enormous potential.

potential.

To help the reader find the necessary information quickly the book is presented in a series of self-contained units that are grouped under four major headings. Terminology, Design. Copyfitting, and Phototypesetting Systems. In some cases information has been repeated so that each unit remains complete in self.

Although phototypesetting grew out of

traditional metal typesetting. I have avoided references to metal type so as not to confuse the reader. I have, however, included all the important metal type terms—many with illustrations—in the glossary.

Some of the information, as well as several of the fusitration, originally appeared in my earlier books Designing with Type and Production for the Graphic Designer, but this book is in no way intended to be a soft the serious student interested in the basec student interested in the basec of Graphic Designer is for the designer companies of the Companies of the

Job made up.

Copy Preparation

Character counting can be simplified if the copy is properly prepared. Copy should be typed double-space on standard $8\frac{1}{2}$ " x 11" bond paper in a column about six inches wide, with a generous margin on the left for typesetting instructions. Each page should have approximately the same number of lines and characters per line. To prevent mixups, every page should be numbered and carry the job title. The word "end" should appear on the last page.

All phases of editing and design should be done on the original manuscript, not a car-

bon or duplicator copy. If there are any corrections, they should be written clearly above the line, preferably in ink. If corrections are extensive, the page should be retyped—typographers charge extra for working with "dirty" copy.

To make copy preparation easier, many clients will type the copy on specially printed sheets of paper that are calibrated across the top in both pica and elite typewriter units. This helps the typist see exactly where to end each line. To further simplify matters, some sheets have a vertical line (or lines) indicating one or several specific line lengths. Some also have numbers running down the left-hand margin to indicate each

double-spaced line. Needless to say, working with copy typed on these sheets makes the job of character counting much easier for the designer.

JOB AND PAGE Craig/l NUMBER

Character counting -- and typesetting -- can be simplified if the copy is properly prepared. Copy should be typed on standard 8½ x 11 bond paper, and on one side of the sheet only. A good column width is about 6", which allows a generous margin on the left for type specifications. The lines should be double-spaced, each having approximately the same number of characters. Each page should contain the same number of lines. Number all pages and include the job title to avoid confusion should the pages get separated. All corrections should be written clearly, above the line, and preferably in ink. If corrections are extensive, the page should be retyped. All editing and design instructions should be made on the original manuscript and not a copy.

Properly prepared copy.

WIDE MARGIN ON LEFT FOR TYPE SPECIFICATIONS

Type Specification Chart

When preparing copy, especially complex copy, it is sometimes handy to have a checklist of the various design decisions that must be made: typeface, type size, measure, wordspacing, letterspacing, etc. After the form is filled out it should be sent to the typographer along with the job. It is also a good idea for the designer to keep a copy in the event that the job has to be matched at some future date or patches have to be set.

A type specification chart is shown below. You may of course wish to make up your own.

Note: Some of the items shown on the chart may affect the cost of the job; for instance, makeup, kerning, hung punctuation, extra proofs, etc. You may wish to check with the typographer before specifying them.

Date:	Job Number:	
Typographer:	System:	
Type (typeface, type size, linespacing,	and measure)	
Type Arrangement		,
Justified		
Unjustified		
Flush left, ragged right	Minimum line	pica
Flush right, ragged left	Minimum line	pica
Centered		
OK to hyphenate		
Letterspacing		
Normal		
Loose		
Tight		
Very tight		
Touching		
Letterspacing acceptable to justify line	□ Yes □ No	
Wordspacing		
Normal		
Loose		
Tight		
Very tight		
If justified, set with units minimum and	d units maximum wordspacing.	

Paragraphs

Indent all paragraphs em(s)

First paragraph flush, indent all others em(s)

All paragraphs flush left with line(s) space between.

Minimum acceptable widow is characters.

Miscellaneous

Kerning

Ligatures

Hung punctuation

Other

Makeup

Make up complete job

Do not make up, but set in galleys

Make up sections indicated

Set patches

Set rules in position

Do not set rules in position

Proofing

Reader's proof		Number of proofs	Number of proofs					
Repro proofs		Number of proofs						
Paper	RC	Stabilization	Other					
Film	Positive	Negative						
	Right-reading	Wrong-reading						
Special proofs								

Special instructions

PHOTO TYPE SETTING SYSTEMS

When you use a typewriter you approximate the phototypesetting process: by striking the keys you provide simultaneous "input" and "output." As you approach the end of each line you determine its length and whether or not to hyphenate the last word. Some phototypesetting systems are basically this simple. Others are more complex.

This section describes the components of a typical phototypesetting machine and compares various phototypesetting systems. If you know what each system can and cannot do, you can match the job to the equipment and better control the quality and the cost.

Basic Components

Although phototypesetting systems vary greatly, they all have three basic components: a *keyboard* for input; a *computer* for making end-of-line decisions; and a *photounit*, or typesetter, for output.

Add to these three basic components a device for editing and correcting, such as a visual display terminal (VDT), and you have a typical phototypesetting system.

Phototypesetting components vary depending on the system: they may be simple or complex; separate or combined into a single master unit.

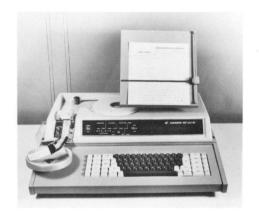

Keyboard, for input.

Computer, for making end-of-line decisions.

Photounit, or typesetter, for output.

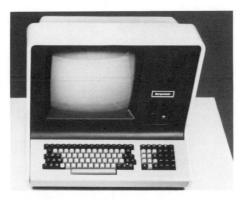

Visual display terminal (VDT), for editing and correcting.

Keyboard/Input

Before copy can be set it must first be typed on a special keyboard. This keyboard is similar to a standard typewriter, except that it has keys to control typeface, type size, letterspacing, wordspacing, and linespacing.

Some keyboards record the copy as it is being typed. After the copy has been recorded, the medium (tape, disc, or card) can be used for either editing or setting type, or it can be stored for future use. Other keyboards are "on-line," that is, the keyboard and the photounit are interconnected, so that the type is set as the operator types

it. (Direct-entry systems are covered more fully on pages 180 and 181.)

On most keyboards the operator can see the words as they are being typed, so if a mistake is made it can be corrected at the keyboarding stage. Some keyboards have a visual display ("soft" copy), while others produce typewritten copy ("hard" copy). Still others have neither and are referred to as "blind" keyboards, but these are rare today.

There are two basic keyboard systems: counting and non-counting. The major difference between the two is that with a counting keyboard end-of-line decisions (hyphenation and justification, or H/J) are made by the keyboard operator, while with a non-

counting keyboard these decisions are made by a computer. The particular system you choose will be dictated by the type of job you are setting. Let's examine both.

Special keys control typeface, type size, letterspacing, wordspacing, etc.

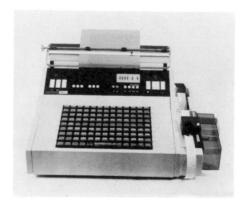

Typewritten, or "hard" copy.

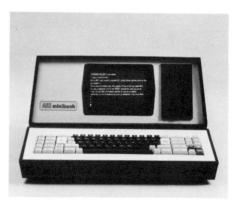

Visual display, or "soft" copy.

END-OF-LINE DECISIONS Hyphenation and Justification

The counting keyboard operator makes the end-of-line decisions when the line he is setting falls within the "justification range" near the end of the measure. It is within this range that the line can be physically justified by the phototypesetting machine. The quality of the setting will be dictated by the quality of the keyboard operator's decisions. Here are some of the questions he must ask himself when justifying a line:

- Can the next word fit on the line or can it be hyphenated, and where?
- If not, do I add extra wordspace and letterspace. If so, where?
- When the line is justified, will the wordspacing be objectionably loose or tight?

COUNTING KEYBOARD

The counting keyboard (also referred to as a "justifying" keyboard) is the more sophisticated and expensive of the two systems. With the counting keyboard, the operator rather than the computer makes all end-of-line decisions. For the best results the operator should not only be familiar with the phototypesetting system, but also have a knowledge of typography.

Before a job can be keyboarded the operator must know the typeface, point size, line length, minimum and maximum word-spacing, etc. As the operator types each line, the unit values of the individual characters are totaled and shown on a scale.

(See page 24 for a detailed discussion of the unit system.) When the line nears the specified measure, the operator is warned by a light or audible signal. At this point the operator decides whether to hyphenate, and if so, where. After the line is completed, a key is punched and the copy is recorded.

Because the end-of-line decisions have been made, the tape (or disc), referred to as a "justified" tape, can go directly to the photounit for typesetting. By the same token, because all the decisions have been made and recorded, if changes are necessary the entire job may have to be re-keyboarded. One change that can be made without re-keyboarding is linespacing. Another is type

size, but any change here will affect the line length proportionately: since the linebreaks are already determined, smaller type sizes will result in shorter lines while larger type sizes will produce longer lines.

Because counting keyboards are operator-controlled, they are used for jobs that include more complex settings, such as tabular material, mathematical equations, scientific formulas, etc.

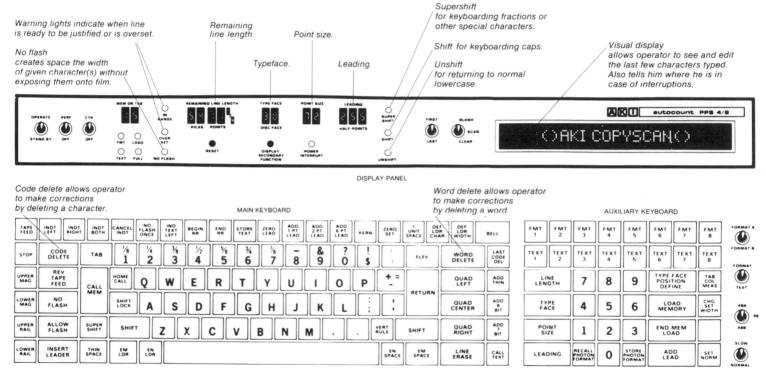

Special instruction keys for coding out the proper magazine (font), changing from roman to italic, to caps, or to boldface, etc.

Regular typewriter keys

Special instruction keys for wordspacing, letterspacing flush left, flush right, etc.

Program formatting keys for setting pre-specified instructions stored in computer memory. For example: "Set text in font #1, 28 picas wide, indent paragraphs 1 em, and hang all end-of-line punctuation."

Counting keyboard.

NON-COUNTING KEYBOARD

The non-counting keyboard (also referred to as a "non-justifying" keyboard) is much simpler and less expensive than the counting keyboard and is used mainly for setting straight copy.

Unlike the counting keyboard, which requires a skilled operator, the non-counting keyboard requires an operator with the ability to type accurately—preferably at high speeds. The operator's only concern is to type the copy and add the basic formatting instructions, such as type style (roman, italic, bold, paragraph indents, etc.). All end-of-line decisions are made by the computer.

As the operator types the copy, the key-

board produces a tape (or disc), commonly referred to as an "unjustified" tape. It is also called an "idiot" tape because it cannot be used to set type until type specifications have been added and the computer has made the end-of-line decisions. By the same token, because there are no type specifications or linebreaks, a single tape can be used to set copy in a number of different typefaces and measures.

Among the advantages of the noncounting keyboard is that copy can be keyboarded in advance of type specifications. For example, if you are working on a large job, copy can be keyboarded as it is received and the type specifications

One of the advantages of the unjustified, or idiot, tape is that copy can be keyboarded in advance of type specifications. If the type specifications are already included, they can be changed before the type is set. Furthermore, the same tape can be used to set a given job in a variety of typefaces and measures.

8/10 HELVETICA

One of the advantages of the unjustified, or idiot, tape, is that copy can be keyboarded in advance of type specifications. If the type specifications are already included, they can be changed before the type is set. Furthermore, the same tape can be used to set a given job in a variety of typefaces and measures.

10/12 PALATINO

One of the advantages of the unjustified, or idiot, tape, is that copy can be keyboarded in advance of type specifications. If the type specifications are already included, they can be changed before the type is set. Furthermore, the same tape can be used to set a given job in a variety of typefaces and measures.

9/11 TIMES ROMAN

Same tape (or disc) used to set same job three different ways.

added later when the job is complete.

Perhaps the major advantage of the non-counting keyboard is input speed. It is estimated that one-third of a counting keyboard operator's time is spent making end-of-line decisions. The non-counting keyboard operator, on the other hand, is free to type continuous copy at maximum speed, leaving it to the computer to determine hyphenation and justification.

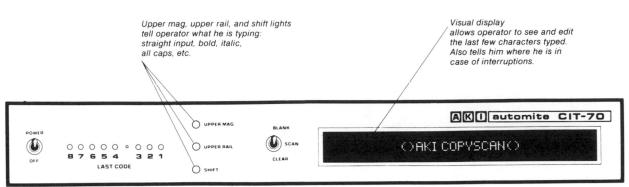

DISPLAY PANEL

Code delete allows operator to make corrections by deleting a character.

KEYBOARD

Word delete allows operator to make corrections by delecting a word.

d Character.						111	IBOAND							-,
REPEAT	CODE		2	3/8 3	4	5% 5	³ ⁄ ₄ 6	7 7	-][& 9	? Ø	() [!	ADD THIN	WORD DELETE (OPT)
ADD 8 BIT	REV TAPE FEED	BELL	\mathbf{v}	E	R	T	Υ	U	1	0	Р	(a -	RETURN OR	QUAD LEFT
ADD 7 BIT	TAPE FEED	SHIFT	A S	D	F	G][J	K	L] ;	,	PLUS ELEVATE	QUAD CENTER
UPPER RAIL	ELEV	SHIFT	z	x	С	v	В	N	M	,	.][l _i	SHIFT	QUAD RIGHT OR UM
LOWER RAIL	THIN SP		EM LDR									EN SPACE	EM	LOWER MAG OR PAPER FEED

Special instruction keys for wordspacing, letterspacing, etc.

Regular typewriter keys.

Special instruction keys for wordspacing, letterspacing, flush left, flush right, center, etc.

Non-counting keyboard.

(Keyboard Input continued)

TAPES AND DISCS

Although there are a variety of ways to record and store copy, most systems use either paper tape, magnetic tape, or discs. Each offers different advantages.

Paper Tape. At present, paper tape is the most widely used recording medium, although this seems certain to change as more manufacturers move to magnetic tape and discs. Paper tape is approximately one-inch wide, and perforated. For each character typed, a unique configuration of holes is punched. Because the holes are permanent, the tape cannot be reused. Also, if corrections are necessary, a new tape must be punched.

Paper tape is not only bulky and difficult to store, but it contains less information in a given space than either magnetic tape or discs.

Magnetic Tape. Magnetic tape, more commonly referred to as "mag tape," can be either open-end (on reels) or in cassettes. Magnetic tape permits a more concentrated recording of information than paper, so although the initial cost is higher, it is less expensive in terms of the amount of information that can be recorded. Furthermore, magnetic tape can be erased and reused. Magnetic tape systems are also faster, quieter, and more reliable than paper systems.

Paper tape, reproduced actual size.

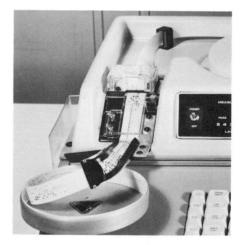

Paper tape.

Discs. Among the discs presently used in phototypesetting the "floppy disc," or diskette, is most widely used—especially with the more popular, inexpensive direct-entry systems. The floppy disc is not unlike a flexible 45 RPM record, except that the information is recorded electronically, in segments, rather than in grooves. Floppy discs are inexpensive, reliable, and can store more information in a given space than either paper or magnetic tape. Some can even be used on both sides. Furthermore, they are easy to store and are reusable.

One of the major advantages of the disc is the ease with which corrections can be made. Paper and magnetic tapes are "serial," which means that in order to get to a certain point on the reel you must start at the beginning and play it through. Discs, on the other hand, have "random access," which means that it is possible to go directly to a specific area.

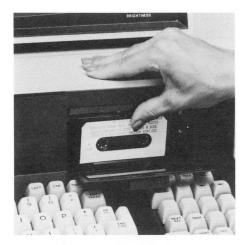

Magnetic tape cassette.

Disc ("floppy disc" or "diskette").

Computer

The computer has a number of functions: making end-of-line decisions; storing information (formatting codes, type instructions, etc.); and controlling the output of the photounit. Some computers are also equipped with special programs that automatically kern, hang punctuation, and adjust letterspacing.

How well a computer performs is dictated by its programming (referred to as "software," to differentiate it from the equipment itself, which is referred to as "hardware"). The more extensively the

computer is programmed and the larger its memory, the better the chances of correct hyphenation, more consistent wordspacing, and generally good typography.

Because clients often wish to change programs, some manufacturers have software that can be updated when necessary. Programs involving major changes are usually handled by the manufacturer, while simple changes, such as formats, are usually made by the typographer.

Not all systems require large computers: simple tasks, such as counting units, can be handled by a counting device, or microprocessor.

Computers not only vary in function,

software, and size, but also in where they are located within the phototypesetting system: they can be part of the keyboard or photounit, or they can be separate (stand-alone).

It is one of the computer's jobs to make sure that al 1 wordbreaks follow the rules of grammar. However, p hototypesetting would be much simpler and require much less-sophisticated equipment if we would just eliminate hyphenation and allow the words to break wherever they may. This would be especially helpful when se tting justified type!

Unfortunately, setting type without the proper hyphen ation would not only create some very unusual wordbre aks, but also require a major adjustment in our reading habits, therefore we shall continue to depend on the computer to hyphenate words in the manner to which we have become accustomed.

Stand-alone computer.

Computer combined with output unit.

Interior of a small computer containing four microprocessor chips.

Computer Programs

There are five kinds of programs that computers use to resolve linebreaks: hyphenless, discretionary, logic, exception dictionary, and true dictionary. However, not all computer programs are of the same quality, nor are all computers designed to use all five programs.

Hyphenless. In this system, no words are hyphenated. The lines are justified by increasing or decreasing the wordspacing, and on some machines, the letterspacing. This can create some very poor wordspacing and letterspacing, which may require the

resetting of lines to create more pleasing results.

Discretionary. Here, the computer needs a little help from the keyboard operator. As the operator types the copy, every word of three syllables and over is hyphenated. The computer, when justifying a line, uses its "discretion" to choose only the hyphenation it needs, disregarding that not needed.

Logic. The computer is programmed with a specific set of rules of hyphenation (hyphenate between double consonants, before *ing*, etc.). All words covered by these rules will be hyphenated accordingly. If the rules cannot be applied, the word will not be hyphenated; instead, the line will be justified by adding

wordspace and/or letterspace. As with the hyphenless system, this can result in cases of poor wordspacing, again making it necessary to reset lines.

Also, there are words that can be hyphenated according to logic, but should not be; for example, *ring* should not be hyphenated *r-ing*. There are many words like this that are exceptions to the rules of hyphenation. For this reason some computers have an exception dictionary.

Exception Dictionary. To avoid poor hyphenation, some of the more sophisticated computers are equipped with an exception dictionary. This dictionary covers words and proper nouns that are exceptions

When setting type hyphenless, the lines are justified by increasing or decreasing the wordspace. On some machines, letterspacing can be adjusted to help justify the line. This can be distracting and the designer should have a sample set before deciding whether he wants to use letterspacing as well as wordspacing. disadvantage of hyphenless setting is that wordspacing can be disastrous, especially if setting type to a short measure.

If composition must be set hyphenless, it is a good idea to consider having it set flush left, ragged right. This way the wordspacing will be even and any excess space will be at the end of the lines where it is not noticeable.

Copy set hyphenless.

The com-puter is basic-ally an adding machine with an ex-pand-ed memory. Its job is to process the unjust-ified tapes and, among other things, to make end--of--line decis-ions. How well it does this is deter-mined by the com-puter's pro-gramm-ing (re-ferred to as "soft-ware." to differ-entiate it from the equip-ment itself, which is re-ferred to as "hard-ware"). The more thor-oughly the com-puter is pro-grammed, the better the chances of correct hyphen-ation, even word-spacing, and gener-ally good typog-raphy.

Copy typed with discretionary hyphens.

to the computer's rules of logic. The computer first searches the exception dictionary. If the word is listed (for example, *ink-ling*), the computer hyphenates accordingly. If the word is not listed, the computer tries to hyphenate it according to the rules of its logic system. If no rule is applicable, the word will not be hyphenated and wordspace will be used to justify the line.

Not all exception dictionaries are the same; some contain only a small number of words while others, with expanded memory capacity, are very extensive. Some computers, with sufficient memory capacity, carry a complete dictionary plus most common proper names in their memory bank. But

these are not in wide use because of their high cost.

True Dictionary. In this system, common words of six or more letters are properly hyphenated and stored as a guide for the computer. If a word is not in the true dictionary, it will not be hyphenated and the line will be justified by adjusting the wordspacing (or letterspacing). The number of words in a true dictionary program (which can be adjusted to suit a particular client's needs) is usually in the range of 12,000.

Note: Regardless of the system and the program, errors will appear. Discretionary systems depend on the operator's ability to put

the hyphens in the correct place. Logic, on the other hand, does not always work because of the exceptions (approximately 40% error), and no exception dictionary can cover every exception. And a true dictionary program is not likely to include all the necessary

Furthermore, the computer cannot distinguish between dual meanings of certain words. For example there is a world of difference between pre-sent and pres-ent, minute and min-ute, or re-cord and rec-ord.

However, errors can be kept to a minimum if you choose a phototypesetting system with a computer that has been programmed for your kind of job.

- Insert a hyphen before the suffixes ing, ed, ly, ty, day.
- Insert a hyphen after the prefixes non, pop, air, mul, gas, gar, cor, con, com, dis, ger, out, pan, psy, syn, sur, sul, suf, sub, mis, ul, un, im, il, ig, eu, es, os, and up.
- Insert a hyphen in a sequence of numbers broken up by commas after a comma.
- Do not hyphenate if less than five letters in a word, or if less than two characters before or after a hyphen. For example: ring not r-ing.
- Do not insert a hyphen before the suffix ing if preceded by one of the letters d, t, or h.
- Do not insert a hyphen before the suffix ed if preceded by one of the letters v, r, t, p, or where v is a vowel.
- Do not insert a hyphen before the suffix ly if the word ends in bly.
- Do not insert a hyphen before the suffix ty if the word ends in hty.

cross-ing not cros-sing

> INK-LING not INKL-ING

THER-APIST not
THE-RAPIST

Some exceptions not covered by logic.

aaaword, abandons, abandonment, abasement, viated, abbreviations, abdicates, abdication, abd ablebodied, abnormality, abnormally, abolish, al ing, aded abrasion, abrasive, abidging, abridgme solutely, absolved, absorbed,, absorbedly, absort er, abstention, abstracted, abstraction, abstractly bundant, abusiveness, academic, academically, ac cent, accentuate, accentuation, acceptability, acce bility, accessible, accessory, accidents, accidentall tion, accolades, accommodates, accommodating, nied, accompaniment, accompanist, accompanyii cordingly, accordionist, accosted, accountability, accrual, accumulate, accumulating, accumulation cusingly, accustomed, acetate, acetone, acetylene achingly, acidic, acidity, acknowledge, acknowledge acquaintance, acquiesce, acquirement, acquisitior batics, acting, actionable, activate, activation, act acumen, acutely, adamant, adaptability, adaptab addiction, additionally, additive, addressee, addre heres, adherence, adhering, adhesion, adhesive, a ing, adjourned, adjournment, adjudge, adjudicate adjustable, adjuster, adjustment, adlib, administe administrator, admirable, admiration, admired, a mission, admittance, admitted, admonishment, ac doption, adoration, adoring, adorning, adornmer dulterate, adultery, adulthood, advanced, advanc advents, adventitious, adventures, adventurer, ad adversity, advertised, advertisement, advertiser, a vised,, advisedly, adviser, advissory, advocate, ac affair, affects, affected, affectionate, affective, affi

Typical rules of logic.

Entries from a true dictionary program.

Photounit/Output

The photounit, or typesetter, is a combination of photographic, electronic, and mechanical components that sets type. Some photounits are so fast that it would take the total input of several keyboard operators to fully utilize its capacity.

To set type, a high-intensity light is flashed through the characters (carried as negative images on the type font), projecting them onto photosensitive paper or film.

In some systems the font remains stationary while the light source moves; in others the font spins, or rotates, while the light

source remains stationary. Photounits also vary in other ways:

Fonts and Image Carrier. Type fonts come in a variety of forms (discs, disc segments, film strips, grids) and are not interchangeable from one system to another. The type font is carried on an image carrier (or image master), many of which hold more than one font, which permits on-machine mixing of typefaces and typestyles. A typical combination of type fonts would be roman/italic or roman/bold. In some cases, manufacturers will make up special combinations based on the client's needs.

Font makeup also varies in the number and variety of characters: some have 86

characters, while others may have 96, 100, 112, 120, etc. Some fonts include small caps while others may have ligatures, foreign accents, special symbols, etc.

Font-Carrying Capacity. The number of typefaces available is dictated by the font-carrying capacity of the machine. For instance, if a machine holds four fonts "online," you have four typefaces to work with. ("On-line" means that not only are the fonts on the machine, but they can automatically be brought into position by keyboard command.)

Font-Changing System. Font changes can be either automatic or manual. Automatic font changes are achieved by keyboard

Mergenthaler Linotype V-I-P.

Dymo Pacesetter Mark IV.

Harris Phototronic TXT.

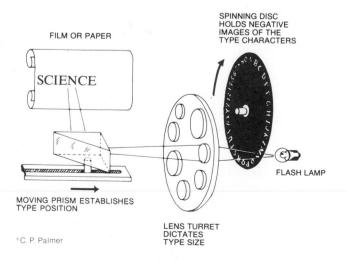

Basic principle of phototypesetting.

command, which means that output is continuous. For each manual change, however, the machine must stop, give a visual or audible signal, and the operator must change the font by hand. This can be time consuming and expensive.

Type Sizes. The number of type sizes the machine is capable of setting and how type-size changes are made varies from one system to another. Some systems operate on a one-to-one ratio; that is, a 7-point font sets 7-point type and an 8-point font sets 8-point type, etc.

Other systems use two or more master fonts that can be reduced or enlarged through a series of lenses to produce a

range of type sizes. For example, an 8-point master may set 5-point through 10-point type while a 12-point master may set 10-point through 36-point type. (The number of masters and range of type sizes vary from system to system.)

Still other systems use a single master and a zoom lens to set all sizes.

Speed. Typesetting speed is based on the number of newspaper lines per minute a machine can set. A newspaper line is straight copy set in 8-point type to an 11-pica measure. Typesetting speeds usually vary between 15 and 200 lines per minute depending on the system.

Note: It is not possible to say which combina-

tion of the above will produce the highestquality type. Also to be considered are such factors as the design of the typeface, the quality of the lens system, the accuracy of the machine in positioning the characters, as well as the general attention to detail that the typographer gives to the job, from input through processing.

Disc segment font.

Film strip font.

Five glass disc fonts on one image carrier.

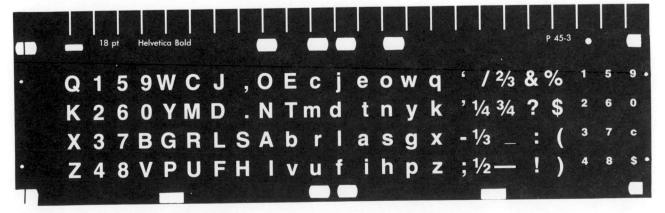

Grid font.

Processors and Proofing Methods

After the type has been set, the paper (or film), contained in a light-tight cartridge, is removed from the photounit and is ready to be developed.

The most common developing method is to place the cartridge into a *processor* that automatically develops and dries the paper. The particular type of processor is dictated by the paper you use: a stabilization processor for stabilization paper and an RC, or lith, processor for RC paper. (See Paper and

Film on page 189.)

Processors can be either daylight-loading or darkroom-loading. Daylight-loading processors, as the name suggests, can be used under normal lighting conditions, while the darkroom-loading processor can only be used under safelight conditions.

Not everyone uses a processor; some people prefer to develop the paper in the traditional way, that is, working in the darkroom with trays of chemicals.

After the type is developed, a proof is made. (See Proofs on page 146.) There are a number of ways to produce proofs, and not only does the cost of the individual proof vary, but also the cost of

the equipment. The most suitable proofing method is dictated by the number of proofs needed and the quality required.

If the job is set on paper, the most common method of producing a reader's proof is the duplicator copy, such as Xerox®. A duplicator copy can be made on equipment available in most offices. For a reproduction-quality proof, Kodak has a PMT® (photomechanical transfer) method and Agfa has a Copyproof® method.

For jobs set on film, the typographer is more likely to use Diazo. This is a photographic contacting process that produces high-quality reading or reproduction proofs in paper or film. The Diazo process can also

Removing cartridge from photounit.

Kodak Ektamatic processor for stabilization paper.

produce proofs on tissues in a variety of colors. Because they are fairly transparent, tissues are ideal for positioning type over art.

Visual Graphic Corporation's Pos One for processing RC paper.

IBM 3400 duplicator being used to make copies of proofs.

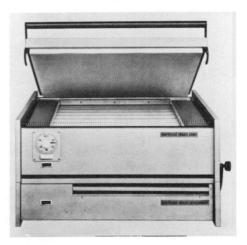

Diazo for making reader's proofs from film.

Editing and Correcting

It has been estimated that it takes thirty times longer to correct a typing error than it does to type something correctly. There are four stages of the typesetting process at which corrections may be made: before keyboarding, during keyboarding, after keyboarding, and after typesetting. Editing and correcting become more costly with each stage, so try to make all changes as early as possible.

BEFORE KEYBOARDING

This is the best and least expensive time to make corrections. First, the copy should be

properly typed, with adequate margins for type specifications and coding (see page 145). Well-organized and cleanly marked copy reduces the possibilities for error. Second, make sure the copy has been carefully edited and approved by all parties.

DURING KEYBOARDING

The next best time to make corrections is during keyboarding. Most keyboards are equipped with a visual display unit that enables the operator to see and correct errors as the copy is being typed. Other keyboards produce hard (typewritten) copy that can be read and corrected as it is being typed.

AFTER KEYBOARDING

There are two methods of editing a tape or disc after keyboarding: visual display terminal (VDT) and line printer.

Visual Display Terminal. The visual display terminal, also called an editing and correcting terminal, is the most widely used method of editing. A typical VDT consists primarily of a video tube for display and a keyboard for typesetting. By playing the tape/disc through a VDT, the operator can get a visual readout of the copy. If an error is found (or if new copy has to be added) the correction is typed on the keyboard and a new, corrected tape/disc is automatically produced. Some of the more sophisticated editing terminals not only make

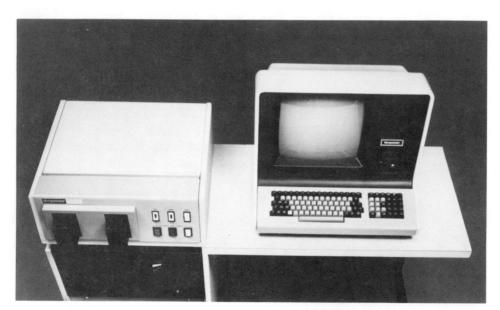

Visual display terminal (VDT).

The VDT produces a visual readout of the copy.

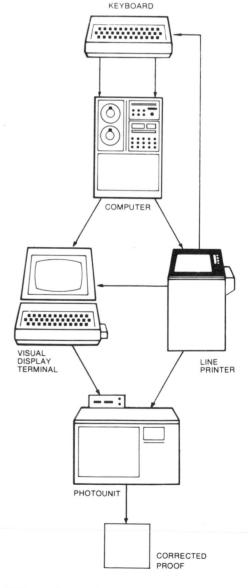

Editing and correcting sequences using either a VDT or a line printer.

the corrections, but will also automatically rejustify any lines that are affected.

Line Printer. A line printer produces a hard-copy printout for proofreading. When the tape/disc is played through a line printer, the job prints out in typewriter-like characters, line for line, each line unjustified (flush left, ragged right) and numbered for reference. By studying the printout it is possible to detect keyboarding errors, poor hyphenation, and widows, and to determine the number of lines that the typeset copy will occupy. The disadvantage of the printout is that command and formatting codes are interspersed with the copy and can be distracting. Also, unless you know how to read these codes there is no way

of distinguishing one typeface, type style, or type size from another.

Line printers, unlike VDTs, do not have keyboards, so corrections must be made on a separate keyboard.

AFTER TYPESETTING

There are two basic methods of making corrections after the type has been set: editing-and-merging or setting patches. **Editing-and-Merging.** First the operator locates the copy to be corrected on the VDT (or line printer printout). The correction is typed on the keyboard, which simultaneously produces a corrected tape or disc. The tape/disc is then run through the photounit, which sets

the type with the correction in position.

Editing-and-merging technique can also be used to delete or insert new copy.

Setting Patches. If the corrections are not extensive, the typesetter will simply set a patch. The corrected word or line is keyboarded and the tape/disc is run through the photounit. Film patches are stripped into the original film by the typesetter; paper patches are pasted into the original reproeither by the typesetter or designer.

Note: Not all errors are caused by designers, copywriters, and keyboard operators; some can be caused by machine malfunction.

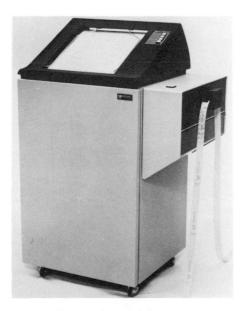

The line printer produces hard copy.

```
abarup 10-26 adv for pms thurs
   oct 26 American Basketball As-
3
   sociation Roundup< < < < <
    By United Press International<
4
5
   It was Dan Issel's birthday
6
   but he blew out the Dallas
7
   Chaps rather than candles.
8
    Issel marked his 24th birth-
9 day Wednesday night with a
10 season-high 29 points as he led
   the Kentucky Colonels to a
11
   116108 victory over the Chaps.
12
   A last period sport sparked by
13
   Issel and Walt Simon, who fin-
14
   ished with 21 points, 11 in the
15
16
   final period, put the game out
17
   of reach.
18
    Collis Jones had 31 points and
19
   16 rebounds, both career highs,
20 for the Chaps.
21
    In the only other American
22
   Baskeetball Association game,
   Joe Caldwell scored 24 points
   and the Carolina Cougars took
   advantage of 23 Denver turn-
26 overs to defeat the Rockets
   118112.
27
   Mack Calvin and Billy Con-
28
   ningham added 22 points each
29
   for the Cougars while Marv
   Roberts led Denver with 24. adv
32
   for pms thurs oct 26
33
     upi 10-26 02:21 ded
```

Printout from a line printer.

Direct-Entry Systems

Direct-entry (also referred to as direct-input) phototypesetting machines have become the most widely used form of phototypesetting today: they are relatively inexpensive, simple to operate, and ideal for setting straight copy. Direct-entry systems are widely used for in-house typesetting operations in such places as offices, agencies and design studios.

Direct-entry systems are basically selfcontained typesetting facilities that combine input, output, and computer (or counting device) in the same unit (on-line): as the keyboard operator types, the copy is set.

Like all phototypesetting systems, directentry machines vary in many ways: the number of typefaces available and the quality of their design; the on-line type size range (usually 5-point through 36-point); the number of units to the em; and the capacity to do tabular work and set foreign languages.

Some of the newer, more complex directentry systems also offer features found only in the larger commercial phototypesetting machines discussed earlier: the capacity to record and store copy; editing, correcting, and updating capabilities; the capacity to utilize additional keyboards (off-line input); increased output speed; automatic kerning; adjustable letterspacing, etc.

Some systems are designed with computer programs (software) that can be updated when necessary. The amount of change possible depends on the system: in some cases the entire program can be changed (usually done by the manufacturer); in other cases, only specific areas can be changed, such as formats covering type specifications and/or repetitive text. Either way, it makes for a more flexible, less-expensive computer system as compared with the larger commercial typesetting machines that work with large, expensive, fixed programs.

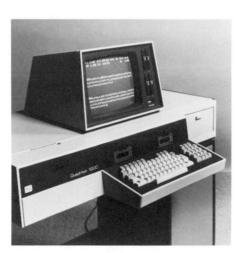

Direct-entry system.

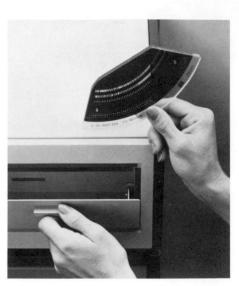

The font is inserted.

Although direct-entry machines have adopted many of these features, they are still basically low-cost units, best suited for inhouse operations.

Input. Keyboarding is simple and can be done by a good typist. The keyboard resembles an electric typewriter plus a small number of command keys for special functions, such as typeface changes, line lengths, and setting type justified and unjustified.

End-of-Line Decisions. With most directentry systems, the typist can either make the end-of-line decisions (hyphenation and justification) or be assisted by a computer (or microprocessor).

Output. With direct-entry, copy is set as it is keyboarded. This means that the speed of the output is dictated by the speed of the input (the keyboard operator's typing speed and ability to make accurate end-of-line decisions). Because the keyboard operator types much slower than the output unit's, capacity to set type, the output unit is idle most of the time. One way to remedy this is to have the computer make all the end-ofline decisions (sometimes referred to as automatic hyphenation, thus permitting the operator to concentrate on high-speed typing. Another way is to use supplementary (off-line) keyboards that feed into the output, thereby fully utilizing its capacity.

Editing. Most machines offer a visual display that permits the typist to see the words as they are typed. The visual display unit varies with the system: some show only a few characters while others are large enough to show blocks of copy, including specifications (font, point size, line length, etc). Some also use a cursor, which is an electronic light indicator designed to aid the editing process. (See VDTs on page 178.)

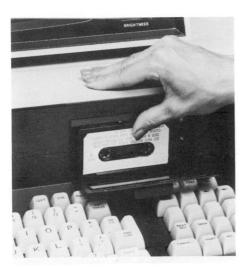

The tape cassette is added.

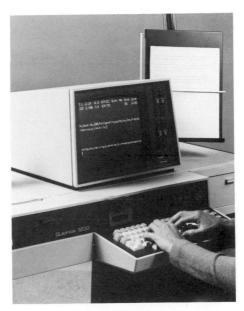

Copy is keyboarded, edited, and set.

The cartridge is removed for processing.

Photodisplay Systems

Photodisplay systems offer a simple, inexpensive method of setting display type. Although some machines can set small sizes, most specialize in sizes larger than 18 point.

The larger type sizes are usually very sharp because the characters on the font are large to begin with (up to 72 point).

Photodisplay machines are manually operated with the typesetting speed dictated by three factors: the speed of the operator, the desired quality of the setting, and whether the spacing is done visually (by the operator) or automatically.

The majority of photodisplay machines set type on 2" continuous rolls of paper or film; other machines set type on wider rolls or sheets. The 2" strip is adequate for setting single lines of type, but it can be a problem if type is to be set on more than one line. In this case, either the operator or the designer has to cut the words apart and position them.

Most photodisplay machines work on the same principle: the type font (a disc, grid, or film strip) is placed on the machine and manually adjusted to bring the character to be set into position. Then a key is pressed and a light beam exposes the character onto the photosensitive paper. After the job has been set, the paper is developed, fixed, and

washed. The development operation takes place either in the machine or in a separate unit

With photodisplay machines, there are two basic systems of letterspacing: visual and automatic. Visual letterspacing permits the operator to see what is being set and to manually control the letterspacing. Automatic letterspacing, on the other hand, is done mechanically and is generally predetermined. In some cases, automatic letterspacing can be adjusted by the operator to make the overall setting looser or tighter.

Not all photodisplay machines are designed to operate under normal lighting conditions. Some, especially those having

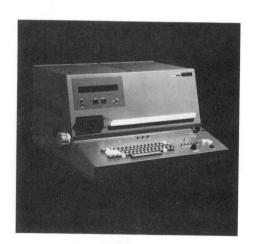

Compugraphic CG7200.

Alphatype Filmotype.

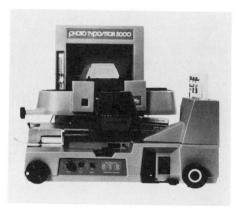

Visual Graphic Corporation Photo Typositor.

visual spacing, can only be operated under safelight conditions to avoid exposing the photosensitive paper to light. On the other hand, automatic letterspacing machines are generally totally enclosed and can be operated under normal lighting conditions.

When you specify letterspacing, use the terms shown in the spacing guide on page 58, for wordspacing, use the terms shown on page 66. See also pages 127 and 134 for information regarding reproportioning display type and special effects.

StripPrinter, Inc. StripPrinter.

VariTyper Headliner 8200.

3M Company Promat.

CRT Systems

The CRT (cathode ray tube) typesetter represents the most advanced state of the typesetting art. CRTs are high-speed phototypesetting machines that use a sophisticated computer and an electronic video tube to "generate" thousands of characters per second.

There are two ways in which CRTs generate type. In the first method, information about the shape of the characters is stored in a computer. To set type, the information is generated electronically from a digital font onto a video tube, from which it is trans-

ferred, via a lens system, onto photosensitive paper or film. In the second method, a photographic font (or negative image master) is used. The machine scans the font, re-creates the type on the video tube, and then transfers it via a lens system onto the paper or film (in some cases microfilm, or printing plate).

CRTs do not set type as complete characters, but as composites of small dots or fine lines. Although invisible to the naked eye, they can be seen with a magnifying glass. Some CRTs can also break down photographs, drawings, paintings, etc. into lines or dots, permitting complete makeup of both type and illustrations.

A unique feature of the CRT system is its capacity to electronically expand or condense a typeface, allowing the designer to control—within reason—the number of characters per line. Type can also be made bolder or slanted (oblique).

Two factors control the quality of CRT type: the number of dots or lines used to form the characters and the speed at which the type is generated. When the type is generated at a slow speed the quality is higher than when the type is generated at a high speed. Often, a typographer will use a high speed for reading proofs and a slower speed for the reproduction proofs.

CRTs are used mainly for newspapers,

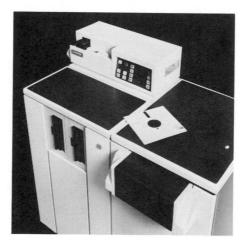

Mergenthaler Linotype Linotron.

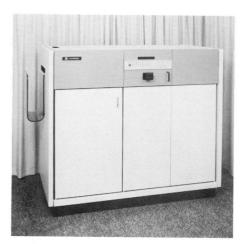

Harris Fototronic.

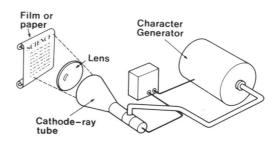

timetables, inventories, phone directories, price lists, and other high-volume typesetting jobs.

Enlargement of character generated as dots.

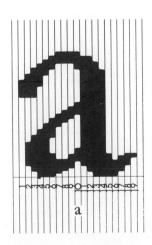

Enlargement of character generated as lines.

The Intertype Fototronic-CRT phototypesetting system is an integrated circuit device designed to give unmatched flexibility and reliability using a new concept for the setting of pages of type images. It makes use of computer technology to generate graphic arts quality photo-composition at rates of thousands of characters per sec-

The Intertype Fototronic-CRT phototypesetting system is an integrated circuit device designed to give unmatched flexibility and reliability using a new concept for the setting of pages of type images. It makes use of computer technology to generate graphic arts quality

The Intertype Fototronic-CRT phototypesetting system is an integrated circuit device designed to give unmatched flexibility and reliability using a new concept for the setting of pages of type images. It makes use of computer

The Intertype Fototronic-CRT phototypesetting system is an integrated circuit device designed to give unmatched flexibility and reliability using a new concept for the setting of pages of type images.

The Intertype Fototronic-CRT phototypesetting system is an integrated circuit device designed to give unmatched flexibility and reliability using a new concept for the setting of

The Intertype Fototronic-CRT phototypesetting system is an integrated circuit device designed to give unmatched flexibility and reliability using a new concept for the setting of pages of type images. It makes use of computer

10-point Times Roman condensed, extended, and obliqued (slanted) electronically.

Area Composition Systems

Area composition systems, also referred to as page makeup systems, photocomposing systems, video layout systems, and composition and layout systems, are basically sophisticated visual display terminals consisting of a keyboard with editing and layout controls, and a cathode ray tube for a video screen. By combining these elements into a single unit, the keyboard operator is able to prepare complete ads with all the elements in position. Here is how it works:

The designer lays out the ad and specifies

the copy as usual. The copy is keyboarded and a tape is produced. The tape is then "read," via a "reader," into a page makeup terminal and the copy appears on the video screen ready for layout. All copy appears the correct size, set width, and line length, with correct linespacing and hyphenation. Although the individual type styles shown on the screen are not exact, they adequately show the relative weight of the type.

Using a keyboard cursor (a light indicator that can be directed anywhere on the screen) and copyfitting keys, the operator positions the copy on the screen, following the designer's layout. If necessary, the operator can edit copy, change type size,

adjust line length, and reposition copy.

When the layout is satisfactory, the operator strikes a key, transmitting the copy and the layout codes to the photounit for composition. The result is a one-piece paper repro ready for mechanicals or a film suitable for platemaking.

Area composition systems are widely used by newspapers for setting retail and classified ads. They are also used for setting directories such as the Yellow Pages. At present, area composition systems are seldom used for advertising agency, book publishing, or commercial work. However, it is not difficult to foresee the system, operated by the designer, replacing tight layouts.

Harris Fototronic high-cost video layout system. Copy appears on screen for makeup. When all the elements are satisfactory, a key is pressed and a tape or disc is made for typesetting.

Harris Fototronic low-cost video layout system.

Compugraphic's Advantage offers an inexpensive mark-up/makeup system.

OCR

OCR, or optical character recognition, is one more way to set type. What makes the OCR unique is the system's capacity to electronically read typewritten copy and convert it into a tape ready for the photounit.

With most phototypesetting systems, a job is actually typed twice: the original copy, typed by the client, must be retyped by the keyboard operator in order to produce a tape or disc. It is this second typing that the OCR eliminates, which not only reduces typesetting costs but also eliminates potential errors introduced during the retyping.

With the OCR system, the copy is typed once, on a special typewriter that has a specially designed alphabet. Formatting codes for type specifications are typed along with the copy, which is then put through a scanner that electronically reads the coded copy, producing a tape ready to operate the photounit.

One of the major advantages of the OCR system is that it does not require an expensive keyboard and a highly trained keyboard operator to produce a tape. Furthermore, once the tape is produced, the job may be set in-house or sent out to a typographer.

Context OCR

Scanner reads typed copy and produces a tape ready to be set.

This is a sample of the OCRB typefont, widely used in the US and Europe for text-reading OCR applications. It is an easily-read font, but is not appropriate for normal correspondence. This font is read by the Context 210 Model page reader.

This is a sample of IBM Courier 72 typefont, one of the most popular standard typewriter typefonts. It is widely used in government, industry, and lawfirm settings. This font can be read by the Context Model 310 page reader.

Paper and Film

There are two types of photographic material used on phototypesetting machines: paper and film. Phototypesetting paper is a smooth paper that has been coated with a light-sensitive emulsion. Phototypesetting film is a clear acetate that has been similarly treated. Type set on paper is black on an opaque white background. Type set on film is black on a transparent background.

The photographic material you choose can affect the quality of the setting. Let's examine each:

PAPER

Photographic paper can be divided into three groups: conventional photographic paper, RC (resin-coated) paper, and stabilization paper.

Conventional Photographic Paper. Conventional photographic paper is a smooth, high-quality paper. After exposure the paper is developed, either manually, using chemicals in a tray, or automatically, using a processor. Manual development is the less expensive process, but it requires longer developing and drying times. Also, conventional photographic paper, if developed manually, is more susceptible to variations and staining than when developed in an au-

tomatic processor. Automatic processors, on the other hand, can be expensive.

Conventional photographic papers are generally too slow for most phototypesetting machines, but they can be used on some photodisplay machines.

RC Paper. (Kodak RC.) Resin-coated paper is similar to conventional photographic paper except that the paper base has been given a special plastic coating. This not only makes the paper more durable, more waterproof, and more resistant to fading, but also more expensive. One advantage of RC paper is that the density of the type is more easily matched from one setting to another—which is very important when the

Paper Positive

Film Positive

Right Reading

Paper Negative

Film Negative

Wrong Reading

How the type is prepared is often dictated by the printing process.

Type set on film.

typographer is trying to produce type of consistent weight.

RC paper can be developed either in a tray or processor. The plastic coating reduces the fixing and washing times, prevents chemical stains, and makes the size of the type more consistent. The trend in the phototypesetting industry is definitely toward RC-type papers.

Stabilization Paper. (Kodak Type S and Agfa TP6.) Stabilization paper is unusual in that it carries some of its developing agents in the emulsion of the paper. To develop the image an activator is used to activate the developing agents. To stop and fix the action a stabilizer is used.

Stabilization paper is not actually stable, and the image can fade within a few days. Also, as some of the chemicals remain with the paper, there is the possibility of staining. Because of these factors, stabilization paper is best suited for quick, turn-around jobs where proofs or mechanicals are not stored for future use. Newspapers are large users of stabilization paper.

Although the price of stabilization paper is about the same as RC paper, the processors are much less expensive. Agfa offers a combination stabilization and RC paper (TP6WP) which combines the quick developing time of stabilization paper with the permanence and stability of RC paper.

FILM

Film is approximately twice as expensive as paper but produces a higher-quality result. The major reason is that the acetate base provides a smoother, more stable surface for the photographic emulsion than paper. The grain of the paper, although fine, can cause perceptible irregularities in the type, especially in typefaces with fine serifs.

Film can be processed in trays or in the same processor used for RC paper.

The designer usually does not come in contact with the actual film. The typographer will supply a paper proof (Diazo, Kodak PMT, or Agfa Copyproof) for proofreading and dummying purposes. Corrections, if any, are

Kodak Versamat processor for RC paper.

Compugraphic dryer for drying paper proofs.

Compugraphic waxer applies wax adhesive to back of repros for paste-up in mechanicals.

indicated on the proof and set by the typographer who then makes up a film mechanical.

Film mechanicals are based on the designer's layout and made up on a light table by a "stripper." Type and illustrations are stripped into position with the aid of a "grid," which is an acetate sheet with black key lines. The stripper uses the grid to position the type and art the same way the designer uses a T-square and triangle.

The designer should be aware that not all phototypesetting machines are designed to accommodate film; some use only paper.

PAPER VS. FILM

If a job is set on paper, the designer must first

make a mechanical, or pasteup. The printer shoots the mechanical and from the film positive (or negative) makes the printing plate.

If the job is set on film, the typographer (or stripper) makes a film mechanical that is sent—via the client—to the printer. The printing plate is made directly from the film mechanical. Because the step of shooting the paper mechanical is bypassed, the type is usually sharper when set on film than when set on paper.

Although no one questions the superior quality of film, this does not mean that it is impossible to set high-quality type on paper. In fact, for most jobs paper is more than

Working with paper proofs on a drafting table.

Working with film proofs on a light table. The stripper is checking the weight of the type with an enlarging glass.

CORRECT EXPOSURE

OVEREXPOSED

UNDEREXPOSED

adequate, especially if you are setting regular type and the job is to be printed on standard paper.

Note: Whether you choose paper or film, be aware that the typographer's failure to control exposure or development can cause variations in the weight (color) of the type. This is particularly serious when setting patches. To insure maximum quality many typographers test their chemicals and processors several times a day.

Another factor to consider is that emulsions can vary from lot to lot. So if a job is started on one lot and finished on another, there may be a difference in the weight of the

type. (This difference can sometimes be overcome by exposure controls on the photounit.)

A densitometer. A means of quality-control, whereby the density (degree of blackness) of the type can be checked.

An optical comparator. A quality-control device that measures the thickness of individual characters by means of a grid calibrated in millimeters (shown enlarged above) to ensure type that is uniform in weight.

A loupe, shown actual size. This is a simple magnifying lens that can also be used to check the quality of type.

Choosing a System

Phototypesetting equipment is produced by a large number of manufacturers, each offering a wide variety of keyboards, computers, output units, and visual display terminals. Some systems are designed for high-speed composition of straight copy, such as newspapers; others are designed for more complex work, such as charts, tabular matter, and textbooks. Add to this a wide range of computer programs, and you can see how difficult it might be to choose the best phototypesetting system for your needs.

Before buying a particular piece of equip-

ment (or choosing a typographer) consider your typesetting needs. It is important that you match the job to the equipment, and the best way to do this is to become familiar with the different phototypesetting systems available. If possible, visit typographers and manufacturers' showrooms to see the actual equipment and study its capabilities: take into account the lens system, how changes are made (manual or automatic), fontcarrying capacity, automatic programs to save keyboarding time, etc. Also, check the quality of the type itself; have a sample set showing your kind of job-not just a line, but a block, so you can judge the type design, color, linespacing, etc.

Another factor to consider when looking for the "right" system is the typesetting limitations of the equipment. Just because a particular machine is capable of setting type as specified does not mean that it is economically advisable to do so. Setting the type may involve complex keyboarding or manual changes that could slow down the typesetting operation and therefore add to the typesetting cost.

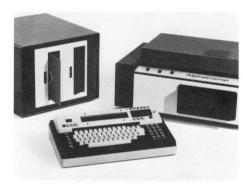

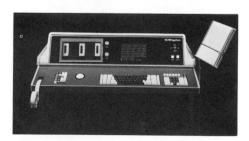

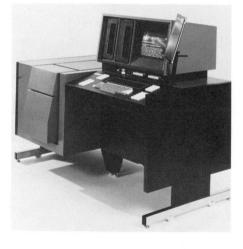

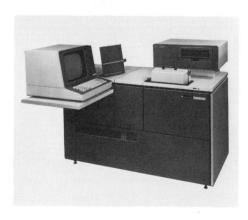

A few of the phototypesetting systems available.

Choosing a Typographer

Ideally, a good phototypographer should have both a strong typographic background and a knowledge of the phototypesetting process. Many phototypesetting shops are run by people who have one but not the other. Some typographers have spent their lives with metal type; they know typography, but not phototypesetting. Others know only phototypesetting; their prices can be attractive, but the problems caused by their unfamiliarity with typography may more than eat

up any savings. In either case, the simplest job can become a disaster, resulting in lost time, aggravation, and a less than acceptable job for the client.

Typographers, like designers, have their own esthetic standards and spend a great deal of time improving equipment and programs in order to attain the highest degree of typographic refinement and control. So when choosing a typographer take the time to spell out your typographic needs; for example, letterspacing, wordspacing, minimum and maximum line lengths, whether hyphenation is acceptable, etc. If these items are not specified, the typographer will follow shop practice, which may or may

not be what you want, and which could result in corrections along with disputes over who pays for them.

Working with a skilled typographer and a good phototypesetting system can help you get the best typography for your money. If a job requires special keyboarding or handwork, a good typographer can often suggest an alternate, less expensive way to get the same results.

Note: Good maintenance eliminates time lost correcting unnecessary errors, therefore choose a typographer with reliable equipment and a strict maintenance program.

The original typographer—a good metal man but not experienced in phototypesetting!

APPENDIX

Point Systems

Metric System

Punctuation

Glossary

Manufacturers of Phototypesetting Equipment

Notes and Credits

Bibliography

Index

Point Systems

There are two major type measuring systems in use today: the *English/American* System, used primarily by the Englishspeaking world, and the *Didot System*, used by the rest of the world. They are very similar.

Until the eighteenth century there was no standardized method of measuring type, there were only vague categories of type sizes and with names such as canon, primer, pica, etc. During the mid-eighteenth century, Pierre Fournier, a French type designer and printer, developed a mathematical system for denoting type sizes. This was later refined by François Ambroise Didot, whose name is used for the system.

During the late-nineteenth century the United States and England developed their own system, which was based upon Didot's. The system, referred to as the English/ American System, was adopted by the United States in 1886 and England in 1898.

Both systems are based on points. The Didot point, however, is slightly larger than the English/American point. For example, a 9-point European Helvetica measures close to 10 points on the English/American System. Apart from this, the only difference that may be of interest to the designer is that in the English/American System twelve points make a pica, while in the Didot System twelve points make a "cicero."

Here is a comparison between the two systems of the more common type sizes:

DIDOT	PICA
4	4.3
5	5.4
6	6.4
7	7.5
8	8.6
9	9.7
10	10.7
11	11.8
12	12.9
14	15.0

It is interesting to note that at present there are a number of European countries that are attempting to convert the present point systems to the metric system, and it may be only a matter of time before we are all measuring type in millimeters.

Metric System

The metric system is a decimal system (based on increments of ten). It is the world's most widely used system of measurement, and it is only a matter of time before it will be fully adopted by the United States. At present, the metric system is already used by many of our major industries and by government agencies, including the Armed Forces. Its adoption is bound to affect phototypesetting and printing, and for this reason we have included the basics of the metric system in this book.

Also, included in this section is a brief discussion of degrees Celsius, also to be adopted shortly by the United States.

BASE UNITS

There are a number of different base units of measurement in the metric system, but we shall concern ourselves with only the three major units: the *meter* (m), for measuring length; the *gram* (g), for measuring weight; and the *liter* (I), for measuring volume.

The value of each of these base units is fixed: a meter is a little longer than a yard; a gram is about one-third of an ounce; a litter is a little more than a quart. But these units are not always convenient; they may be too large or too small, depending on what is being measured. To accommodate the fullest possible range of measurements, a prefix is added to the base units to make them smaller or larger. (See below).

Any prefix may be added to any base unit, although in practice there are some combinations that are seldom, or never, used. Of the above prefixes, the most commonly used are *milli*, *centi*, and *kilo*. Some of the combinations with which you may be familiar are the millimeter (mm), centimeter (cm), kilometer (km), milligram (mg), and kilogram (kg).

	PREFIX AND SYMBOL	DECIMAL EQUIVALENT
One thousand times smaller	milli (m)	.001
One hundred times smaller	centi (c)	.01
Ten times smaller	deci (d)	.1
Base unit		1.00
Ten times larger	deka (da)	10.00
One hundred times larger	hecto (h)	100.00
One thousand times larger	kilo (k)	1000.00

METER

The meter is the metric unit of length and the symbol is "m." The meter is a little longer than a yard (39.37 inches) and for this reason it is often referred to as "the metric yard." It is used to measure anything we now measure in yards or feet: height, rooms, distance, fabric, etc.

The millimeter (mm) is one onethousandths of a meter. It is used for measuring film, tools, machinery, arms and ammunition, etc. It is also used in the graphic arts field to measure the thickness of paper and seems almost certain to replace the point in measuring type and linespacing.

The centimeter (cm) is one onehundredths of a meter. It is used to measure objects we would normally measure in feet or inches: body dimensions, garment measurements, etc. When measuring larger objects, meters and centimeters can be combined; for example, 1 meter 6 centimeters could be either 106 centimeters or 1.06 meters (106 cm or 1.06 m).

The kilometer (km) is one thousand meters, or between one-half and two-thirds of a mile. Kilometers are used wherever we use miles: distance, speed limits, etc.

centimeter .3937 inch meter 39.3700 inches

kilometer 39370.0000 inches or .6214 mile

GRAM

The gram is the metric unit of weight and the symbol is "g." One gram is about one-third of an ounce (.0353 ounce) and is used to weigh anything we now weigh in ounces; for example, butter, cheese, coffee, chocolates, etc.

The *milligram* (mg) is one onethousandths of a gram. It is used for measuring items in very small quantities, such as drugs, chemicals, etc.

The kilogram (kg) is one thousand grams (a little over two pounds) and is used to weigh anything we now weigh in pounds; for example, a bag of potatoes may weigh 2 kilograms. Your body weight will also be measured in kilograms: 6 kilograms (132 pounds); 7 kilograms (154 pounds), etc.

milligram (mg) .0000353 ounce
gram .0353 ounce
kilogram 35.3000 ounces, or 2.2 pounds

LITER

The liter is the metric unit of volume and the symbol is "I." One liter is slightly more than a quart (1.06 quarts). The liter is used to measure anything we now measure in quarts or gallons, from a bottle of beer to a tankful of gas.

The milliliter (ml) is one one-thousandths of a liter and is used to measure items packaged in small quantities, such as soda, toothpaste, shampoo, etc. It is also used for measuring the ingredients in recipes.

liter (1)

1.0567 quarts

milliliter (ml)

.00155 ounces

DEGREES CELSIUS

Degrees Celsius (formerly called degrees centigrade) will eventually be fully adopted by the United States. When this happens all temperatures will be expressed in degrees Celsius rather than the degrees Fahrenheit we are presently using. This will not only affect how we read the atmospheric temperature, but also how we read body temperature, cooking temperature, and the temperature at which photographic paper and film are developed.

There are two key figures to remember in degrees Celsius: 0 degrees, the temperature at which water freezes, and 100 degrees, the temperature at which water boils. Add to these two figures the ideal room temperature of 20 degrees (68°F), a warm summer day of 30 degrees (86°F) and a cool evening of 10 degrees (50°F). Once you become familiar with these few figures it will not be long before you can fill in the gaps.

TYPESETTING SYMBOLS

When setting type, the metric symbols, rather than the full name, should be used (2 km, not 2 kilometers). A space should be left between the number and the symbol, except for degrees Celsius, where no space is left (10°C). A period is never used after a symbol unless it is at the end of a sentence. Symbols are always shown as singular (1 km, 10 km, and 100 km).

Symbols are written in lowercase, with these exceptions: the C for degrees Celsius is capitalized because it is derived from the name of the originator of the system, Anders Celsius. Also, some nations have chosen to capitalize the symbol for liter to avoid confusion between the lower case I and the numeral 1. The U.K. and Europe use an italic lowercase I for the same purpose.

METRIC CONVERSION FACTORS

When you know	Multiply by	To find
inches	2.54	centimeters
feet	30.48	centimeters
yards	0.91	meters
miles	1.61	kilometers
ounces	28.35	grams
pounds	0.45	kilograms
pints	0.47	liters
quarts	0.95	liters
gallons	3.78	liters
degrees Fahrenheit	Subtract 32 and then multiply by 5/9	degrees Celsius
degrees Celsius	Multiply by 9/5 and then add 32	degrees Fahrenheit

Punctuation

(&...!?[?]

The finest typography in the world is useless if the message cannot be understood. Before specifying type, scan the copy to see if it makes sense and if there is an overall consistency of punctuation and style. This is especially important when dealing with display type or any highly visible copy such as heads, captions, lists, and tabular matter. However, do not change punctuation without first discussing it with the copywriter or editor.

Although there are specific rules of punctuation, it is sometimes possible to have more than one acceptable solution. For example, there are "house styles" as well as differences between American and British usage. This means that the preferred punctuation of one client may not be the same as that of another.

Here are the common punctuation marks and their uses. This represents a mere outline, and it is recommended that every designer acquire a copy of an accepted book on style such as *A Manual of Style* (University of Chicago Press) or *Words Into Type* (Appleton-Century-Crofts).

The reader should also consult Design Considerations of Punctuation on page 114.

Period. The period marks the end of a sentence. It is also used with abbreviations, such as Mr., Ms., U.S.A., etc. The period may sometimes be omitted in display type, after heads, and at the end of short captions.

The period is *always* placed inside the closing quotation mark, whether it is part of the quoted matter or not.

The designer said, "We need the type right away."

Colon. The colon is used after a word, phrase, or sentence to introduce a list, series, direct quote, or further amplification. It replaces the phrases "that is" and "for example." A colon is also used in expressions of time and in the salutation of a letter.

When the colon is used as punctuation within a sentence, the clause following the colon starts with a lowercase letter. However, if the colon introduces a series of complete sentences, each sentence should start with a cap. Also, lists, tabular matter, and directional indications (left, right) following a colon may be capped. A colon is placed outside the closing quotation mark unless it is part of the quoted matter.

Serif: the short stroke that projects from the ends of the main strokes.

There are three measurements with which the designer should be familiar: points, picas, and units. The author asks: "Has phototypesetting created a new typography?"

The name of a typeface may differ: Helvetica is also called Claro, Helios, Geneva, or Vega.

The time is 10:30 A.M.

Dear Sirs:

Semicolon. The semicolon represents a pause greater than that marked by a comma and less than that marked by a period. Its most common use is to separate complete and closely related clauses. It is also used to separate items in a list that have internal comma punctuation. A semicolon is placed outside the closing quotation mark unless it is part of the quoted matter.

The difference between one typeface and another is often subtle; it may be no more than a slight difference in the shape of the serif.

Each typeface has a name for identification: it may be that of the designer, Baskerville; or of a country, Helvetica; or it may be simply a name, Futura.

Comma. The comma signifies a pause while reading. It separates independent clauses, words in a series, items in a list, and figures. It also introduces a direct quote. The comma, like the period, is *always* placed inside the closing quotation mark. Here are some samples:

The job is running late, and the designer needs the type right away.

A point is a small, fixed amount of space. Picas, points, and units can be confusing. The test is May 1, 1980.

The designer said, "Just keep on trying," and we could feel the tension in the air.

Question Mark. The question mark is used after any sentence or phrase that asks a direct question. It should not be used after an indirect question ("I wonder if I'll get my type today.") or a question that embodies a request not requiring an answer ("Will you please be seated."). A question mark is placed outside the closing quotation mark unless it is part of the quoted matter.

What is a typeface?

Exclamation Point. The exclamation point indicates strong feeling, surprise, or irony and is used to achieve emphasis. It is placed outside the closing quotation mark unless it is part of the quoted matter.

A typeface refers to a specific design of an alphabet—and there are hundreds!

Quotation Marks. Quotation marks may be single ('') or double ("'"). In modern American usage, single quotes are used only when setting off a quote within a quote. For all other purposes double quotes are used. Quotation marks are used to set off direct quotes; excerpted text; titles of poems, stories, and articles; and to draw attention to a word or phrase.

When quoting excerpted text that is longer than one paragraph, each paragraph opens with a quotation mark but only the final paragraph closes with one.

No quotation marks are necessary if excerpted text is set indented or in a smaller type size.

Commas and periods are *always* set inside the closing quotation mark. All other punctuation is set inside if part of the quote, outside if not.

Sans serif is French for "without serif."

Hyphen. The hyphen is used to join compound words and to indicate a wordbreak at the end of a line. It is also used to separate prefixes and suffixes from the root word.

The non-designer, too, is involved with photo-typesetting.

The type you are now reading is 8-point Helvetica. The job prints out in typewriter-like characters.

En-Dash. The en-dash is slightly longer than the hyphen. It takes the place of the word "to." It also sets off prefixes and suffixes from compound words that are either separate or joined by a hyphen. An en dash is marked for the typesetter like this:

The number of characters in a font is usually 86–120.

It is a wastepaper basket-like container.

Em-Dash. The em-dash is the mark commonly meant by the term "dash." It indicates an abrupt break in thought or speech, and it may be used instead of commas or parentheses to set off a parenthetical clause. An em-dash is marked for the typesetter like this:

This book offers the designer—and nondesigner—a complete guide to phototypesetting.

To set lines of type equal in length—or justified—the space between words must be adjusted.

2-Em-Dash. The two-em-dash is used after an initial letter to represent a proper noun. It is marked for the typesetter like this:

Helvetica was designed by Mr. M--- in 1957.

3-Em-Dash. The three-em-dash is used to avoid repetition in bibliographies when there is more than one book by the same author. After the initial listing, the author's name is indicated by a three-em-dash. It is marked for the typesetter like this:

Craig, James. Designing with Type
———. Phototypesetting: A Design Manual
———. Production for the Graphic Designer

Parentheses. Parentheses are used to enclose matter which is not essential to the meaning of the sentence. They may also be used to enclose "asides" by the author as well as references in the text.

Some typestyles are created by varying the weight (thickness of stroke).

Brackets. Brackets are used to indicate parentheses within parentheses. They are also used to enclose editorial interpolations (comments, queries, explanations, corrections, or directions inserted into the text).

(See Designing with Type [2nd ed.].)

"A complete, graphically illustrated guide to phonotypesetting [sic]."

Ellipsis Points. Ellipsis points (or ellipses) are three periods set in a row. They indicate suspended thought, an omission in excerpted text, and in fiction, a pause in speech or thought. When omitting copy from an incomplete sentence, there should be a space before the final word and the first ellipsis point. When omitting copy after a complete sentence, the final word should be immediately followed by four points, the first of which is the period that ends the sentence.

"A font is a complete alphabet of one size of one typeface. . . . The number of characters in a font varies . . ."

Slash. A slash (also called a shilling mark or slant) between words indicates that the reader may choose between them. A slash may also be used in presenting numbers and tabular material, and in setting built-up fractions.

You can mix roman with italic and/or boldface.

Braces. Braces are used to join two or more lines of type. They come in a range of sizes to accommodate any number of lines.

Garamond
Bembo
Poliphilus
Blado
Old Style typefaces

Asterisk. An asterisk after a word or sentence indicates that further information, or a reference, may be found in a footnote. * They are placed after all punctuation except an em-dash and a closing parenthesis if the matter referred to is within the parentheses. If there is more than one instance on the same page where a footnote is called for, a dagger or other reference mark is used. If more are needed, double marks are used.†

†See Reference Marks in the Glossary for a complete list.

^{*}The footnote is always preceded by an identical reference mark.

Glossary

AA. Abbreviation of "Author's Alteration." It is used to identify any alteration in text or illustrative matter which is not a PE (Printer's Error).

Accent. Mark over, under, or through a character, as a guide to pronunciation.

Name	Example
Acute	é
Breve	ĕ
Cedilla	Ç
Circumflex	ê, ô
Grave	è
Macron	ā
Tilde	ñ
Umlaut	ë, ö, ü

Acetate. Transparent plastic sheet placed over a mechanical for overlays.

Acute. Accent above a letter: é.

Adaptable fraction. A fraction made up of three separate parts: numerator, slash, denominator. This method is often used when setting large text-size fractions.

Advertising rule. Thin rule used to separate one magazine ad from another.

Agate. Unit of measurement used in newspapers to calculate column space: 14 agate lines equal 1 inch. (Agate was originally the name of a 5½-point type.)

Alignment. Arrangement of type within a line so that the base of each character (excluding descenders) rests on the same imaginary line, i.e. base-aligning. Also the arrangement of lines of type so that the ends of the lines appear even on the page; that is, flush left, flush right, or both.

All in. All copy and proofs are available.

Alphanumeric. Contraction of "alphabet and numeric" that refers to any system combining letters and numbers.

Alphasette. Phototypesetting system manufactured by Alphatype Corporation.

Alphatype. Phototext and display composition system manufactured by Alphatype Corporation.

Alterations. Any change in copy after it has been set. See AA and PE.

Ampersand. Name of the type character "&" used in place of "and." Derived from the Latin *et.*

Analogue computer. Type of computer that represents numerical quantities as electrical or physical variables, used in the industry to turn valves or machinery on and off. Such computers are not used in phototypesetting. See Digital computer.

Arabic numerals. Ten figures, zero and numerals 1 through 9, so called because they originated in Arabia, as opposed to Roman numerals.

Art. All original copy, whether prepared by an artist, camera, or other mechanical means. Loosely speaking, any copy to be reproduced.

Artwork. See Art.

Artype. Brand name for a self-adhering type printed on transparent sheets that can be cut

out and placed on artwork. Available in a wide range of type styles and sizes.

Ascender. That part of the lowercase letter that rises above the body of the letter, as in *b*, *d*, *f*, *h*, *k*, *l*, and *t*.

Asterisk. Reference mark used in the text to indicate a footnote. Also used to indicate missing letters or words.

Asymmetrical type. Lines of type set with no predictable pattern in terms of placement.

Author's alteration. See AA.

Author's proof. Proof to be sent to the author for the purpose of having it returned marked "OK" or "OK with corrections."

Backbone. Bound edge, or spine, of a book. **Backslant.** Typeface which slants backward; that is, opposite to italic. This effect can be obtained on some photodisplay machines.

Bad break. Incorrect end-of-line hyphenation, or a page beginning with either a widow or the end of a hyphenated word.

Bad copy. Any manuscript that is illegible; improperly edited, or otherwise unsatisfactory to the typesetter. Most typographers charge extra for setting type from bad copy.

Bad letter. Any letter that does not set or print clearly.

Baseline. Imaginary horizontal line upon which all the characters in a given line stand.

Bastard size. Non-standard size of any material used in the graphic arts.

Binary. In computer systems, a base-2 numbering system using the digits 0 and 1.

Binary code. In computer systems, a code that makes use of two distinct characters, usually 0 and 1.

Bits. In computer systems, the smallest units of information. Each represents one binary digit, 0 or 1. The word is derived from the first two letters of *binary* and the last letter of *digit*.

Black letter. Also known as *gothic*. A style of handwriting popular in the fifteenth century. Also, the name of a type style based on this handwriting.

Bleed. Area of plate or print that extends ("bleeds" off) beyond the edge of the trimmed sheet. Applies mostly to photographs or areas of color. When a design involves a bleed image, the designer must allow from ½" to ½" beyond the trim page size for trimming. Also, the printer must use a slightly larger sheet to accommodate bleeds.

Blind keyboard. In photocomposition, a tape-producing keyboard which has no visual display and which produces no hard copy.

Block. In computer systems, a group of words, characters, or digits held in one section of an input/output medium and handled as a unit.

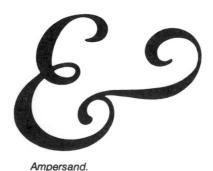

Blow-up. Enlargement of copy: photograph, artwork, or type.

Blue line. Blue nonreproducible line image printed on paper showing the layout. Used for a stripping guide or for mechanicals. Because the blue lines are nonreproducible, they do not show when the layout sheets are photographed for platemaking.

Blueprints. Also called *blues*. Blue contact photoprints made on paper, usually used as a guide for negative assembly, preparing layouts, or as a preliminary proof for checking purposes.

Body. In composition, the metal block of a piece of type that carries the printing surface. It is the depth of the body that gives the type its point size. In printing, a term that refers to the viscosity, consistency, and flow of a vehicle or ink.

Body matter. Also called *body copy.* Regular reading matter, or text, as contrasted with display lines.

Body size. Depth of the body of a piece of type measured in points.

Body type. Also called *text type*. Type, from 6 point to 14 point, generally used for body matter.

Boldface. Heavier version of a regular typeface, used for emphasis. Indicated as *BF*.

Booklet. Small book, usually having a soft cover

Borders. Decorative lines or designs available in type, used to surround a type form or page.

Boxed, or boxed in. Matter enclosed by rules or borders.

Brace. Character used to embrace or connect lines, particularly in mathematics: }.

Brackets. Pair of marks used to set off matter extraneous or incidental to the context: [].

Break for color. To indicate or separate the parts of a mechanical to be printed in different colors.

Break in copy. Term meaning that part of the copy is missing.

Breakline. Short line, usually at the end of a paragraph.

Breve. Accent above a letter: ē.

Broadside. Large printed sheet folded for mailing.

Brochure. Pamphlet bound in the form of a booklet, usually consisting of eight or more pages.

Brownprint. Also called a *brownline* or *Van Dyke*. A photoprint made from a negative and used as a proof to check the position of the elements before the printing plate is made.

Buffer. In computer systems, a data-storage area situated between computer units. It may be a piece of hardware, an area of memory, a disc, or a tape.

Built fraction. Fraction made up from two or more characters. For example, 3/16 would be made from a 3 followed by a / followed by a 16, as opposed to a piece fraction.

Built-up letter. Letter in which the outline is drawn first and then filled in.

Bulk. Thickness of printing papers, measured by pages per inch (PPI).

Butted lines. Two or more linecast slugs placed side by side to produce a single line of type.

Byte. In computer systems, a group of adjacent *bits* operated on as a unit and usually shorter than a word. It can be one complete character.

C. & s.c. See Caps and small caps.

California job case. Tray in which handset type is stored and from which it is set. The individual cubicles are arranged for a minimum of motion and are sized to accommodate letters in quantities related to frequency of use.

Calligraphy. Elegant handwriting, or the art of producing such handwriting.

Camera-ready art. Copy assembled and suitable for photographing by a process camera with a minimum number of steps.

Capitals. Also known as caps or uppercase. Capital letters of the alphabet.

Caps and small caps. Two sizes of capital letters on one typeface, the small caps being the same size as the body of the lowercase letters. Indicated as *c&sc.* LOOKS LIKE THIS.

Caption. Explanatory text accompanying illustrations.

Cardinal numbers. Normal sequence of numbers, one, two, three, as compared with ordinal numbers, first, second, third, etc.

Carry forward. To transfer text to the next column or page.

Case. Type tray. Each character in a font of type has its own section in the tray, called a *type case*. Also, the covers of a casebound or hardcover book.

Case fractions. Also called *solid fractions*. A small fraction (as opposed to a large fraction) that is available as a single character (as opposed to a piece fraction).

Casting. Typesetting process in which molten metal is forced into type molds (*matrices*). Type can be cast as single characters or as complete lines. Also, the casting of metal printing plates (*stereotypes*) from matrices (*mats*) for newspaper or book work.

Casting-off. Calculating the length of manuscript copy in order to determine the amount of space it will occupy when set in a given typeface and measure.

Cathode ray tube (CRT). In phototypesetting, electronic tube used to transmit letter images, in the form of dots or lines, onto film, photopaper, microfilm, or offset plates.

Cathode ray tube display. Another term for a visual display terminal (VDT).

Cedilla. Accent positioned under the c to indicate that it should be pronounced as an s: c.

California job case.

Composing stick.

Centered type. Lines of type set centered on the line measure.

Center spread. See Spread.

Central processing unit. Section of the computer that controls the interpretation and execution of instructions.

Chad. In phototypesetting, the paper waste resulting from holes being punched in paper tape or cards.

Chapter heads. Chapter title and/or number of the opening page of each chapter.

Character count. Total number of characters in a line, paragraph, or piece of copy to be set in type.

Character generation. In CRT phototypesetting, the projection or formation of typographic images on the face of a cathode ray tube, usually in association with a highspeed computerized photocomposition system.

Character grid. See Matrix.

Characters. Individual letters, figures, punctuation marks, etc., of the alphabet.

Characters-per-pica (CPP). System of copyfitting that utilizes the average number of characters per pica as a means of determining the length of the copy when set in type.

Chase. In letterpress printing, the rectangular steel frame into which type and engravings are locked up for printing.

Cicero. Typographic unit of measurement predominant in Europe; approximately the same as our pica.

Circulating matrix. In composition, the mold (matrix) from which Linotype and Intertype linecasting machines cast type. Called "circulating" because the matrices are automatically returned to the magazine for reuse.

Circumflex. Accent positioned over the character: ê.

Clean proof. Proof containing no corrections.

Close matter. Type set solid and with very few breaks.

Close spacing. Type set with very little space between words.

Close-up. To bring together by removing space. Indicated like this:

Cold type. Term used generally to describe type set by means other than casting, which is referred to as *hot type*. More specifically used to describe typewriter or strike-on composition rather than phototypesetting. Should not be used as a synonym for phototypesetting.

Colophon. Inscription in a book that contains information relating to its production. Usually placed at the end of the book.

Column inch. Publication measurement based on a space one column wide and one inch deep.

Column rule. Rule used to separate columns of type.

Command. In phototypesetting, the portion of a computer instruction that specifies the operation to be performed. For example,

what typeface, point size, linespacing, etc. is required.

Comp. See Comprehensive.

Composing room. That part of a typesetting shop or a printing plant in which type is set, or composed.

Composing stick. In metal composition, a metal traylike device used to assemble type when it is being set by hand. It is adjustable so that lines can be set to different measures.

Composition. See Typesetting.

Compositor. Also called *typesetter* or *typographer.* A person who sets and arranges type, either by hand or machine.

Comprehensive. More commonly referred to as a *comp*. An accurate layout showing type and illustrations in position and suitable as a finished presentation.

Computer. Device for performing sequences of arithmetic and logical processes used in typesetting to store information and make the mathematical, grammatical, and typographic spacing and end-of-line decisions, i.e., hyphenation and justification.

Computer program. Series of instructions prepared for the computer.

Computerized composition. Sometimes (erroneously) called *computer composition*. Composition produced with the aid of a computer, which when properly programmed speeds up the mathematical decisions needed to drive a typesetting machine. An unjustified ("idiot") tape is produced on a keyboard and subsequently run through a computer which instantaneously adds up the set widths of every character and space on the line, makes all the end-of-line decisions such as hyphenation and justification, and then produces (outputs) a second, justified, tape used to drive the phototypesetter (or metal linecasting machine).

Condensed type. Narrow version of a regular typeface.

Contact print. Photographic print made by direct contact as opposed to enlargements or reductions made by projection where there is no direct contact. Prints are made from a film negative (or positive) in direct contact with photographic paper, film, or printing plate. The size is a one-to-one relationship. Contact prints are usually made on a vacuum frame (contact printing frame). See also Projection and Reflection.

Contact printing frame. See Vacuum frame.

Continuous-tone copy. Any image that has a complete range of tones from black to white, such as photographs, drawings, paintings.

Contraction. Shortening a word by omitting letters other than the first and last.

Control tape. Tape that contains control information such as formats, parameters, set-widths, etc. As distinct from the text or data tape.

Copy. In design and typesetting, typewritten copy. In printing, all artwork to be printed:

type, photographs, illustrations. See also Continuous-tone copy and Line copy.

Copyfitting. Determining the area required for a given amount of copy in a specified typeface.

Counter. Space enclosed by the strokes of a letter, such as the bowl of the *b*, *d*, *p*, etc.

Counting keyboard. In phototypesetting, an input keyboard that adds up the unit widths of the characters and spaces set and indicates the space used and the space remaining in a line. The keyboard operator must make all end-of-line decisions regarding hyphenation and justification. The counting keyboard produces a perforated justified paper tape used to drive a typesetting machine. See also Non-counting keyboard.

CPI. Characters Per Inch. The measurement of the packing density of a magnetic tape, drum, disc or any linear device that information is recorded on.

CPS. Characters Per Second. A measurement referring to the output speeds of phototypesetting equipment.

Crop. To eliminate part of a photograph or illustration.

Cross head. Heading that crosses over one or more columns of text.

CRT. See Cathode ray tube.

Cursives. Typefaces that resemble handwriting, but in which the letters are disconnected.

Cutoff rule. Hairline that marks the point where a block of type moves from one column to another, or the end of a story in a column of type. Also, in newspapers, the horizontal dividing line between typographic elements.

Cut-out lettering. Self-adhering transfer type carried on acetate sheets that is cut out and placed on the working surface. Examples are Formatt and Letraset.

D

Dagger. Second footnote reference mark after the asterisk. Looks like this: †.

Data. General term for any collection of information (facts, numbers, letters, symbols, etc.) used as input for, or desired as output from, a computer.

Data bank. Mass storage of information which may be selectively retrieved from a computer.

Data processing. Generic term for all operations carried out on data according to precise rules of procedure. The manipulation of data by a computer.

Deadline. Time beyond which copy cannot be accepted.

Dead matter. Type that is not to be used again, as compared with live matter.

Decimal equivalents. Here are some of the more common fractions that you might be called upon to change into their decimal equivalents:

Six	teenths	
1/16	.0625	
3/16	.1875	
5/16	.3125	
7/16	.4375	
9/16	.5625	
11/16	.6875	
13/16	.8125	
15/16	.9375	
	Eighths	
1/8	.125	
3/8	.375	
5/8	.625	
7/8	.875	
Quarters	, Thirds, Halves	
1/4	.250	
1/3	.333	
1/2	.500	
2/3	.666	
3/4	.750	

Definition. Degree of sharpness in a negative or print.

Delete. Proofreader's mark meaning "take out." Looks like this:

Descenders. That part of a lowercase letter that falls below the body of the letter, as in q, j, p, q, and y.

Diatype. Phototypesetting machine manufactured by H. Berthold A.G., Germany.

Diazo. Photographic proofing process used to produce photoproofs and high-quality photorepros from film positives. The specially coated Diazo process paper is exposed in contact printing to ultraviolet light and chemically (ammonia) developed.

Didot. Typographic system of measurement used in the non-English-speaking world. Comparable to our point system.

Digital computer. Computer that represents and processes Information consisting of clearly-defined, or discrete, data by performing arithmetic and logical processes on these data. As opposed to the *analogue computer*.

Dimension marks. L-shaped points or short marks on mechanicals or camera copy outside the area of the image to be reproduced, between which the size of reduction or enlargement is marked. Looks like this:

Direct-impression composition. See Typewriter composition.

Dirty copy. See Bad copy.

Disc. In phototypesetting, the circular image-carrier of negative type fonts.

Discretionary hyphen. Hyphen that is keyboarded with the copy, which may or may not be used in the printed matter.

Display type. Type that is used to attract attention, usually 18 point or larger.

Distribution. In metal type composition, the act of returning the type, leads, rules, slugs, furniture, and other printing materials to their storage places after use.

Dot leaders. Series of dots used to guide the eye from one point to another.

Downtime. Time interval during which a device (typesetting equipment, printing

Diatype.

Em-quad.

En-quad.

3-to-the-em.

4-to-the-em.

5-to-the-em.

press, etc.) is malfunctioning or not operating; or the time spent waiting for materials, instructions, O.K.'s, etc., during which work is held up.

Drop initial. Display letter that is inset into the text.

Dummy. Preliminary layout of a printed piece showing how the various elements will be arranged. It may be either rough or elaborate, according to the client's needs.

Duplex. In linecaster machines, a matrix that carries two molds. Also refers to the character that occupies the secondary position in a duplex matrix.

E

Editing. Checking copy for fact, spelling, grammar, punctuation, and consistency of style before releasing it to the typesetter.

Editing terminal. Also called an editing and correcting terminal. In phototypesetting, a tape-operated visual display unit (VDT), using a cathode ray tube on which the result of keyboarding (captured on tape) is displayed for editing purposes via its attached input keyboard prior to processing the copy in a typesetting machine.

Electronic scanner. Photoelectric equipment for scanning full-color copy by reading the relative densities of the copy to make color separations. The scanner is capable of producing negative or positive film either screened or unscreened. The scanner can only separate copy that is thin enough to be wrapped around a drum, therefore limiting copy to transparencies and photographic prints. In printing, refers to an electric "eye" on a press that scans the printed sheet as it passes through the press for the purpose of register control, quality control, ink density, and register for cutoff, etc.

Elite. Smallest size of typewriter type: 12 characters per inch as compared with 10 per inch on the pica typewriter.

Ellipses. Three dots (...) that indicate an omission, often used when omitting copy from quoted matter.

Em. Commonly used shortened term for *em-quad*. Also, a measurement of linear space, or output, used by typographers, i.e., how many ems does the copy make?

Em-dash. Also referred to as a *long dash*. A dash the width of an em guad.

Em-quad. Called a *mutton* to differentiate it from an *en-quad*, called a *nut*, which is one-half the width of an em. In handset type, a metal space that is the square of the type body size; that is, a 10-point em-quad is 10 points wide. The em gets its name from the fact that in early fonts the letter *M* was usually cast on a square body.

Em-space. Space the width of an *em-quad*. **Emulsion.** In photographic processes, the photosensitive coating that reacts to light on a substrate.

Emulsion side. Dull, or matte, emulsion-coated side of photographic material, as opposed to the glossy side.

En. Commonly used shortened term for en-quad.

En-dash. A dash the width of an en quad. Used to take the place of the word "to," as in "from 1978–79."

End-of-line decisions. Generally concerned with hyphenation and justification (H/J). Decisions can be made either by the keyboard operator or by the computer.

Enlarger font. Negative film font used by Alphasette to produce type sizes larger than 16 or 18 point.

En-quad. Also called a *nut*. The same depth as an em but one-half the width: the en space of 10-point type is 5 points wide.

Estimating. Determining the cost of typesetting a job before it is undertaken.

Exception dictionary. In computer-assisted typography, that portion of the computer's memory in which exceptional words are stored. Exceptional words are those words which do not hyphenate in accordance with the logical rules of hyphenation. For example, *ink-ling* would be an exceptional word since computer hyphenation logic would break it *inkl-ing*.

Exposure. In photography, the time and intensity of illumination acting upon the light-sensitive coating (emulsion) of film or plate.

Extended. Also called *expanded*. A wide version of a regular typeface.

Face. That part of metal type that prints. Also, the style or cut of the type: typeface.

Family of type. All the type sizes and type styles of a particular typeface (roman, italic, bold, condensed, expanded, etc.).

Feet. That part of a piece of metal type upon which it stands.

Filler. Any copy used to fill in a blank area.

Film advance. Distance in points by which the film in the photounit of a phototypesetting machine is advanced between lines. A film advance of 11 points for a 10-point font means that the text is set with 1-point leading. A film advance of 9 points for a 10-point font results in "minus leading."

Film makeup. See Film mechanical.

Film mechanical. Also called a *photomechanical*. A mechanical made with text, halftones, and display elements all in the form of film positives stripped into position on a sheet of base film. A film mechanical is the equivalent of a complete type form; from the film mechanical photorepros or contact films are made for the platemaker.

Film processor. Machine which automatically processes sensitized and exposed film and/or paper: develops, fixes, washes, and dries.

First proofs. Proofs submitted for checking by proofreaders, copy editors, etc.

First revise. Also called *corrected proof*. The proof pulled after errors have been corrected in first proof. Additional corrections may call for second, third (or more) revises.

Fit. Space relationship between two or more letters. The fit can be modified into a "tight fit" or a "loose fit" by adjusting the *set-width*.

Fixing. Process by which a photographic image is made permanent.

Flat. Assemblage of various film negatives or positives attached, in register, to a piece of film, goldenrod, or suitable masking material ready to be exposed to a plate. Also, when referring to printed matter, flat refers to a lack of contrast and definition of detail, as opposed to sharp, or contrasty.

Flop. To turn over an image (e.g., a halftone) so that it faces the opposite way.

Flush left (or right). Type that lines up vertically on the left (or right).

Flyer. Advertising handbill or circular.

Folder. Printed piece with one or more folds.

Folio. Page number. Also refers to a sheet of paper when folded once.

Font. Complete assembly of all the characters (upper and lowercase letters, numerals, punctuation marks, points, reference marks, etc.) of one size of one typeface: for example, 10-point Garamond roman. Font sizes (characters in a font) vary from 96 to 225, depending on the makeup of the font. Special characters (those not in a font) are called *pi* characters.

Form. In letterpress, type and other matter set for printing, locked up in a *chase*, from which either a printed impression is pulled or a plate is made. In offset, refers to the *flat*. Also refers to a printed piece or document containing blank spaces for the insertion of details or information and designed for use in office machines.

Format. General term for style, size, and overall appearance of a publication. Also, the arrangement or sequence of data.

Formatt. Brand name for a self-adhering type, printed on acetate sheets to be cut out and applied to the mechanical.

Formatting. In phototypesetting, translating the designer's type specifications into format, or command, codes for the phototypesetting equipment. Formatting is gradually replacing markup.

Fotosetter. Trade name for a first-generation, circulating-matrix phototypesetting machine manufactured by Harris-Intertype. No longer made, but about 100 still in use.

Fototronic. Trade name for a line of secondand third-generation phototypesetting machines manufactured by Harris-Intertype, now Harris Corp.

Fototronic CRT. Trade name for a thirdgeneration phototypesetting system incorporating high-speed cathode-ray-tube technology, manufactured by Harris Corp.

Foundry lockup. Form properly squared and tightly locked up for making molds for electrotypes, stereotypes, etc. Bearers surround the live matter. A proof of the locked-up form is called a *foundry proof*.

Foundry type. Metal type characters used in hand composition, cast in special hard metal by type founders.

Fractions. These come in three styles. *Adaptable*, which are made up of three separate characters: two large (text-size) numerals separated by a slash (3/4). *Case*, which are small fractions available as a single character (3/4). *Piece*, which are small fractions made up of two characters: nominator and slash or separating rule as one character, and the denominator as the second character (3/ and 4 to make 3/4, for example).

Furniture. In letterpress, the rectangular pieces of wood, metal, or plastic, below the height of the type, used to fill in areas of blank space around the type and engravings when locking up the form for printing.

G

Gallery. Cameras and darkroom of an engraving plant.

Galley. In metal composition, a shallow, three-sided metal tray that holds the type forms prior to printing. Also refers to the *galley proof*.

Galley proof. Also called a *rough proof.* An impression of type, usually not spaced out or fully assembled, that allows the typographer or client to see if the job has been properly set.

Gigo. "Garbage in, garbage out." Programming slang for bad input produces bad output.

Glossy. Photoprint made on glossy paper. As opposed to matte.

Grain. Direction of the fibers in a sheet of paper.

Grave. Accent above a letter: è.

Gray scale. Series of density values, ranging progressively from white through shades of gray to solid black. Used in film processing to check the degree of development.

Grid. In photocomposition, the rectangular carrier of a negative type font used in some systems. Also refers to the cross-ruled transparent grids over which all parts of a page or book layout will be assembled, or made up, in phototypography.

Grotesque. Another name for sans serif typefaces.

Hairline. Fine line or rule; the finest line that can be reproduced in printing.

Hanging indent. In composition, a style in which the first line of copy is set full measure and all the lines that follow are indented.

Hanging punctuation. In justified type, punctuation that falls at the end of a line is set just outisde the measure in order to achieve optical alignment.

Hard copy. Typewritten copy produced simultaneously with paper or magnetic tape and used to help keyboard operator spot errors and to supply proofreaders with copy to read and correct before the tape is com-

Galley.

Kerned letters.

mitted to typesetting. Also convenient for marking operating instructions to the photounit operator.

Hardware. In phototypesetting and the word-processing field, a term referring to the actual computer equipment, as opposed to the procedures and programming, which are known as *software*.

Head. Top, as opposed to the bottom, or foot, of a book or a page. In phototypesetting, a device that can read, write, or erase data on a storage medium.

Heading. Bold or display type used to emphasize copy.

Headline. The most important line of type in a piece of printing, enticing the reader to read further or summarizing at a glance the content of the copy which follows.

Headliner. In phototypesetting, a trade name for a machine that produces display sizes of type, manufactured by VariTyper Corp.

Head margin. White space above the first line on a page.

Holding lines. Lines drawn by the designer on the mechanical to indicate the exact area that is to be occupied by a halftone, color, tint, etc.

Hot type. Slang expression for type produced by casting hot metal: Linotype, Intertype, Monotype, and Ludlow, and sometimes handset foundry type.

Hung initial. Display letter that is set in the left-hand margin.

Hyphenation. Determining where a word should break at the end of a line. In type-setting, computers are programmed to determine hyphenation by the following methods: discretionary hyphen, logic, exception dictionary, and true dictionary.

Incunabula. Early printing, specifically that done in the 15th century.

Indent. Placing a line (or lines) of type in from the regular margin to indicate the start of a new paragraph. The first line can either be indented, or it can hold the measure and all subsequent lines in the paragraph can be indented. The space used for an indent is usually one em.

Index. Alphabetical list of items (as topics or names) treated in a printed work that gives each item the page number where it can be found. Also a character used to direct attention:

Indicia. Information printed by special permit on cards or envelopes that takes the place of a stamp.

Inferior characters. Small characters that are usually positioned on or below the baseline. Generally used in mathematical settings.

Initial. First letter of a body of copy, set in display type for decoration or emphasis. Often used to begin a chapter of a book. *See also* Drop, Hung, *and* Raised initials.

Input. In computer composition, the data to be processed.

Input speed. Rate at which the copy is translated into machine form.

Insert. Separately prepared and specially printed piece which is inserted into another printed piece or a publication.

Interlinespacing. Also called *linespacing*. In photocomposition, term for *leading*.

Intertype. Trade name for a linecasting machine similar to Linotype. Manufactured by Harris-Intertype Corp., now Harris Corp.

Italic. Letterform that slants to the right: looks like this.

Job shop. Commercial printing plant, as opposed to a publication, or "captive," shop. Justified type. Lines of type that align on both the left and the right of the full measure. Justify. Act of justifying lines of type to a specified measure, right and left, by putting the proper amount of interword space between words in the line to make it even, or "true."

K

Kerned letters. Type characters in which a part of the letter extends, or projects, beyond the body or shank, thus overlapping an adjacent character. Kerned letters are common in italic, script, and swash fonts.

Kerning. Adjusting the space between letters so that part of one extends over the body of the next. In metal type, kerning is accomplished by actually cutting the body of the type for a closer fit. In phototypesetting, it is accomplished by deleting one or more units of space from between characters. Compo-

Idiot tape. Common term for an unformatted, i.e., unhyphenated, unjustified tape. Cannot be used to set type until command (format) codes are added and processed by a computer that makes all the end-of-line decisions.

Illustration. General term for any form of drawing, diagram, halftone, or color image that serves to enhance a printed piece.

Image master. Also called a *type matrix*. In phototypesetting, the type fonts, i.e., a disc, filmstrip, etc.

Impose. In typesetting and makeup, the plan of arranging the printing image carrier in accordance with a plan. To make up.

Imposing stone. See Stone.

Imposition. In printing, the arrangement of pages in a press form so they will appear in correct order when the printed sheet is folded and trimmed. Also, the plan for such an arrangement.

Imprint. Printing of a person's or a firm's name and address on a previously printed piece by running it through another printing press.

sition set this way is often termed "set tight" or set with minus letterspacing.

Key. To code copy by means of symbols such as numbers or letters. Also refers to a device for tightening *quoins* or a device to tighten the hooks used with a patent base.

Keyboard. In linecasting, phototypesetting, and typewriter or strike-on composition, that part of the typesetting machine at which the operator sits and types the copy to be set. See also Counting keyboards and Noncounting keyboards.

Keyboardist. Keyboard operator.

Keyboard layout. Position of the keyboard keys.

Keyline. Most paste-up art has key lines, which are the outlines of areas or of objects the designer has drawn, showing where a panel, color tint, or halftone is to be positioned. See Mechanical.

Kicker. Also called a *teaser*. A short line above the main line of a head, printed in smaller, or accent, type.

Kill. To delete unwanted copy. Also, to "kill type" means to distribute or dump metal type from a form that has already been printed, or to destroy existing negatives or press plates.

Kleenstick. Brand name for a pressuresensitive adhesive-backed paper. When repros are pulled on Kleenstick, they can be put down on the mechanical directly, without rubber cement.

KPH. Keystrokes per hour.

Large fractions. Fractions made up of text-size numbers, as opposed to case fractions.

Layout. Hand-drawn preliminary plan or blueprint of the basic elements of a design shown in their proper positions prior to making a *comprehensive*; or showing the sizes and kind of type, illustrations, spacing, and general style as a guide to the printer.

L.C. Lowercase, or small letters of a font.

Leader. Row of dots, periods, hyphens, or dashes used to lead the eye across the page. Leaders are specified as 2, 3, or 4 to the em; in fine typography they may be specified to align vertically.

Lead-in. First few words in a block of copy set in a different, contrasting typeface.

Leading. (Pronounced *leading*.) In metal type composition, the insertion of *leads* between lines of type. In phototypesetting, the placement of space between lines of type: also called *linespacing* or *film advance*.

Leads. (Pronounced *leds.*) In metal type composition, the thin strips of metal (in thicknesses of 1 to 2 points) used to create space between the lines of type. Leads are less than type-high and so do not print.

Legibility. That quality in type and its spacing and composition that affects the speed of perception: the faster, easier, and more accurate the perception, the more legible the type.

Letraset. Brand name for a rub-off, or dry-transfer, type.

Letterfit. In composition, the quality of the space between the individual characters. Letterfit should be uniform and allow for good legibility. In body type, the typesetter has no control over letterfit because it is an integral characteristic of the font structure. In display types, the designer is responsible for obtaining proper letterfit by cutting and fitting the letters (set on paper or film) until the optimum esthetic arrangement is achieved.

Letterspace. Space between letters.

Letterspacing. In composition, adding space between the individual letters in order to fill out a line of type to a given measure or to improve appearance. In metal type, letterspacing is achieved by inserting thin paper or metal spaces, which are less than type-high and so do not print, between the letters. In phototypesetting, letterspacing is achieved mechanically by keyboarding extra space between letters or increasing the set-width of the face. In phototypesetting, minus letterspacing (or kerning) is also possible.

Ligature. In metal or linecast type, two or three characters joined on one body, or matrix, such as *ff, ffi, ffl, Ta, Wa, Ya*, etc. Not to be confused with characters used in logotypes cast on a single body.

Lightface. Lighter version of a regular typeface.

Linecaster. Typesetting machine (Linotype, Intertype) that casts entire lines of type in metal, as opposed to those that cast individual characters (Monotype).

Line copy. Any copy that is solid black, with no gradation of tones: line work, type, dots, rules, etc.

Line cut. See Line engraving.

Line drawing. Any artwork created by solid black lines: usually pen and ink. A drawing free from wash or diluted tones.

Line engraving. A printing plate which prints only black lines and masses.

Line gauge. Also called a *type gauge* or a *pica rule*. Used for copyfitting and measuring typographic materials.

Line length. See Measure.

Line mechanical. Accurate paste-up of all line copy, ready to be shot (photographed).

Line negative. High-contrast negative of line copy. Areas to be recorded are clear; all other areas are light-blocking.

Line overlay. Line work put on overlay to pre-separate line from halftone. Used in preparation of art for reproduction.

Line printer. In phototypesetting, a high-speed tape-activated machine that produces a hard copy printout for editing and correcting purposes. Specifically, a device capable of printing the line of characters across a page, i.e., 100 or more characters simultaneously as continuous paper advances line by line in one direction past type bars, a type cylinder or a type chain capable of printing all characters in all directions.

Line printer proof. Proof printed by a line printer and used for reading purposes, or

Linotype.

checking the outcome of typesetting before actual setting.

Linespacing. In phototypesetting, the term for *leading*.

Line work. Artwork consisting of solid blacks and whites, with no tonal values.

Lining figures. See Modern figures.

Linofilm. Trade name for a line of phototypesetting machines and a system manufactured by Mergenthaler Linotype.

Linotron. Trade name for high-speed cathode ray tube phototypesetting machines and systems manufactured by Mergenthaler Linotype.

Linotype. Trade name for a widely used linecasting machine that sets an entire line of type as a single slug. Manufactured by Mergenthaler Linotype.

Lithography. In fine art, a planographic printing process in which the image area is separated from the non-image area by means of chemical repulsion. The commercial form of lithography is offset lithography.

Live matter. Type matter which is to be held, or used for printing, as opposed to dead matter.

Lockup. In letterpress printing, a type form properly positioned and made secure in a chase for printing or stereotyping.

Logotype. Commonly referred to as a *logo*. Two or more type characters which are joined as a trademark or a company signature. Not to be confused with a ligature, which consists of two or more normally connected characters.

Lowercase. Small letters, or minuscules, as opposed to caps.

LPM. Lines per minute. A unit of measure for expressing the speed of a typesetting system; usually straight matter set in 8-point type on an 11-pica measure, or approximately 30 characters per line.

Ludlow. Trade name for a typecasting machine for which the matrices are assembled by hand and the type is cast in line slugs. Used principally for setting large display type and newspaper headlines. Manufactured by Ludlow Typograph Co.

M

Machine composition. Generic and general term for the composition of metal type matter using mechanical means, as opposed to hand-composition. The use of machines incorporating keyboards and hot metal typecasting equipment, i.e., Linotype, Monotype.

Machine Language. Language used by a machine or computer.

Magazine. Slotted metal container used to store matrices in linecasting machines.

Magnetic disk. Flat circular plate having a magnetic surface on which to store data.

Magnetic drum. Cylinder having a magnetic surface on which to store data.

Magnetic storage. Storage device using magnetic properties of materials on which to

store data; e.g., magnetic cores, tapes, and films.

Magnetic tape. In typewriter composition and photocomposition, a tape or ribbon impregnated with magnetic material on which information may be placed in the form of magnetically polarized spots. Used to store data which can later be further processed and set into type.

Makeready. Process of arranging the form on the press preparatory to printing so that the impression will be sharp and even. In letterpress, makeready is done by evening-up the impression under the tympan packing to make certain all the printing elements are type-high and that the paper and form come together close enough to transfer the ink, but not so close that the surface will be bruised or the paper punctured. The object of makeready is to ensure a "kiss impression."

Makeup. Assembling the typographic elements (type and art) and adding space to form a page or a group of pages of a newspaper, magazine, or book. Makeup is the management of white space; that is, the mechanical and esthetic arrangement of the elements of a piece into a legible format for final reproduction.

Margins. Areas that are left around type and/or illustrative matter on a page: the top, bottom, and sides.

Markup. In typesetting, to mark the type specifications on layout and copy for the typesetter. Generally consists of the typeface, size, line length, leading, etc. See also Formatting.

Master proof. Also called a *printer's proof* or *reader's proof.* A *galley proof* containing queries and corrections which should be checked by the client and returned to the typographer.

Masthead. Any design or logotype used as identification by a newspaper or publication.

Mat. In cast-type composition, the common (slang) term for a Linotype, Ludlow, or Monotype matrix.

Matrix. (More commonly called a *mat.*) In foundry-cast type, the mold from which the type is cast. In linecasting, the specially designed mold for casting a character; lines of matrices are assembled for casting a slug. In phototypesetting, the glass plate that contains the film font negative: also referred to as a *type master*.

Matte finish. Paper with an uncalandered, lightly finished surface. Also, in photography, a textured, finely grained finish on a photograph or photostat, as opposed to glossy.

Mean line. More often called the *x-line*. The line that marks the tops of lowercase letters without ascenders.

Measure. Length of a line of type, normally expressed in picas, or in picas and points.

Mechanical. Preparation of copy to make it camera-ready with all type and design elements pasted on artboard or illustration board in exact position and containing instructions, either in the margins or on an overlay, for the platemaker.

Merge. In photocomposition, a technique for combining items from two or more sequenced tapes into one, usually in a specified sequence, using a computer to incorporate new or corrected copy into existing copy and produce a clean tape for typesetting.

Metric system. Decimal system of measures and weights with the meter and the gram as the bases. Here are some of the more common measures and their equivalents:

kilometer 00.6214 mile meter 39.37 inches 00.3937 inch centimeter millimeter 00.0394 inch kilogram 02.2046 lbs. 15.432 grs. (av.) gram inch 02.54 cms. foot 00.3048 meter vard 00.9144 meter 00.4536 kilogram pound

Minuscules. Small letters, or lowercase.

Minus linespacing. Also called *minus leading*. The reduction of space between lines of type so that the baseline-to-baseline measurement is less than the point size of the type.

Mixing. Capacity to mix more than one typeface, type style, or size on a line and have them all base-align.

Modern. Term used to describe the type style developed in the late 18th century.

Modern figures. Also called *lining figures*. Numerals the same size as the caps in any given typeface: 1, 2, 3, 4, 5, 6, 7, 8, 9, 10. As opposed to Old Style, or non-lining, figures: 1, 2, 3, 4, 5, 6, 7, 8, 9, 10. Modern figures align on the baseline.

Modification: Reproportioning of type in one dimension while holding the other. Simple modification, such as condensing or expanding, italicizing or backslanting can be achieved directly on most photodisplay machines. More complex modification is usually done with special cameras or lenses.

Monophoto. Phototypesetting systems, manufactured in four models by the Monotype Corporation.

Monotype. Trade name for a typecasting machine that casts individual characters in lines (rather than lines of type as a solid slug, as in Linotype). Manufactured by the Monotype Corporation.

Mortise. See Kerning.

Mortising. Cutting of a rectangular cavity, or hole, in an engraving block to allow type or other engravings to be inserted.

Mutton quad. Also called a *mutt*. Nickname for an *em-quad*.

N

Negative. Reverse photographic image on film or paper: white becomes black and black becomes white; imtermediate tone values are reversed. Also, a short form of the term "film negative" used in photography or in

photomechanical processes to make printing plates.

Nick. In hand composition, the grooves in the body of the type pieces that help the compositor assemble the letters. In film, a notch or notches in the edge of the film used to identify the type of film when handling in the darkroom.

Non-counting keyboard. In phototypesetting, a keyboard at which the operator types the copy to be set, producing a continuous tape which is then fed into a computer to determine line length and hyphenation and justification.

Non-lining figures. See Old Style figures. Numerals, Arabic. See Arabic numerals. Numerals, Roman. See Roman numerals. Nut. Nickname for an en-quad.

Oblique. Roman characters that slant to the right.

OCR. Abbreviation for optical character recognition.

Offline. Refers to equipment not directly controlled by a central processing unit or to operations conducted out-of-process. As opposed to online.

Offset. Commonly used term for offset lithography. Also used interchangeably with set-off.

Offset lithography. Also called photolithography and, most commonly, offset. The commercial form of lithographic printing. Offset lithography is a planographic printing method; it is the only major printing method in which the image area and the non-image area of the printing plate are on the same plane. They are separated by chemical means, on the principle that grease (ink) and water (the etch in the fountain solution) do not mix. The ink is transferred from the plate onto a rubber blanket and then to the paper.

O.K. proof. When written on a proof it indicates there are no errors.

O.K. with corrections. May also be indicated *O.K.* with changes. Indicates proof is approved if corrections are made.

Old Style. Style of type developed in the early 17th century.

Old Style figures. Also called *non-lining figures*. Numerals that vary in size, some having ascenders and other descenders: I, 2, 3, 4, 5, 6, 7, 8, 9, 10. As opposed to Modern, or lining, figures: 1, 2, 3, 4, 5, 6, 7, 8, 9, 10.

Online. Refers to equipment directly controlled by a central processing unit. As opposed to offline. The term generally refers to the operation of input/output devices.

Open matter. Type set with abundant linespacing or containing many short lines.

Optical character recognition. Process of electronically reading typewritten, printed, or handwritten documents used in photocomposition. Copy to be set is typed on a special typewriter, then read by an OCR scanner

Monophoto.

which produces a tape for typesetting. This avoids the necessity for keyboarding by the keyboard operator, permitting typesetting by a typist.

Ornamented. Typeface that is embellished for decorative effect.

Outline. Typeface with only the outline defined.

Output. In phototypesetting, type that has been set. Also, the processed tape from a computer.

Page proofs. See Proofs.

Pagination. The numbering of pages in consecutive order.

Pamphlet. Generally used interchangeably with *booklet*. Also used to designate a minor booklet of a few pages.

Paper tape. Strip of paper of specified dimensions on which data may be recorded, usually in the form of punched holes. Each character recorded on the tape is represented by a unique pattern of holes, called the *frame* or *row*. Frames usually consist of 5, 6, 7, or 8 tracks or channels, although some tape-controlled typesetting equipment requires 15- or 31-channel tape.

Paragraph mark. Typographic elements used to direct the eye to the beginning of a paragraph (¶ □). Often used when the paragraph is not indented.

Parameter. Variable that is given a constant value for a specific process. Commonly used in the printing industry to refer to the limits of any given system.

Paste-up. See Mechanical.

Patch film. Film added or stripped into film that has already been made up for the camera. This happens when repro patches are sent in late, shot, and stripped in film form (as opposed to being pasted on the mechanical and the entire mechanical page being reshot).

Patching. Method of making corrections in repros or film in which the corrected "patch" is set separately and pasted into position on the repros or shot and stripped into film. See also Patch film.

PE. Abbreviation of "Printer's Error," or mistake made by the typesetter, as opposed to AA.

Perforator. In composition, a keyboard unit that produces punched paper tape. Each character and function is given a unique code which is punched across the tape. In bindery work, a machine that punches a series of closely spaced holes in paper.

Photocomposing. To photomechanically arrange continuous-tone, line, or halftone copy for reproduction. *Not a synonym for photocomposition*. Also, the technique of exposing photosensitive materials onto film or press plates using a photocomposing machine (also called a step-and-repeat machine).

Photocomposition. See Phototypesetting.

Photocopy. Duplicate photograph, made from the original. Also, the correct generic term for Photostat, which is a trade name.

Photodisplay. Display matter set on paper or film by photographic means.

Photodisplay font. Font in the form of a disc, grid, or negative film strip, that carries a display alphabet.

Photodisplay unit. Machine that photographically sets display type.

Photographic paper. Chemically sensitized paper used for photographic printing.

Photolettering. Sometimes used as a synonym for photodisplay, but more specifically a system of assembling film positives of letters for later use in producing film or paper prints.

Photomechanical. Complete assembly of type, line art, and halftone art in the form of film positives onto a transparent film base from which autopositive diazo proofs can be pulled for checking and from which a one-piece control film negative can be made for the production of printing plates.

Photomechanical transfer materials (PMT). Photomechanical papers manufactured by Eastman Kodak: Kodak PMT Negative Paper, for making enlarged or reduced copies in a process camera; Kodak PMT Reflex Paper, for making reflex copies or contact proofs of line and halftone negatives in a contact frame; Kodak PMT Receiver Paper, a chemically sensitive paper for making positive prints in a diffusion transfer processor (can also be used to make photorepros).

Photon. Trade name for a line of typesetting machines, available in a variety of models. Manufactured by Photon, Inc.

Photoprint. Also called a *photorepro* or *photocopy.* In phototypesetting, final proof with all typographic elements in position ready to be pasted into mechanical. Similar to a reproduction proof in metal typesetting.

Photoproof. In phototypesetting, a rough proof for proofreading. Similar to a galley proof in metal typesetting.

Photorepro. Reproduction-quality proof of phototype. Produced by phototypesetting on photosensitive paper or by contact printing (through a film negative) of phototypeset materials. (Term used mainly in New York City area.)

Photostat. Trade name for a photoprint, more commonly referred to as a stat. Stats are most commonly used in mechanicals to indicate size, cropping, and position of continuous-tone copy. The original copy is photographed by a special camera and produces a paper negative. From this a positive stat is made. Stats can be either matte or glossy in finish. The use of stats pasted in mechanicals as actual shooting copy is a common but quality-negating practice. Only absolutely sharp stats should be used. Matte-finish stats are preferred since aberration due to the gloss when photographing the mechanical is minimized.

Phototext. Text matter set by means of photocomposition.

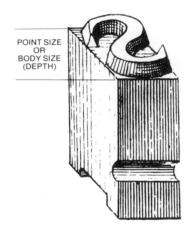

Point.

Phototype. Photographically composed type: type set on a phototypesetting machine.

Phototypesetter. One of various machines used to photographically set, or compose, type images.

Phototypesetting. Also known as *photo-composition* and erroneously as *cold type*. The preparation of manuscript for printing by projection of images of type characters onto photosensitive film or paper which is then made up in mechanicals or photomechanicals, from which printing plates can be produced. Phototypesetting machines always produce positive images of type, either on photosensitive paper or film.

Phototypography. Process of producing matter from graphic reproduction via the use of all-photomechanical means: phototypesetting machines, cameras, photoenlargers, photocomposing machines, and photosensitive substrates.

Photo Typositor. Semiautomated photodisplay unit manufactured by the Visual Graphics Corporation.

Photounit. Output, or phototypesetting unit of a photocomposition system: the unit responsible for the actual setting and exposing of the type onto photosensitive film or paper.

Pi. Metal type that has become indiscriminately mixed, such as when a type form spills, so that it is unusable until it is put back in order.

Pica. Typographic unit of measurement: 12 points = 1 pica (1/16" or 0.166"), and 6 picas = 1 inch (0.996"). Also used to designate typewriter type 10 characters per inch (as opposed to elite typewriter type, which has 12 characters per inch).

PI characters. Special characters not usually included in a type font, such as special ligatures, accented letters, mathematical signs, and reference signs. Called *sorts* by Monotype.

Piece fraction. Also called a *built fraction* or a *split fraction*. A small fraction made up of two parts (a ³ and a /₄ to make the fraction ³/₄, for example) as opposed to a case fraction.

Point. Smallest typographical unit of measurement: 12 points = 1 pica, and 1 point = approximately 1/72 of an inch (0.01383"). Type is measured in terms of points, the standard sizes being 6, 7, 8, 9, 10, 11, 12, 14, 18, 24, 30, 36, 42, 48, 60, and 72 in point size.

Positive. Photographic reproduction on paper, film, or glass that corresponds exactly with the original: the whites are white (i.e., clear), the blacks are black (i.e., opaque), as opposed to a negative, in which the tonal values are reversed.

Preparation. Also called *prep work*. In printing, all the work necessary in getting a job ready for platemaking: preparing art, mechanicals, camera, stripping, proofing.

Press proof. Proof pulled on the actual production press (as opposed to a proofing press) to show exactly how the form will look when printed. Press proofs are expensive and are normally requested only as a final check at the time of printing. Press proofs

are usually checked right at the printing plant while the press waits.

Pressure-sensitive lettering. Type carried on sheets that is transferred to the working surface by burnishing. Examples are Artype and Prestype.

Primary letters. Lower case letters which do not have ascenders or descenders; e.g., a, c, e, m, n, o, etc.

Print. Paper photograph made from a negative: a black and white photograph.

Printer's error. See PE.

Printout. In phototypesetting, printed output in typewriter-like characters, done by a line printer.

Process camera. Also called a *copy camera* or a *graphic arts camera*. A camera specially designed for process work such as halftone-making, color separation, copying, etc. Process cameras are usually large and sturdily built.

Process lettering. Also called photolettering or photo process lettering. A photodisplay method in which alphabets converted to film are assembled piece by piece from a file box by hand. Fonts are usually available in one size of each style and assembled words are enlarged or reduced to fit the layout. Assembly is done by skilled lettering artists who retouch, modify, or improve upon the finished result before releasing it.

Program. In phototypesetting, the generic reference to a collection of instructions and operational routine, or the complete sequence of machine instructions and routines necessary to activate a phototypesetting machine, that is fed into and stored in the computer: the more sophisticated the programming, the more versatile and the higher the quality of composition the system will provide.

Projection. Negative or positive made by passing light through film and projecting the image onto paper or film. This is the same principle used by photographic enlargers. See also Contact print and Reflection.

Proofreader. Person who reads the type that has been set against the original copy to make sure it is correct and who also may read for style, consistency, and fact.

Proofreader's marks. Shorthand symbols employed by copyeditors and proofreaders to signify alterations and corrections in the copy. These symbols are standard throughout the printing industry and are illustrated in most dictionaries, and on page 157 of this book.

Proofs. Trial print or sheet of printed material that is checked against the original manuscript and upon which corrections are made. See also Galley proof, Line printer proof, Master proof, Photoprint, Photoproof, Reader's proof, Reproduction proof and Rough proof.

Protype. Trade name for a manually operated photodisplay machine for display composition.

Prove. To pull a proof. Also refers to the testing of the accuracy of a computer program, i.e., to verify the program.

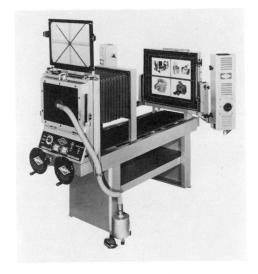

Process camera.

Punched tape. In typesetting, a tape into which a pattern of holes is punched by a keyboard-actuated punch. The tape activates the typesetting machine when it is fed through a tape reader.

Q

Quad. Piece of type metal less than typehigh used to fill out lines where large spaces are required. An em-quad is the square of the particular type size: a 10-point em-quad is 10 points x 10 points. An en-quad is half the width of an em-quad. Quads are also made in 1½-em, 2-em, and 3-em sizes.

Quadding. Setting quads, or spaces larger than the normal wordspaces, in a line of type. Traditionally, this meant inserting quads to justify lines of type. In linecasting or photocomposition it is also used to denote how to position the type by spacing it with quads: *quad left* is flush left, *quad right* is flush right, and *quad center* is centered. On command, the machine inserts space, in the form of quads or in increments of space representing quads, to perform the function desired.

Quoins. (Pronounced *coins*) Expansible blocklike or wedge-shaped devices operated by the use of a *quoin key* and used with metal type to lock up a type form in the chase prior to putting it on press.

Register marks.

Ragged. See Unjustified type.

Raised initial. Display letter that basealigns with the first line of text.

Reader. Specialized device that can convert data represented in one form into another form. Readers used in typesetting include OCR readers, magnetic tape or card readers, punched tape or card readers, and in specialized application, mark-sensing readers.

Reader's proof. Also called a *printer's proof*. A galley proof, usually the specific proof read by the printer's proofreader, which will contain queries and corrections to be checked by the client.

Reading head. Device capable of sensing information punched or recorded on tape and converting it to another form of storage, or into signals that will operate a computer or a typesetting machine.

Recto. Right-hand page of an open book, magazine, etc. Page 1 is always on a recto, and rectos always bear the odd-numbered folios. Opposite of verso.

Reference mark. Symbol used to direct the reader from the text to a footnote or other reference. The common marks are as follows:

Star or asterisk § Section

† Dagger || Parallels

‡ Double-dagger ¶ Paragraph

Reflection. Light is reflected off the image and onto photographic paper or film. This is the basic principle used by copy cameras for shooting mechanicals. The reflection method is capable of enlarging or reducing, or of reproducing an image the same size. See also Contact print and Projection.

Reflection copy. Also called *reflective copy.* Any copy that is viewed by light reflected from its surface: photographs, paintings, drawings, prints, etc. As opposed to transparent copy.

Register marks. Devices, usually a cross in a circle, applied to original copy and film reproductions thereof. Used for positioning negatives in perfect register, or, when carried on press plates, for the register of two or more colors in printing. Register marks should not be confused with corner, bleed, or trim marks.

Reproduction proof. Also called a *repro*. A proof made from type that has been carefully locked up and made ready. Repro proofs are pulled on a special coated paper and pasted into mechanicals.

Reversal film. Special contact film in which the black-white values are preserved in direct relationship to the original; that is, a positive produces a positive, and a negative another negative.

Reverse copy. Copy which is wrong-reading when printed.

Reverse leading. See Leading.

Reverse type. In printing, refers to type that drops out of the background and assumes the color of the paper.

Revise. Change in instruction that will alter copy in any stage of composition.

Roman. Letterform that is upright, like the type you are now reading. Also, more specifically, an upright letterform with serifs derived from the original Roman stone-cut letterforms.

Roman numerals. Roman letters used as numerals until the tenth century A.D.: I=1, V=5, X=10, L=50, C=100, D=500, and M=1,000. As opposed to Arabic numerals.

Rough. Sketch or thumbnail, usually done on tracing paper, giving a general idea of the size and position of the various elements of the design.

Rough proof. Any proof pulled from type on a proofing press or from a plate without makeready showing what the material proofed looks like. Rough proofs are usually pulled for identification purposes only, before filing away type galleys or engravings for storage. Also, an in-house proof pulled to check the work.

Rub-off type. See Pressure-sensitive lettering.

Rule. Black line, used for a variety of typographic effects, including borders and boxes. Rules are actual type-high typographic elements and come in a range of thicknesses called *weights* that are measured in points. Many rules are cast as duplex rules: two or more parallel lines of the same or of different thicknesses cast

on the same body. Fine rules for letterpress work are often made of strip brass or steel. In addition to lines, rules may also be dotted or dashed, or they may contain fancy border designs.

Run. Printing term referring to the number of copies printed.

Run-around. Type in the text that runs around a display letter or illustration.

Run in. To set type with no paragraph breaks or to insert new copy without making a new paragraph.

Running head. Book title or chapter head at the top of every page in a book.

Running text. Also referred to as *straight matter*, or *body copy*. The text of an article or advertisement as opposed to display type.

S

Safelight. Colored lamp used in darkroom work which gives enough light to see by yet does not affect the photographic material.

Sans serif. Typeface design without serifs.

Scaling. Process of calculating the percentage of enlargement or reduction of the size of original artwork to be enlarged or reduced for reproduction. This can be done by using the geometry of proportions or by the use of a desk or pocket calculator, logarithmic scale, or disc calculator.

Script. Typeface based on handwritten letterforms. Scripts come in formal and informal styles and in a variety of weights.

Selectric. Trade name for a strike-on (typewriter) composition system manufactured by IBM.

Series of type. Refers to all the sizes of one particular and unique typeface.

Serifs. Short cross-strokes in the letterforms of some typefaces. Sans serif typefaces, as the name implies, do not have serifs but open and close with no curves and flourishes.

Set-width. Also called *set size* or *set.* In metal type, the width of the body upon which the type character is cast. In phototypesetting, the width of the individual character, including a normal amount of space on either side to prevent the letters from touching. This space, measurable in units, can be increased or decreased to adjust the letterspacing. Letterspacing can also be adjusted by using a larger or smaller than normal set size mode on the photounit. This function can also be performed in metal typography by the Monotype machine.

Shoulder. Space on the body of a metal type or slug which provides for ascenders or descenders. Also provides the minimum space required to separate successive lines.

Show-through. Phenomenon in which printed matter on one side of a sheet shows through on the other side.

Small caps. Abbreviated s.c. A complete alphabet of capitals that are the same size as the x-height of the typeface.

Slug. Line of type set by a linecasting machine.

Software. Computer programs, procedures, etc., as contrasted with the computer itself, which is referred to as *hardware*.

Solid. In composition, refers to type set with no linespacing between the lines.

Solid fraction. See Case fraction.

Sorts. Individual letters in a font of type for use in replenishing used-up type in a case. Also used by Monotype to describe special characters (pi characters) not in the regular fonts.

Spacebands. Movable wedges used by linecasting machines for wordspacing and to justify lines of type. After the line has been set as a row of matrices, the spacebands are forced up to tighten (i.e., justify) the line prior to casting.

Spaces. In handset type, fine pieces of metal type, less than type-high, inserted between words or letters for proper spacing in a line of type.

Spacing. Separation of letters and words in type or the separation of lines of type by the insertion of space.

Spec. To specify type or other materials in the graphic arts.

Split fraction. See Piece fraction.

Square halftone. Also called a square-finish halftone. A rectangular—not necessarily square—halftone, i.e., one with all four sides straight and perpendicular to one another. So called because the edges of the plate are machine-cut on a finishing machine.

Square serif. Typeface in which the serifs are the same weight or heavier than the main strokes.

S.S. Also indicated as *S/S.* Abbreviation for "same size."

Stabilization paper. Stabilizationprocessible (dry-processed) photopaper used in phototypesetting for output in the form of good-quality photorepros. Not the same as conventional photosensitive papers (Kodaline, Resisto), which are chemically wet-processed in a tray or in a film or paper processor. Stabilization-processed materials are sensitive to ultraviolet light and have a lifespan of only about six weeks. If kept for a longer period of time they must be washed and fixed. The nature of these papers is such that they process in a way that causes problems in matching image densities from batch to batch; this is especially troublesome when making corrections in previously set matter.

Stat. See Photostat.

Step and repeat. Method of making multiple images from a master negative of the same subject in accurate register. Stepand-repeat operations are done photomechanically using a photocomposing machine (also called a *step-and-repeat machine*).

Stet. Proofreader's mark that indicates copy marked for correction should stand as it was before the correction was made. Copy to be stetted is always underlined with

Slug.

Selectric®.

a row of dots usually accompanied by the word stet.

Stick. See Composing stick.

Stone. Also called an *imposing stone*. The surface, originally of stone but now of machined metal, on which letterpress forms are assembled, locked up, and planed down prior to putting them on the bed of a press.

Storage. In computer-aided phototypesetting, a device (a magnetic memory tape, disc, or drum) into which data can be entered, in which it can be held, and from which it can be retrieved at a later time.

Straight matter. In composition, body type (as opposed to display type) set in rectangular columns with little or no typographic variations.

Strike-on composition. See Typewriter composition.

Stripper. Also referred to as a makeup man. Worker in a printing plant who assembles and strips negative or positive film onto a flat for making plates. Also refers to the person in a phototypesetting plant who makes up the job in film form (as a photomechanical), usually in positive form, after the job has been set on photodisplay and/or phototypesetting machines.

Stripping. Assembling photographic negatives or positives and securing them in correct position to the paper (goldenrod), film, or glass base used in making the press plates.

Stripping guide. Position layout or translucent layout tissue or rough paste-up which serves as a guide for stripping a film mechanical, etc.

Subtitle. Secondary title.

Swash letters. Italic caps formed with long tails and flourishes.

T

Tape. Punched paper ribbon (between 6-and 31-level) or magnetic (7- or 9-level) tape, produced by a keyboard unit and used as input to activate the photounit of a typesetting system or a computer for subsequent processing of the data thereon for phototypesetting machine input.

Tape editing. In phototypesetting, the transferring of information, via a visual display terminal or a line printer, from one tape to another to produce a correct tape.

Tapemaster. Trade name of a line of phototypesetting machines manufactured by Photon, Inc.

Tape merging. In phototypesetting, a method of editing and correcting tapes in systems in which every line of type is numbered.

Text. Body copy in a book or on a page, as opposed to the headings.

Textmaster. Trade name for a line of phototypesetting machines manufactured by Photon, Inc.

Text type. Main body type, usually smaller in size than 14 point.

Thin space. Metal type, ¹/₅ of an em space. Thumbnails. Small, rough sketches.

Tint. Color obtained by adding white to solid color. In printing, a photomechanical reduction of a solid color by screening.

Titling. Alphabet of foundry type in which the capital letters fill the full face of the type. This permits the setting of caps with a minimum of linespacing. Titling caps have no matching lowercase alphabet.

Transfer type. Type carried on sheets that can be transferred to the working surface by cutting out self-adhesive letterforms (cutout lettering) or by burnishing (pressuresensitive lettering). Examples are Artype, Formatt, Letraset, Prestype.

Transitional. Type style that combines features of both Old Style and Modern. Baskerville, for example.

Transpose. Commonly used term in both editorial and design to designate that one element (letter, work, picture, etc.) and another should change places. The instruction is abbreviated *tr.*

Transposition. Common typographic error in which letters or words are not correctly placed: "hte" instead of "the" or "Once a Upon Time" instead of "Once Upon a Time."

Trim. To cut off and square the edges of a printed piece or of stock before printing.

Trim size. Final size of a printed piece, after it has been trimmed. When imposing the form for printing, allowance must always be made for the final trim size of the stock.

TTS. Abbreviation for Teletypesetter, a trade name for a device that produces a perforated tape which can in turn operate the keyboard of a linecasting machine equipped to receive such input.

Type. Letters of the alphabet and all the other characters used singly or collectively to create words, sentences, blocks of text, etc.

Typecasting. Setting type by casting it in molten metal either in individual characters or as complete lines of type.

Type family. Range of typeface designs that are all variations of one basic style of alphabet. The usual components of a type family are roman, italic, and bold. These can also vary in width (condensed or extended) and in weight (light to extra bold). Some families have dozens of versions.

Type gauge. Commonly called a line gauge. A metal rule with a hook at one end calibrated points and picas on one edge and inches on the other. Used to measure metal type. Also, slotted copyfitting gauges made in various lengths and graduated increments of ens or ems of each type size. These are used to gauge the number of lines set in a given type size; they are also useful for copyfitting.

Type-high. Height of a standard piece of metal type: .918" (U.S.). a plate is said to be "type high" when mounted on wood or metal to the proper height to be used on a letter-press printing press.

Type metal. Metal used for cast type: alloy of lead, tin, and antimony, and sometimes a trace of copper.

Type series. One basic typeface design in its full size range, from 6 point up to 72 point, or sometimes even 120 point.

Typesetter. Term for a person who sets type. Also, any device that sets type.

Typesetting. Assembling of typographic material suitable for printing or incorporating into a printing plate. Refers to type set by hand, machine (cast), typewriter (strike-on), and phototypesetting.

Typestyle. Variations within a typeface: roman, italic, bold, condensed, expanded, etc.

Typewriter composition. Also called *strike-on* or *direct impression* composition. Composition for reproduction produced by a typewriter.

Typographer. Person or persons who set type.

Typographic errors. Commonly called *typos*. Errors made in copy while typing, either at a conventional typewriter, or by the compositor at the keyboarding stage of typesetting. Typos made by the compositor are PE's and are usually corrected free of charge.

Typography. The art and process of working with and printing from type. Today's technology, by mechanizing much of the art, is rapidly making typography a science.

U

U. & L.C. Also written *u/lc.* Commonly used abbreviation for upper and lowercase. Used to specify text that is to be set in caps (usually initial caps) and lowercase letters as written.

Unit. Variable measurement based on the division of the em into equal increments.

Unitization. Designing the characters in a font according to esthetically pleasing width groups. These width groups are measurable in units and are the basis for the counting mechanism of the keyboards and photounits of phototypesetting equipment. Width units can be based on the em (square of a point size) or the set size of the font.

Unit system. Counting method first developed by Monotype and now used for some strike-on typewriters and all phototypesetting systems to measure in units the width of the individual characters and spaces being set in order to total the accumulated units and determine the measure when the line is ready to be justified, and determine how much space is left for justification.

Unit value. Fixed unit width of individual characters.

Unjustified tape. Also called an *idiot tape*. In photocomposition, an unhyphenated, unjustified tape (either magnetic or paper). The tape is keyboarded with no end-of-line signals (no hyphenation or justification), allowing the keyboard operator to type at

maximum speed. The tape is then fed through a computer, which adds the total units accumulated and resolves the hyphenation and justification according to a pre-programmed set of rules and produces a justified tape. The justified tape is used as input to operate the phototypesetting machine.

Unjustified type. Lines of type set at different lengths which align on one side (left or right) and are ragged on the other.

Update. In photocomposition, to incorporate into the master tape the changes required to reflect recent corrections or changes.

Uppercase. Capital letters of a type font: A, B, C, etc.

V

Vacuum frame. Also called a *contact printing frame*. In photoengraving, offset lithography and phototypography, a glass-topped printing frame used for exposing plates or making contact negatives and positives. Close contact between the film and the plate is maintained by the action of the vacuum pumps which expel the air trapped between the two layers of substrate.

Value. Degree of lightness or darkness of a color or of a tone of gray, based on a scale of graduated tonal values running from pure white through all the gradations of gray to black.

Van Dyke. Also known as a *brownline* or a *brownprint*. A photocopy having its image in a dark brown color, used as a proof.

VariTyper. Trade name for a special typewriter capable of setting type directly onto paper. It composes type in a number of different styles and can produce justified type semiautomatically. VariTyper is one of several devices producing direct impression, or strike-on, typography. Manufactured by VariTyper Division, Addressograph-Multigraph Co.

Verso. Left-hand page of a book. Opposite of recto.

V-I-P. Phototypesetting system manufactured by Mergenthaler Linotype Corp.

Visual. See Layout and Comprehensive.

Visual display. Visual representation of computer output. This may be in the form of lines of type shown on the cathode ray tube of a visual display terminal (VDT) or a few words shown on a screen similar to those used on electronic calculators of the keyboard. Both permit the operator to edit and make corrections.

Visual display terminal. Device containing complete logic, a tape reader, a tape punch (or a magnetic tape head), a keyboard, and a cathode ray tube on which copy will be displayed as a composed tape as read by the reader. The operator can edit and correct copy by keying in the corrections. As he does this, a new tape is created for subsequent use in activating a phototypesetting or line-casting machine.

Vacuum frame.

Unitization.

Weight. In composition, the variation of a letterform: light, regular, bold. In paper measurement, the weight of 500 sheets (a ream) of paper of standard size.

WF. Abbreviation for "wrong font." Used by proofreaders to indicate that letters of type fonts have been mixed in typesetting.

White space reduction. See Kerning.

Widow. End of a paragraph or of a column of reading matter that is undesirably short: a single, short word; or the end of a hyphenated word, such as "ing." Widows are usually corrected editorially either by adding words to fill out the line or by deleting a word in the preceding line so that the widow moves up, becoming part of it. Widows can also be overcome by decreasing the set of the last several lines or of the ending paragraph. Decreasing the set is *kerning*.

Width. Variations of letterforms: condensed, extended.

Woodtype. Type made from wood. Usually used for the larger display sizes over 1". Wood type is made in sizes measured in lines, a line being 1 pica in depth. A 10-line face is thus 120-point type.

Wordspace. Space between words.

Wordspacing	Metal Type	Phototype
Very tight	5-to-the-em	3–4 units
Tight	4-to-the-em	4-5 units
Normal	3-to-the-em	6 units
Loose	2-to-the-em	7-9 units

Comparison of metal type wordspacing, measured in segments of the em, with phototype wordspacing, measured in units.

Wordspacing. In composition, adding space between words to fill out line of type to a given measure.

Wrong font. Error in typesetting in which the letters of different fonts become mixed. Indicated by proofreader by "wf."

Wrong-reading. Image that reads the reverse of the original. A mirror image.

X-height. Height of the body of lowercase letters, exclusive of ascenders and descenders.

X-line. Also called *mean line*. The line that marks the tops of lowercase letters.

Xenon flash. Light source often used in phototypesetting machines.

Z

Zip-a-Tone. Trade name for a series of screen patterns imprinted on plastic sheets that can be used to achieve tone of various kinds on art work. Zip-a-Tone comes in dots, lines, stipples, etc.

Manufacturers of Phototypesetting Equipment

Alphatype Corporation

7500 McCormick Blvd. Skokie, Illinois 60076

Founded in 1959, Alphatype has manufactured products that appeal to the quality-conscious market. Alphatype owns Key Corporation, manufacturers of intelligent front-end systems to drive their own and other manufacturers' output machines. Alphatype's present product line is the directinput AlphaComp, the AlphaSette, and the recently introduced CRS (a digitized cathode ray setter).

Compugraphic Corporation

80 Industrial Way Wilmington, Massachusetts 01887

Founded in 1961 to manufacture special-purpose typesetting computers, Compugraphic has since become one of the largest manufacturers of phototypesetting equipment in the world. It has more than 30 different models of typesetting machines, keyboards, video editing terminals, advertising layout terminals, and related devices. It also has one of the largest type libraries of text and display designs in the world. To date, Compugraphic manufactures the EditWriter family, the AdVantage ad layout terminal, VideoSetter CRT typesetters, the Mini Disk Terminal, and numerous other products.

Dymo Graphic Systems, Inc.

355 Middlesex Ave. Wilmington, Massachusetts 01887

Dymo Graphic Systems is a leading manufacturer of computerized composition systems and phototypesetting equipment. It was formed as a result of a merger of Star Graphic Systems and Photon, Inc., and is a subsidiary of Dymo Industries, Inc. In June 1978, Dymo Industries was purchased by Esselte, AB, of Sweden, a multinational company with operations in the printing, publishing and office supplies markets. Current product lines of Dymo Graphic Systems include Dymo Copy Processing Systems, Pacesetter phototypesetters with an extensive library of typefaces, input keyboards, editing terminals, and related peripheral devices.

Graphic Systems, Inc.

Executive Drive Hudson, New Hampshire 03051

Graphic Systems was founded in 1968 to manufacture phototypesetting equipment as

an OEM (original equipment manufacturer) for Singer. It has since initiated its own marketing efforts with an expanded line of equipment, including OCR, VDT, magnetic tape keyboards, and computers. Graphic Systems manufactures the "graphicset" 4 and 8 phototypesetter.

Harris Corporation

P.O. Box 2080 Melbourne, Florida 32901

Harris Corp. was founded in 1916. In addition to making linecasting machines, Harris Corp., formerly Harris-Intertype, is one of the largest manufacturers of phototypesetting machines, electronic editors, advertising layout terminals, and electronic word-processing systems. It also has one of the finest libraries of typefaces. Harris manufactures the Fototronic TXT, 4000, and 7000 series of CRTs.

Itek Corporation

1001 Jefferson Road Rochester, NY 14603

Founded in 1957, Itek Corporation is a multinational organization involved in the manufacture of precision optical devices, electronic devices, and equipment for printing and graphic reproduction. In 1959, Itek Corporation acquired Photostat Corporation—a pioneer in the photocopy field with the original Photostat® machine more than half-acentury ago. Today, Itek's Composition Systems Division manufactures and the Graphic Products Division sells the Quadritek 1200 phototypesetting system and other photocomposition-related products (the Quadritek Editor and the Itek RC Processor).

Mergenthaler Linotype Co.

A Division of Eltra Corp. Mergenthaler Drive, P.O. Box 82 Plainview, New York 11803

Mergenthaler Linotype was founded in 1886 to manufacture the Linotype machine (first successful typesetter). Currently it is a worldwide operation marketing a broad range of graphic arts products, including basic and computerized phototypesetters, high-speed CRT phototypesetters, input keyboards, video editing/correction terminals, and complete composition systems, including software. It also has an extensive library of fine typefaces. Mergenthaler manufactures the V-I-P, Linotron, and Linocomp.

VariTyper

Division of Addressograph Multigraph Corporation 11 Mount Pleasant Ave. East Hanover, New Jersey 07936

Founded in the early thirties as a manufacturer of a typewriter composition system, VariTyper became a division of the Addressograph Multigraph Corporation in 1957, manufacturing word-processing and photo-typesetting equipment, including direct-entry phototypesetters, off-line visual inputs, and direct word processing/phototypesetting interface. VariTyper manufactures the 500, 3500, and 4500 series of Comp/Set phototypesetters and the Headliner 820.

Manufacturers marketing phototypesetting equipment in the U.K. (and abroad):

Addressograph Multigraph

PO Box 17, Maylands Ave. Hemel Hempstead, Hertfordshire England

Alphatype Systems Ltd.

7 Regency Street London, S.W.1. England

H. Berthold A.G.

1000 Berlin 61 Mehringdamm 43, West Germany

Bobst-graphic

Ch/1001 Lausanne Switzerland

Compugraphic Corp.

M.H. Whittaker & Son Ltd. South Accomodation Road Leeds LS9 8LW

Dymo Graphic Systems U.K. Ltd.

Rectory House Rectory Lane, Edgeware Middlesex, England

Harris Systems Ltd.

PO Box 27, 145 Farnham Road Slough, Berkshire England

Itek Graphic Products U.K.

Itek House Mora Street London E.C.1

Linotype-Paul Ltd.

Kingsbury Road London NW9 8UT

Monotype Corp. Ltd.

Salfords, Redhill, Surrey England

Singer-Friden

Computerised Graphic Systems Gagnolet, France

Notes and Credits

These are the typefaces used as samples throughout this book. Linespacing is not given. Also, the word "point" is omitted (for example, 72-point Korinna Bold is listed as 72 Korinna Bold).

Page

- 12 72 Korinna Bold
- 13 72 Helvetica
- 15 24 Times Roman
- 36 Times Roman and Univers
- 17 36 Univers
- 21 72 Korinna Bold and Helvetica Medium
- 22 24 Korinna
- 23 11 Times Roman
- 26 12 Helvetica Light
- 27 12 Helvetica Light
- 28 12 Helvetica Light
- 29 30 Helvetica Light
- 31 42 Helvetica Medium
 - 12 Helvetica
- 36 6 Helvetica Light with Medium
- 6 Helvetica Light with Medium
- 10 Times Roman
- 39 10 Times Roman
- 42 16 Times Roman
- 43 10 and 30 Helvetica
- 45 10 and 12 Times Roman
 - 14 Korinna
- 46 6 through 72 Helvetica Light
- 48 Memphis Light
- 49 Memphis Light
- 12 Sans Serif Gothic with 18 Bold
- 55 12 Sans Serif Gothic with 36 Bold
- 56 10 Bodoni
 - 10 Garamond
 - 10 Helvetica
 - 10 Times Roman
 - 12 Times Roman
 - 14 Times Roman
- 57 7 Aster
 - 7 Trade Gothic
 - 7 Helvetica
 - 7 Avant Garde Gothic Book
 - 10 Helvetica Light
- 62 36 Helvetica
- 63 72 Korinna Bold
- 64 10 Caledonia
 - 10 Helvetica Light Condensed
 - 7 Helvetica
- 65 42 Helvetica Medium
- 70 12 Palatino
- 71 12 Palatino
- 72 12 Palatino
- 73 12 Palatino
- 74 12 Palatino
- 75 12 Palatino
- 76 12 Palatino 77
- 12 Palatino
- 78 12 Palatino
- 10 Trade Gothic Extra Condensed
 - 10 Eurostyle Extended
 - 7 Melior
 - 12 Palatino

- 80 10 Baskerville
- 81 10 Baskerville
- 82 24 Avant Garde Gothic Medium
- 83 24 Avant Garde Gothic Book
- 84 24 Century Expanded
- 86 9 Aster
 - 10 Helvetica
 - 10 Bodoni
 - 10 Times Roman
 - 8 Times Roman
 - 9 Palatino
- 87 10 Trump Mediaeval
- 88 14 Times Roman
- 89 9 Times Roman
 - 10 Times Roman
 - 11 Times Roman
 - 12 Times Roman
- 90 12 Bembo
- 91 12 Bembo
- 92 11 Korinna
- 93 11 Korinna
- 94 11 Korinna
- 95 11 Korinna
- 96 14 Souvenir Light
- 97 14 Souvenir Light
- 98 11 Helvetica Light
- 99 11 Helvetica Light
- 100 11 Sabon
 - 18 Times Roman
- 101 18 Bembo
- 104 10 Helvetica Light with Medium
- 105 10 Helvetica Light with Medium
- 106 24 Goudy Old Style
- 12 Goudy Old Style 107
- 12 Memphis Light 108
- 109 12 Trade Gothic Light
- 111 36 Times Roman
 - 36 Sabon
- 112 18 Times Roman
- 113 24 Palatino
 - 14 Palatino
- 114 11 Bookman
 - 18 Spartan Book
- 115 24 Century Schoolbook Bold
 - 18 Spartan Light
- 116 18 Bodoni Book
 - 24 Bodoni Book
- 117 16 Memphis Light
- 118 36 Avant Garde Gothic Extra Light
- 36 Avant Garde Gothic Extra Light
- 127 Helvetica Medium

The following companies and individuals supplied the photographs and type samples seen throughout this book:

- Copyright, Eastman Kodak Co. 20
- 65 Visual Graphics Corp.
- 122 Photolettering, Inc. and George Abrams
- 124 Letraset, USA Inc.
- 126 Joe Wheeler, Lettering Services, Inc.
- Visual Graphics, Corp. 127
- 128 H. Berthold AG
- 128 The Monotype Corp. Ltd.
- 129 H. Berthol AG
- 129 Letraset, USA Inc.

- 130 H. Bethold AG
- 132/136 Photolettering, Inc.
 - Young & Rubicam, Inc. 137
 - Arthur Brown & Brothers, Inc. 150
- 162/188 Alphatype Corp.

Automix Keyboards, Inc.

H. Berthold AG

Compugraphic Corp.

Comtext Corp.

Digital Equipment Corp.

Dymo Graphic Systems, Inc.

Graphic Systems, Inc. Harris Corp.

Itek Corp.

Mergenthaler Linotype Corp.

The Monotype Corp. Ltd. VariTyper

- 189 Eastman Kodak Co.
- 190 Eastman Kodak Co.
- 190 Beta Screen Corp.

Bibliography

Advertising Agency and Studio Skills. Tom Cardamone. New York: Watson-Guptill, 1970.

ATA Type Comparison Book. Frank Merriman. Advertising Typographers of America.

Bookmaking: The Illustrated Guide to Design and Production. Lee Marshall. New York: R.R. Bowker, 1965.

Compendium for Literates: A System of Writing. Karl Gerstner. Boston: MIT Press, 1974.

Computer Terms for the Typographic Industry. Washington, D.C.: International Typographic Composition Association, 1973.

Dictionary of Contemporary American Usage. Bergen Evans. New York: Random House, 1957.

Design with Type. Carl Dair. Toronto: University of Toronto, 1967.

Designing with Type: A Basic Course in Typography. James Craig. New York: Watson-Guptill, 1971.

Editing by Design. Jan V. White. New York: R.R. Bowker, 1974.

Electronic Composition: A Guide to the Revolution in Typesetting. N. Edward Berg. Pittsburg: Graphics Arts Technical Foundation, 1975.

Elements of Style. William Strunk, Jr., and E.B. White. New York: The Macmillan Company, 1972.

A Manual of Style. University of Chicago Press, 1969.

Pocket Pal. International Paper Company. New York: 1974.

Production for the Graphic Designer. James Craig. New York: Watson-Guptill Publications, 1974.

Lettering for Reproduction. David Gates. New York: Watson-Guptill, 1969.

Type. David Gates. New York: Watson-Guptill, 1973.

Type and Typography. Ben Rosen. New York: Van Nostrand Reinhold, 1963.

Words Into Type. Englewood Cliffs, N.J.: Appleton-Century-Crofts, 1974.

Index

AAs (author's alterations), 146 Abbreviation periods, space after, 115 Aligning leaders, 108 Alignment, optical, in display type, 118 Area composition systems, 186 Ascenders, 12 Asymmetrical type arrangement, 75

Body size. See Point size
Boldface type, 16; used to create emphasis, 91
Borders, 130
Boxes, 109
Broken rules, 102
Bullets, 110

Capital letters, 12; and letterspacing, 65 Case fractions, 113 Centered type, 74 Character counting, 141; by alphabet length, Character count table, 142-143 Characters (type), 12 Characters, inferior and superior, 112; to make up fractions, 113 Compact type. See Condensed type Comping, 154-155 Comps (comprehensives), 153 Computer (decision-making unit), 170 Computer programs, 172-173 Contour settings, 97 Conventional photographic paper, 188 Copyfitting, 139-159 Copy mark-up, 144 Copy preparation, 157 Counters, 12 Counting keyboard, 165 CRT (cathode ray tube) systems, 184-185

Dashes, 115-116 Degrees Celcius, 199 Demibold type. See Semibold type Depth (of a column of type), establishing, 148, 150 Descenders, 12 Design considerations when working with phototype, 31-137 Diamond leaders, 108 Didot system, 196 Dingbats, 128 Direct-entry systems, 180 Discretionary computer program, 172 Discs, 169 Display heads, specifying, 104 Display initials, 98-99 Display type, 21; comping, 155; and letterspacing, 65; optical alignment in, 118; and punctuation marks, 114-116 Drop initials, 98

Editing and correcting, 178–179
Editing-and-merging, 179
Elite typewriter, 140
Em, the, 24
Emphasis, creating, 90–91; with underscores, 107
End-of-line decisions: on counting keyboard, 165; on non-counting keyboard, 166
Exception dictionary, 172
Expanded type. See Extended type

Family of type, 18 Figures, 111

Film (as substrate), 189; paper vs., 190–191
Film mechanicals, 190
Floppy disc, 169
Font of type, 15
Fonts, 38; carrying capacity and changing system, 174; and image carriers, 174; pi, 40
Formatting codes, 145
Fractions, 113

Galley proofs, 146, 176

Hanging indents, 92 Hardware, 170 Hyphenation, and wordspacing, 76 Hyphenless computer program, 172 Hyphens, aligning with caps, 116 Hung initials, 99 Hung punctuation, 114

Indents, 92 Inferior characters, 112 Initials, display, 98–99 Italic typefaces, 16

Justified tape. See Counting keyboard Justified type, 70–71; and line length, 77 Justifying keyboard. See Counting keyboard

Kerning, 62 Keyboard (input), 164-169

Layouts, 153
Leaders, 108
Leading. See Linespacing
Letterspacing, 26, 58; choosing, 64–65; and wordspacing, 76
Ligatures, 101
Line length, 88; and linespacing, 86; and wordspacing, 77
Line printer, 179
Linespacing, 22, 80; choosing, 86–87; minus, 22; optical, 84; reverse, 85; specifying as white space, 82
Lining figures. See Modern figures
Logic computer program, 172
Lowercase characters, 12

Magnetic tape, 168
Makeup, 156
Manuscript (original copy), correct presentation of, 159
Mark-up, copy, 144
Measuring type, 20
Medium type. See Boldface type
Metric system, 198
Minus linespacing, 22
Modern figures, 111

Negative linespacing. See Minus linespacing Non-counting keyboard, 166–167 Non-justifying keyboard. See Non-counting keyboard Non-lining figures. See Old Style figures

Oblique type. See Italic typefaces
OCR (optical character recognition)
systems, 187
Old Style figures, 111
Optical alignment, in display type, 118
Optical linespacing, 84
Outline and shadow typefaces, 124

Paper, photographic. See Photographic paper Paper tape, 168 Paragraphs, indicating, 92 Patches: matching type for, 117; setting, PEs (printer's errors), 146 Photodisplay systems, 182-183 Photographic materials (substrates), Photographic paper, 198; vs. film 190-191 Phototypesetting system(s), 161-193; basic components of, 162; choosing Photounit (output), 174-175 Pica rule, 150 Picas, 20, 23 Pica typewriter, 140 Pi fonts, 41 Points, 20, 21; and linespacing, 22 Point size, 21 Point systems, 196 Processors and proofing methods, 176 Proofreader's marks, 147 Proofs, 146; methods of making, 176 Proportional typewriter, 140 Punctuation: basics of, 200-201; design considerations for, 114-116; in display type, 114-116

RC (resin-coated) paper, 188
Raised initials, 98
Reader's proofs, 146, 176
Reproportioning type, 127
Repros (reproduction proofs), 146, 176
Reverse linespacing, 85
Roman typefaces, 16
Rules, 102–103
Ruling pen, 107
Run-arounds, 96

Sans serif typefaces, 12
Script typefaces, 120
Set-size. See Set-width
Set-width, 25
Small caps, 16, 100
Software, 170
Solid, type set, 22
Special effects, 134
Specifying heads, 104
Specifying type in inches, 48
Stabilization paper, 189
Step-and-repeat, 132
Strip film, 106
Substrate. See Photographic materials
Superior characters, 112

Tabbing, 104 Tabular matter, 104-105; copyfitting, 151 Tapes and discs, 168-169 Terminology, type, 11-29 Text type, 21; comping, 154; and letterspacing, 64 Transfer type, 107 True dictionary, 173 Type alignment: mixing typefaces and, 42; optical, in display type, 118 Type arrangement, 70–75 Type, 12; matching, 117; measuring, 20; reproportioning, 127; setting in circles, 126; specifying in inches, 48 Type, display, 21, 65 Type, family of, 18 Type, text, 21, 64

Typeface(s), 14; choosing, 44-45; design, 32-33; mixing, 42; mixing type sizes and, 55; mixing to create emphasis, 91; outline and shadow, 124; script, 120 Typeface names, 14; differences in, 32-33; cross-reference chart of, 36-37 Typesetter. See Photounit Typesetting speed, 175 Type size(s), 46; and font-changing, 175; choosing, 56; using to create emphasis, 90; mixing, 54; mixing typefaces and, 55; and quality, 50; and x-height, 52 Type specimen books, 19 Type specification chart, 158 Typestyle, 16; using to create emphasis, Type weight, to create emphasis, 91. See also Boldface type Typewriters, and copyfitting, 140 Typographer, choosing a, 193 Typographic guide, 137

Underscores, 106, 107
Units, 20, 24; and letterspacing, 26; and phototypesetting, 29; and set-width, 25; and wordspacing, 28
Unit system and phototypesetting, 29
Unit value, 25
Unjustified tape. See Non-counting keyboard
Unjustified type, 72
Uppercase characters, 12. See also Display type

Vertical rules, 102 Visual display terminal, 178

Wordspacing, 28, 68; and type arrangement, 70–75; choosing, 78; controlling, 76–77
Writing to fit, 152

X-height, 12; and linespacing, 86; and type size, 52

● END OF RUN ●

Emmaus High School Library Emmaus, Pennsylvania

Craig, James, 1930
AUTHOR

Phototypesetting

TITLE

Emmaus High School Library

686.225 Cra

39855

Craig, James, 1930-

Phototypesetting